For Luca
May Your Dreams Come True

The Freak might be you!
An essay on the history of the Sideshow by Peter Schardt

Translated from German by the author

Freak /friːk/ 1) abnormal or unusual idea, act or occurrence 2) person, animal or plant that is abnormal in form, e.g. a five-legged sheep.

Oxford Advanced Dictionary of Current English

Hanspeter Schneider accidentally entered Gibsonton for the first time in 1996. As a professional and passionate photographer he quickly realised what retired clown Tom Cooper meant with the words: "The history is here!". It was an invitation for him to produce this outstanding and personal record of the Sideshow as it faced the demise of the last generation of natural "Freaks" and their memories of a once thriving Sideshow business.

Now, only a few years later, as this record is about to be published, Jeanie Tomaini, the "Half Lady" and Melvin Burkhardt, inventor of the "Human Blockhead", two great stars of this popular culture, are dead. This series of photographs captures images of a time from which few people now remain.

From "Giant's Camp" to Residential Show Business Zone

Gibsonton is "show capital of the world". In winter the largest carnival population in the US resides there, about 7000 people, taking advantage of the Residential Show Business Zone, a singular privilege that allows you to park a rollercoaster in the front yard and, if you have to, keep an elephant in the back, a major condition for many Carnies to settle down. The whole thing started back in the 1920's. The Half Lady and her husband, the Giant, Al Tomaini, once famed as the "strangest married couple in the world", followed an invitation to spend the winter season in Florida. Finding it a quiet, warm and sunny place and because there was good fishing, an all important condition for people who usually did not make a fortune, Al and Jeanie decided to withdraw from the Sideshow business and founded The Giant's Camp: a trailer park, bait shop and marina which became the post-war nucleus of today's Showtown, or as it appears on the map: Gibsonton, Florida.

For decades Jeanie and Al toured all over the country. She was a national celebrity and not long before she died she was even invited to the "Jerry Springer Show" as the grand old lady of the Sideshow culture. Her first experiences of show-life started when as a three years old she began working in shows: "They'd bring me candy and dolls and toys, so what's not to like?". Her mother died young and her father left when she was thirteen but despite the tragedy she made a life on her own. However, being still a child she was given to a foster mother who, as Jeanie soon realised, saw her as little more than a meal ticket. Eventually she was liberated, by marrying "Giant Al", with whom she set up her own road show. Despite what one might think, she did not marry just to make more money as a double act and Al and Jeanie adopted three children. Their schedule was very hard: seven days a week, they would leave their location at dawn for the next town, arrive in time to perform two shows, strike and head out again. One can imagine why one day they had had enough. This hard graft, or as some call it "exploitation",

made enough money for them to invest in The Giant's Camp. Al became policeman and chief of the fire department; Jeanie took care of the children as any other mother did. Is it any surprise the pride show-freaks have in the success they have made of their lives through the exhibition of their bodies?

Of course there are still many Carnies in Gibsonton but only a few show-people of the old era have survived till this day. Roy Huston, the amazing illusionist who made women fly is one. Lobster Boy Jr. and his sister, whose family has for five generations had claws instead of hands and feet, are others. They are children of the unlucky "Lobster Boy" who was tragically murdered in 1992. Melvin Burkhardt was yet another. He had participated in two world fairs in the thirties and toured for many years with the Ringling Bros. and the Barnum & Bailey Circus. He began his career during the Depression, first using his ability to control his muscles to make a living as an "Anatomical Wonder". Originally he wanted to become a movie star but realising he couldn't dance, sing or tell jokes he gave up. Instead he became famous through his unusual abilities. He invented the "Human Blockhead" which involves piercing his head with a huge nail or ice pick, inserted through the nostrils. His combined talents made him a whole Sideshow in himself and his description of himself shows how being a "Freak" is as much a way of life as it is a physical deformity: "I'm just as normal as anyone who comes in the tent to see me. But I can get up on that stage and do something so different that I'm set apart from them. I get paid for being a freak."

Of dimes and suckers, giants and blow-offs: Phileas Barnum's "Greatest Show on Earth"

The old school Sideshow, or as the carnival people used to say "Ten-In-One", was a permanent attraction usually alongside the main circus in the big top. Huge outside banners advertised natural "Freaks" such as Siamese twins, giants or wolf people. Artificial "Freaks" like tattooed men or fakirs and faked "Freaks" such as simulated hermaphrodites (see p76) were also part of the show along with illusionists, animals and all kinds of curiosities like "Pickled Punks" (preserved "Freak" foetuses). But the old Sideshow was first and foremost a "Freak Show". On the banners the performers were glorified in exciting poses and bright colours to attract the passing masses. Of course it needed more than this to lure the crowd into the tent. This was the job of the "Talker". Assisted by one of the acts, they would seduce the potential audience through a sensationalised promotion from a small outside stage. Having paid their dime the audience entered, moving inside from one act to the next. Sometimes guided by an impresario who explained the attractions and answered questions. At the end, having been thrilled and entertained often with a final special attraction, the "blow-off", the audience was usually offered merchandise, like a

postcard with the "Freaks" on it, which, of course, had to be paid for too. Then the next crowd would enter to be thrilled just as the previous one was. That was the way many "Freaks" made a living. Sometimes good, sometimes bad but sometimes becoming stars like the Lobster Family or the Half Lady.

In the 1940's Ringling Bros and the Barnum & Bailey Combined Circus travelled through the U.S. with four different trains stretching up to a length of one hundred railroad cars. By then the Sideshow business was at its peak. It had begun a century before by the Sideshow pioneers, including the most famous of them all, Phileas T. Barnum: "The Prince of Humbugs". In 1841 the itinerant showman bought the American Museum in New York. This precursor to the Sideshow was a permanent exhibition of odd waxworks and stuffed animals. He developed it into an exhibition of living human "Freaks", theatre, wild animals, beauty-contests, inventions, panoramas and ethnology. "Believe it or not!" is the claim millions of Americans associate with this milestone of Sideshow history. In the 1870's an increasingly successful Barnum started buying railroad cars for transporting the show and became the pioneer of mobile mass entertainment.

The monotony of rural life before the rise of mass media and the lack of education meant many were starved for entertainment. People were susceptible to anything new, whether real science or mere showmanship. Carnival people were well aware of this, and were not too scrupulous to show a fake as long as it was good. Ward Hall, the last celebrity of the Sideshow promoters, summed it up when he said "It's all real. Some of it is really real, some of it is really fake, but it is all really good."

The "Freak" in science, superstition and slavery: European predecessors

Barnum visited Europe with his circus and two Sideshows around the turn of the 20th century. As the first big entrepreneur of popular show business he knew that the old continent had never seen such a big and mobile show. Industrialisation and the developments of the civic society in Europe led to the human oddities here finding themselves in Circuses, Amusement Parks (like the Vienna "Prater" created in 1766), permanent exhibitions ("Madame Tussaud's" in London since 1802) and in Panopticums (Castan's Berlin based one opened in 1869). The increasing popularity of medicine and anthropology lead to a fashion of exposing "Freaks" as "natural phenomena" or "anatomical prodigies". And often, just to boost the attraction, their origin was made an exotic fiction: "Albino Tom Jack" for example still claimed in 1939 that he was born in North Greenland but he was a Czech. "Lionel the Lion Man" was another famed "Freak". Lionel suffered from hypertrichosis, a condition causing abnormal hair growth. In his case it led to a covering of hair over his whole body. His story was that his mother

had been severely traumatised while pregnant having witnessed his father being torn into pieces by a lion, resulting in Lionel, a "Lion Kid". Similarly used was the denomination "missing link", a popular term of the times borrowed from Charles Darwin. Lionel even became the subject of many teratological examinations by the famous medic Rudolf Virchow from the Anthropological Society in Berlin.

A special case of the "Freak Show" closely relating to the popularisation of the sciences in the 19th century is represented by the Hunger Artists. Probably the most famous and successful was the Italian Giovanni Succi who engaged in phenomenal feats of fasting. He presented himself as an "immortal materia bound to a spiritual power" (sic.). To improve the perceived authenticity of his actions and thereby increase his value as an act, he put himself under detailed medical observation when he underwent one of his thirty day hunger acts. Interestingly, all the scientists believed him to be a mad fraud despite knowing that the fasting capabilities of the human body is as old as civilisation itself.

The low standards of education at that time and the lack of scientific understanding of the genetic causes behind many physical deformities meant scientific errors and superstitions concerning their origins were widespread. Many believed that "Freaks" were caused by an impregnation during the menstruation, by sexual intercourse with the devil or by an evil look. If one combines these ideas with the traditional paranoia of witchcraft one can begin to understand the ruthless stories of the so called "Wild People": retarded and deformed children abandoned in the wild by their parents. Many who survived were sold to be exploited as jesters or show-freaks. In modern times the term "Wild People" became a general designation for different kinds of retarded "Freaks".
Of course it is highly unlikely that any of these children were actually raised by animals. These were just marketing ideas referencing well-known mythologies.
But there is no doubt of the existence of Kaspar Hauser and Victor de Aveyron. Both were found, unable to speak, and bereft of human knowledge. The latter, found by hunters in a forest, knew only how to move on his hands and feet. The former, suspected to be the illegitimate prince of Baden, was heavily mistreated through complete isolation from early childhood. He was freed as an adolescent only to become the subject of medical examinations and rumour. He eventually died at a young age.

Voluntary and systematic physical distortion of children marks the darkest spot in the history of "Freak" people. Probably best known are the cases of eunuchs and castrati, harem guards and famed soprano singers. However, few know about the practise of a secret gipsy society of the 17th century called the "Comprachicos", the inspiration behind the Victor Hugo novel The Man Who Laughs. This group would buy babies and make them into monsters through deliberate manipulation of their growth and features.

They were then sold to shows and courts and beggars to make people laugh or remind a Christian of his alms duty.

Deformity is much more interesting: "Freaks" in the arts

It was one of the most visionary minds of the 16th century that gave us what is not only a remarkably humane and modern view of the "Freak", but also the first literary record of a Sideshow predecessor: "…what we call monsters are not such to God, who perceives included in the immensity an infinity of forms; and yet you might believe that this figure which leaves us shocked is related and corresponds to some other figure of a genre unknown to men." Michel de Montaigne concluded this having seen a double-bodied child, exhibited for money by two men and a nurse. He perceives deformity as a condition and not as something against nature. Shakespeare too criticizes the great hunger for sensational bodies in The Tempest when Trinculo says of Caliban: "Were I in England now, as once I was, and had but this fish painted, not a holiday fool there but would give a piece of silver". In English society, a mere portrait of Caliban would raise a fortune. Martin Luther is another renaissance intellectual to comment. In his Liber Vagatorum he attacks the countless fakes populating the streets of the early modern times to make a life of mercy.

The Renaissance was a time of great change, filled with fear and excitement in the face of scientific discovery and technological advances. It was also the time when Art first acknowledged "Freaks" as seen in the grotesque art of Bosch, Rabelais and Michelangelo. This was a response, a counter-image to the Christian ideal of beauty. These artists were out to capture the individuality inherent in physical deformity. To them the exaltation of God's beauty through the Devil's creation of deformity and the classicist trinity of the beautiful, the good and the true were ideas founded in a repressive and restrictive dogma. When Montaigne in his essay "On Cripples" states, "I have never seen a greater monster or miracle than myself" he not only underlines the idea of individuality, but also anticipates the radical assertion of the existence of the subconscious and emotional self as would become the fashion in the romantic age.

Baudelaire's Les Fleurs du Mal, Stoker's Dracula or the fairy tales of the Brothers Grimm all pointed to something new, exemplified by Lewis Carroll in Alice in Wonderland: now it is Alice herself who changes in her appearance, becomes a "Freak". The concept of the "Freak" is shown to be subjective, the result of one's point of view rather defined criteria.

More recently, encouraged through the invention of psychology, the idea of the "Freak" in the subconscious has become a popular motif. Kafka's Transformation, Stevenson's Dr. Jekyll and Mister Hyde, Lang's M, Friedkin's The Exorcist, all belong to this tradition: the metamorphosis of the "normal" body into the "Freak" body as a visualisation of some internal evil. It illustrates that we are subject to a socially defined body and mind ideal based on a fiction of healthiness and beauty. The arts reveal that our minds can easily be manipulated into a "Freak-ish" condition and that the history of the "Freak" is intertwined with our own.

The Sideshow is dead! The Show must go on!

While "Freaks" and the grotesque in today's media seem to be fairly commonplace there is no doubt now that the traditional Sideshow is disappearing. Since the 1950's in Europe and America "natural" show-freaks have been dying out. Antenatal diagnostics, abortion and public welfare have all had an effect and human rights codes have been highly successful in stigmatising it as an abuse of the deformed.

In 1969 Ward Hall, in defence of his way of life, won a unprecedented trial against this expression of political correctness. Under suspicion of abusing the disabled for illegal pornography he challenged the Florida Supreme Court, which returned a 6 to 1 verdict in his favour. The law was judged unconstitutional as the Court recognised that every individual has the right to make an independent living.

There are other, less spectacular reasons for the end of the old Sideshow, however, as Ward Hall tells in his memoirs: "…the human labour is too expensive - 100% of the income from the carnival rides goes to the carnival and they run from the very beginning till the end of the fair. But," Ward states optimistically "today it would be a golden time for a big Sideshow. Yes, recently I saw a Donahue show that featured all fat people. I saw an Oprah Winfrey Show that had three sets of Siamese twins…" That's the point: TV and Cinema have adapted the sensationalism of the Sideshow and they probably do it much better, with reproduction of violence, sex and horror available for everyone to see in their living rooms. Of course people will always fight against what they see as exploitation and abuse, but there will always be others ready to cash in on peoples need to be entertained - The Show must go on!

Peter Schardt was born in 1967 in Hadamar, Germany, and studied history, literature and romance languages in Paris. He was co-editor of the magazine Begleiter – Magazin für Pop und Alltag and now works as a freelance journalist for newspapers, magazines and corporate publishing.

it was one of these days. driving south on 41. broken heart, broken dreams. i just got divorced. my father died. heaven stood still. driving. missing you. an endless street. factories. smog and a lot of pollution. driving down the street of gibsonton. dreaming. i'm going back to my friends. looking for jeanie. a half lady, married to a giant. driving.

Gibsonton

in my childhood i was in love with dwarves and little princesses. every night i was invited to see their show. fire eaters, sword swallowers, clowns and magicians. we were dancing and laughing. missing you. noises of working men. trailers. on the left side "showtown". it's karaoke night: ward, chris, jeanie, roy ... everybody is here. tom is singing:

"everybody needs somebody...". broken dreams. driving. you introduced me to your friends. to your wife pat. a trapeze artist. true love. an amazing story. you made me laugh so many times. missing you. your friends became my friends. you met them all: lentini, the three legged man, wolfs lady, the siamese twins, the hermaphrodites ...driving. please stay with me.

let's make a party. i wanna say goodbye. broken dreams. endless street. trailers, animals ... let's put "make up" on and let's dress in glamourous clothes. like in the early days, when you were on stage. "ladies and gentlemen ..." the music is playing. you are the stars. you make people amazed about your talents. they call you "freaks". but you are beautiful freaks.

the music is playing. bruce is
dancing. melvin hammers nails
in his brain and jeanie - she is
my princess. my beautiful
princess. roy, please make the
girls fly again. little pete, eat
our fire. one more time.
for the last time. make my
dream come true.
a show. a sideshow. the last
sideshow.
heaven stood still.

Hanspeter Schneider

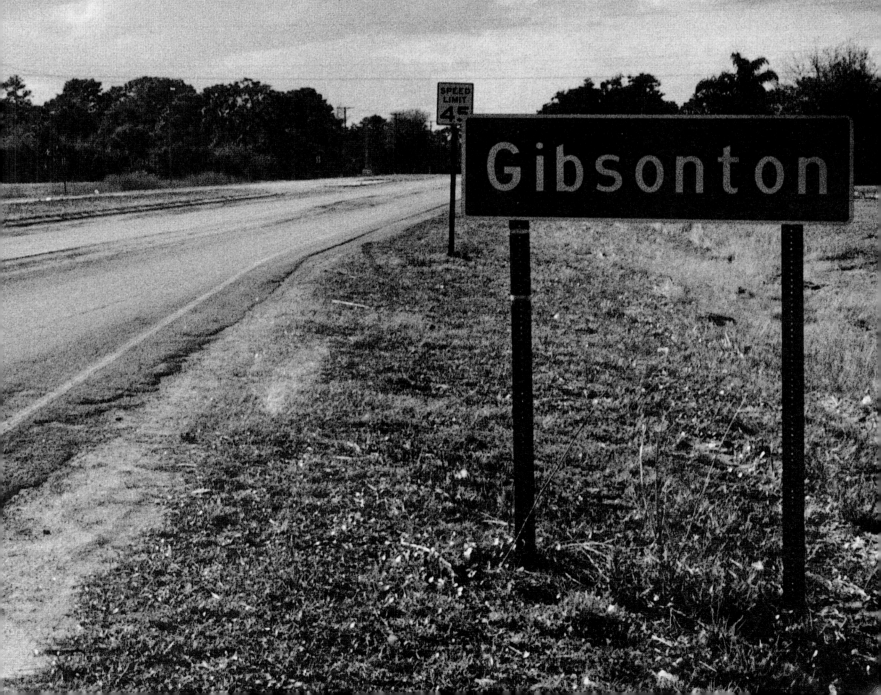

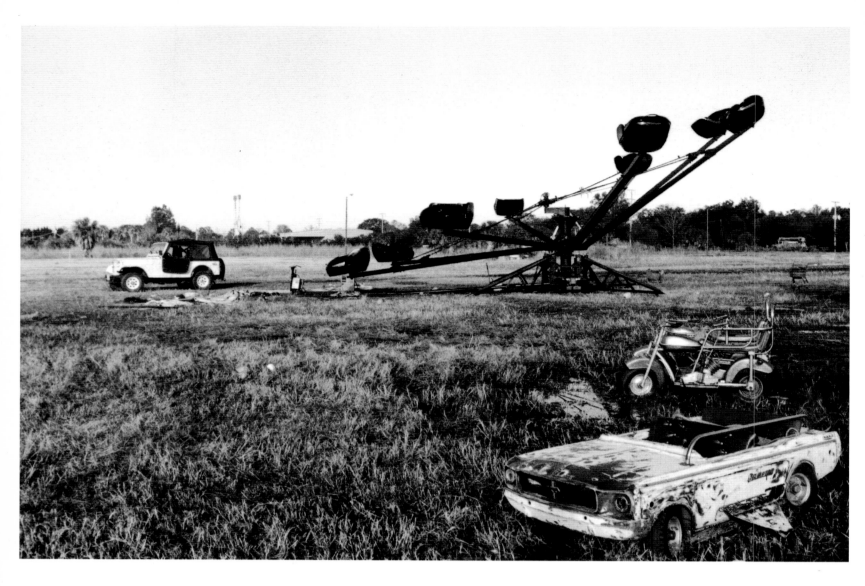

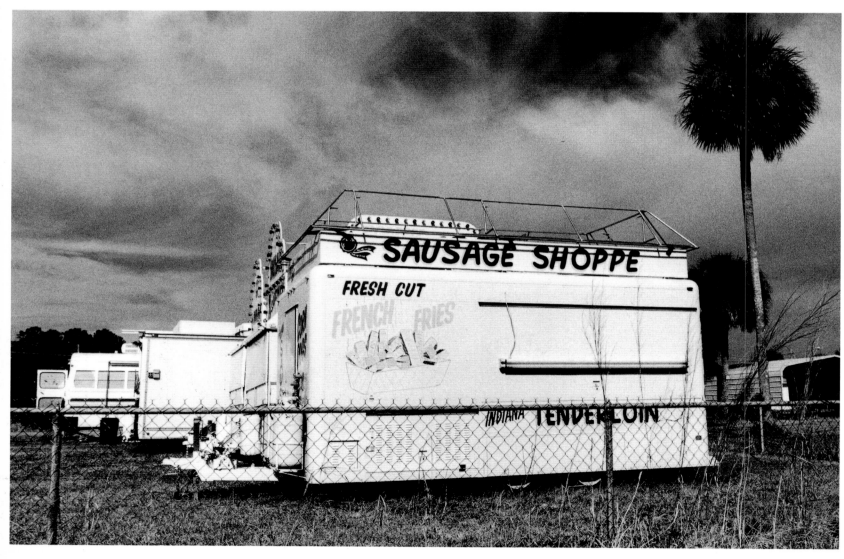

WARNING!
DO NOT DISTURB SOIL!

HAZARDOUS WASTE COVER
DANGEROUS MATERIAL MAY BE PRESENT
BELOW GROUND SURFACE

FOR INFORMATION
(813) 744-6100

"This is not a real town, it's a concept or a state of mind. Sometimes I wonder whether it really exists."

Roy Huston, Illusionist

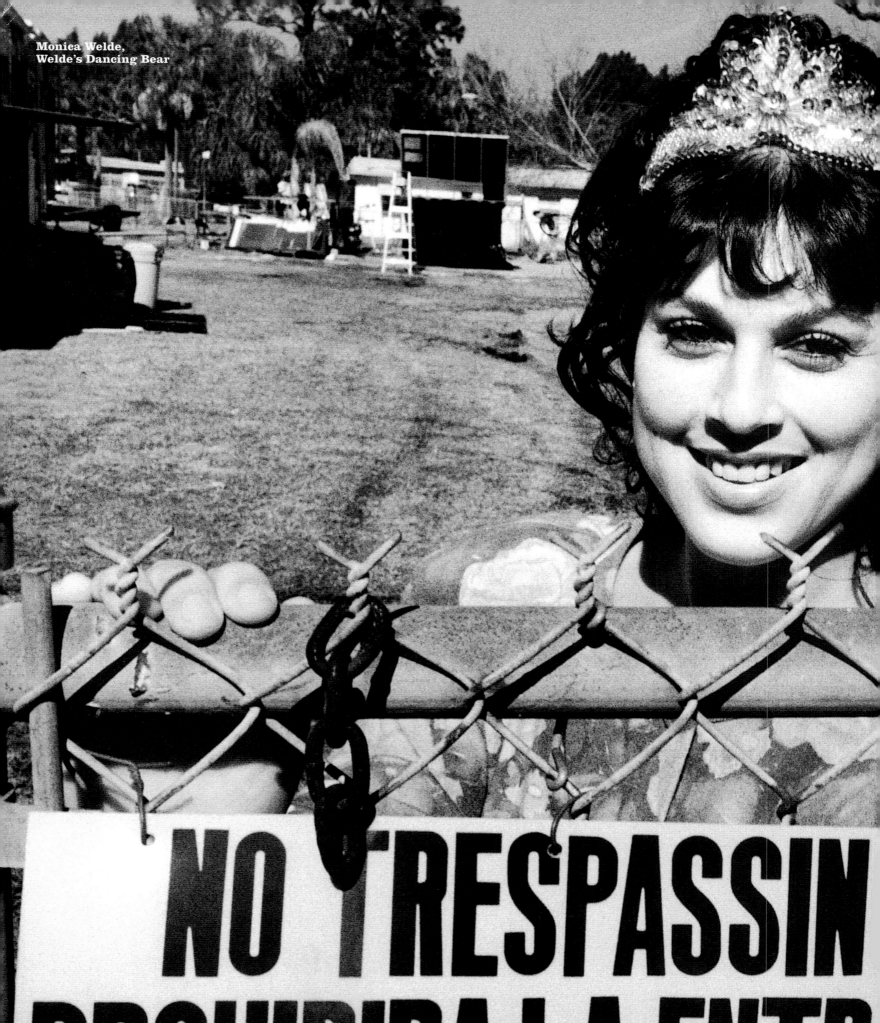

NO TRESPASSIN
PROHIBIDA LA ENTR
THIS LAND IS PROTECTED UNDER RESPA

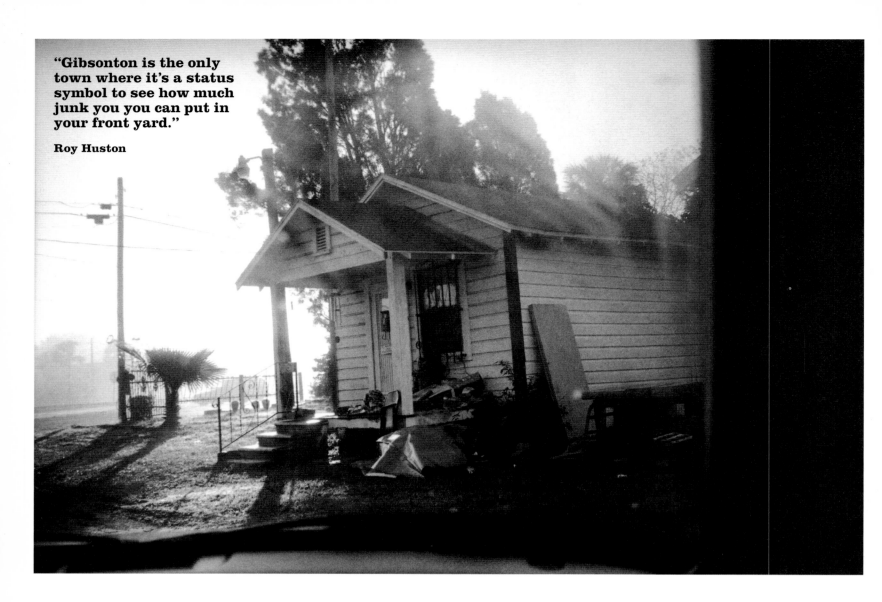

"Gibsonton is the only town where it's a status symbol to see how much junk you you can put in your front yard."

Roy Huston

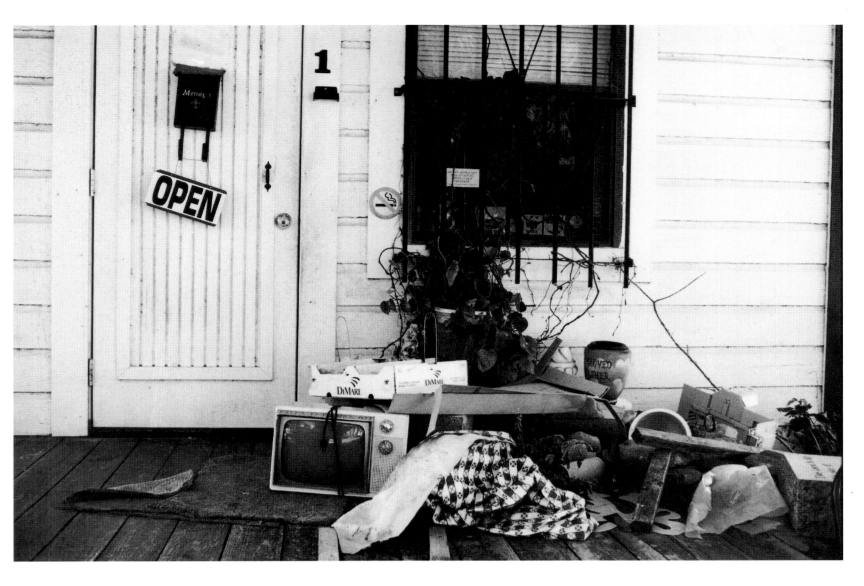

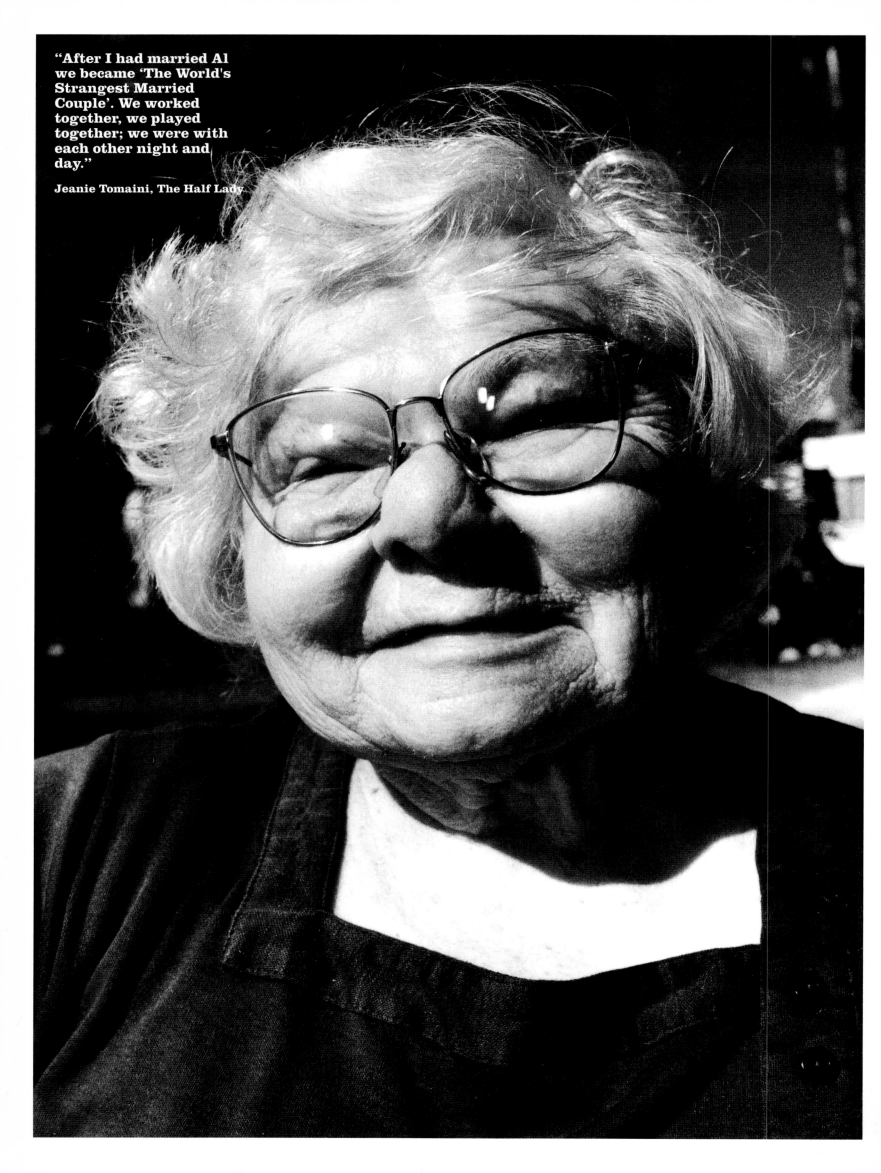

"After I had married Al we became 'The World's Strangest Married Couple'. We worked together, we played together; we were with each other night and day."

Jeanie Tomaini, The Half Lady

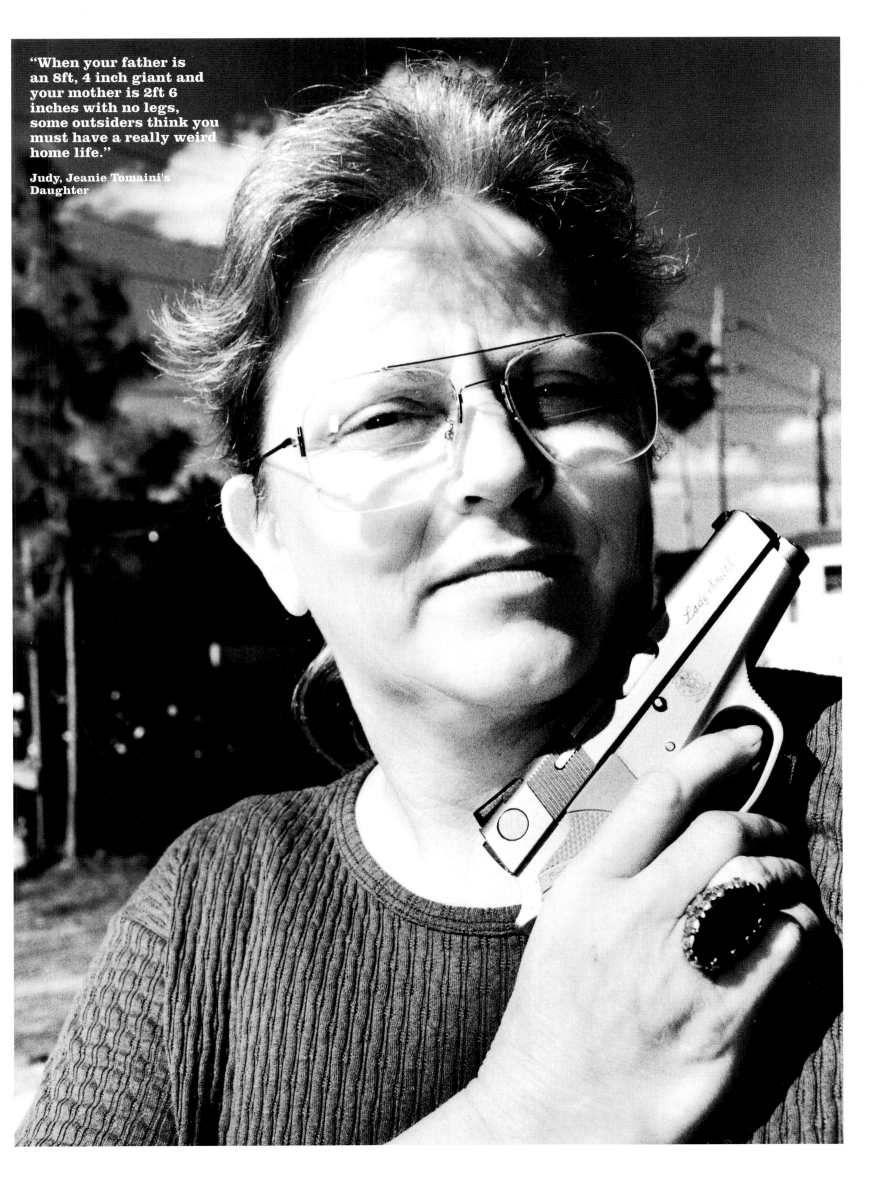

"When your father is an 8ft, 4 inch giant and your mother is 2ft 6 inches with no legs, some outsiders think you must have a really weird home life."

Judy, Jeanie Tomaini's Daughter

"In my earlier days I
didn't have any problems
getting around. It was a
part of the show. I even
walked upside-down
down a ladder."

Jeanie Tomaini

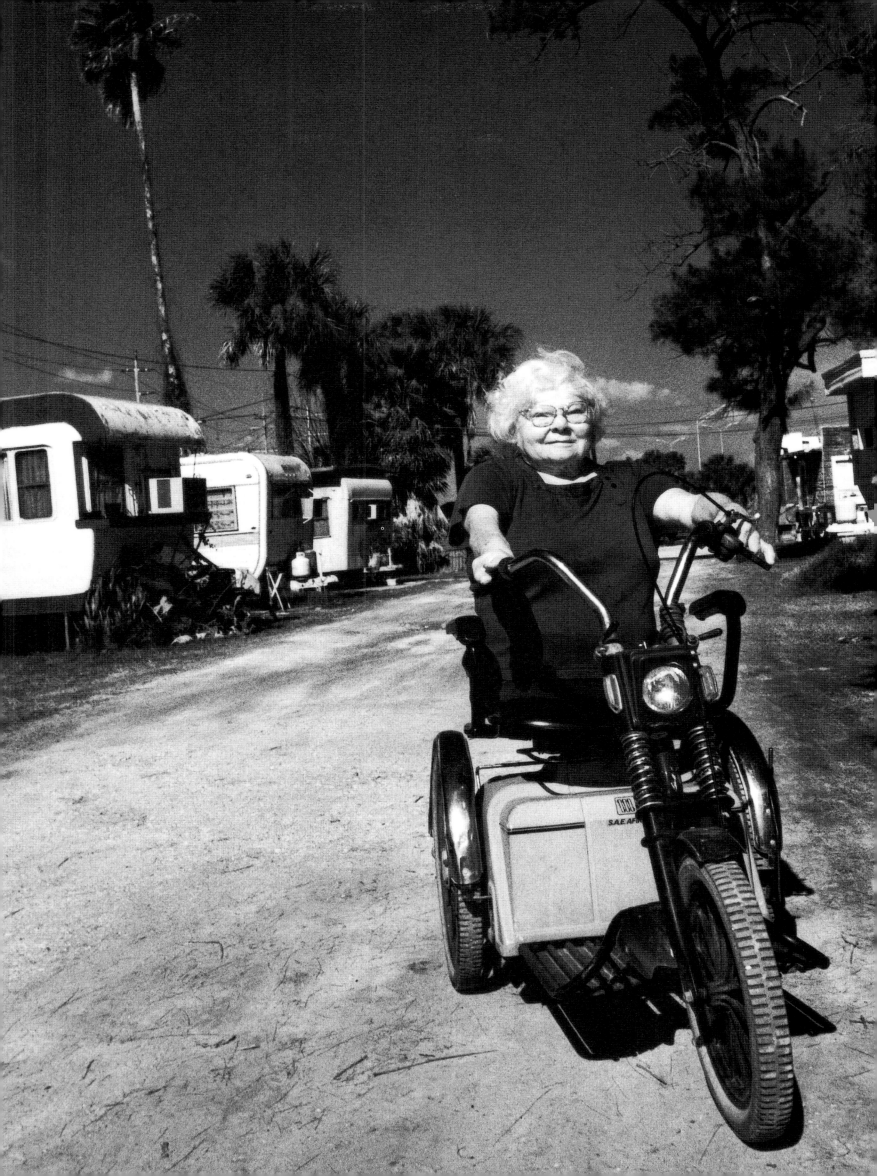

"Once I was interviewed and asked why we got married. I think that was about the most stupid question I ever heard. I loved Al."

Jeanie Tomaini

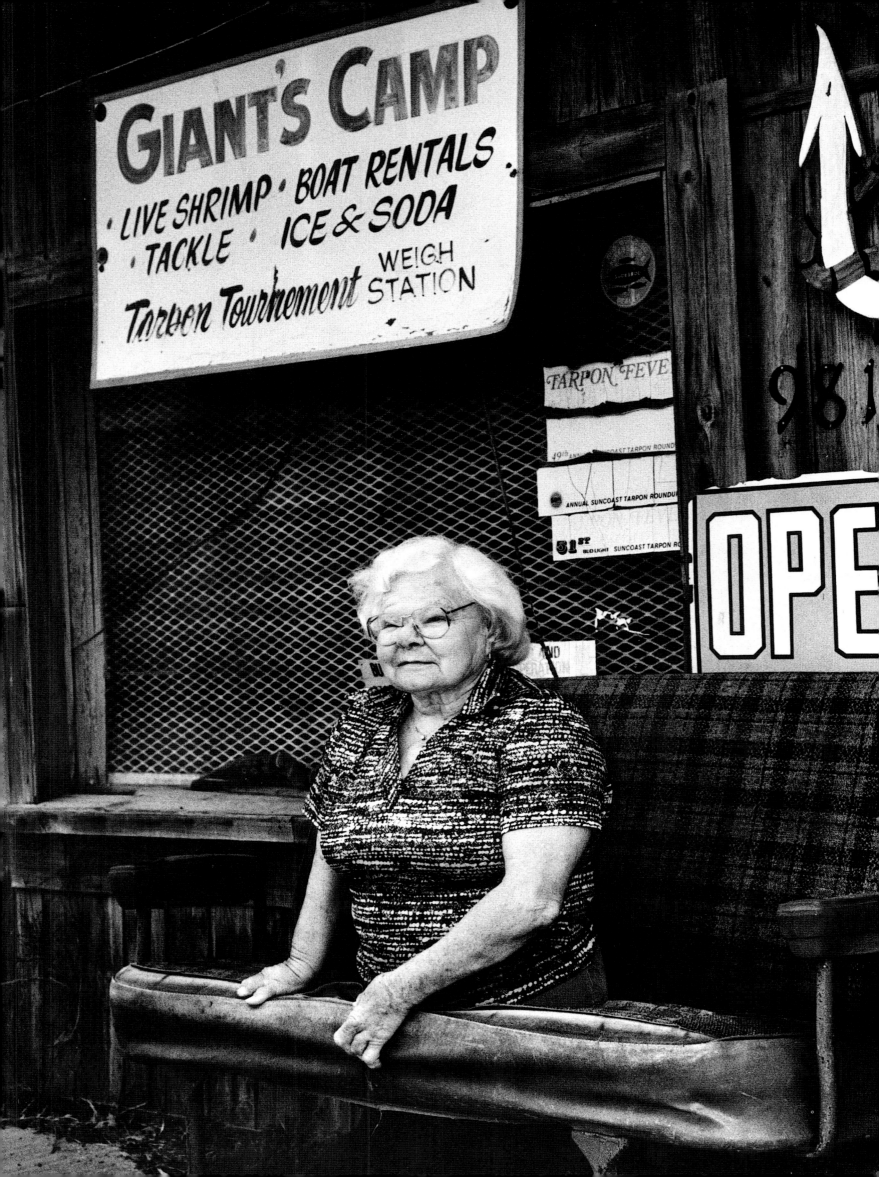

"Well the spaceship landed and I got off. I said, my God what is this? ...so this is called Gib'town, the planet Gib'town, hmmh. Then I looked around and as far as my human eye could see I saw ten acres of property with one showvan after the other. Wow, I thought, this is a neat place. I think I'm going to stay here."

Roy Huston, Illusionist

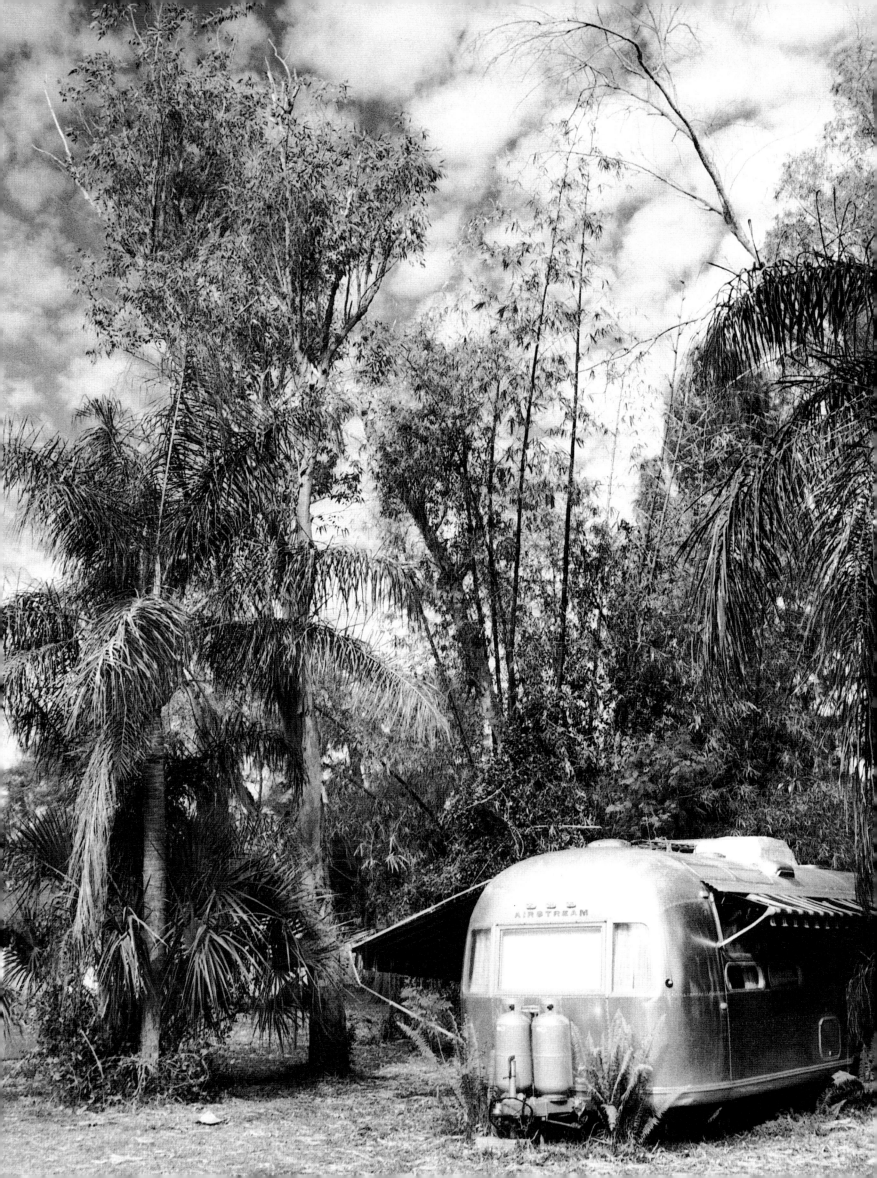

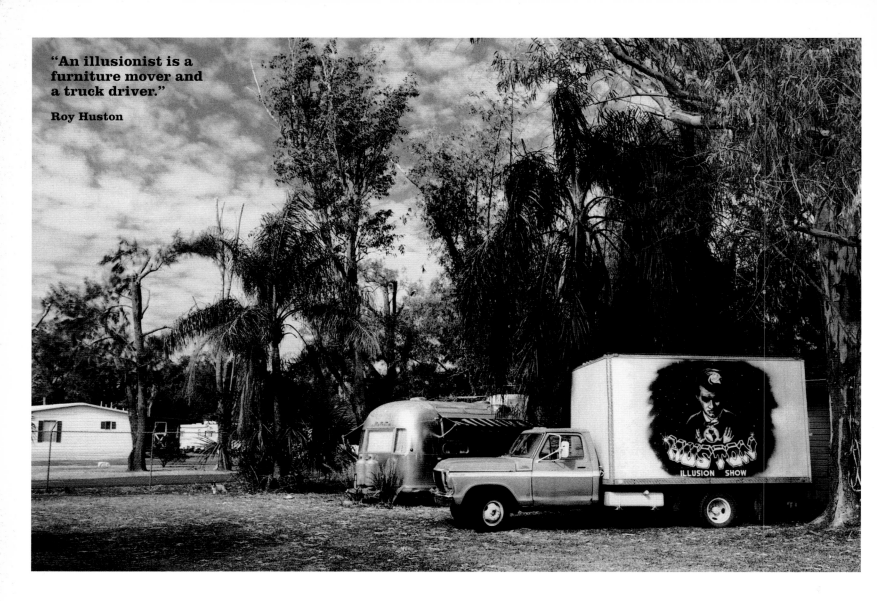

"An illusionist is a furniture mover and a truck driver."

Roy Huston

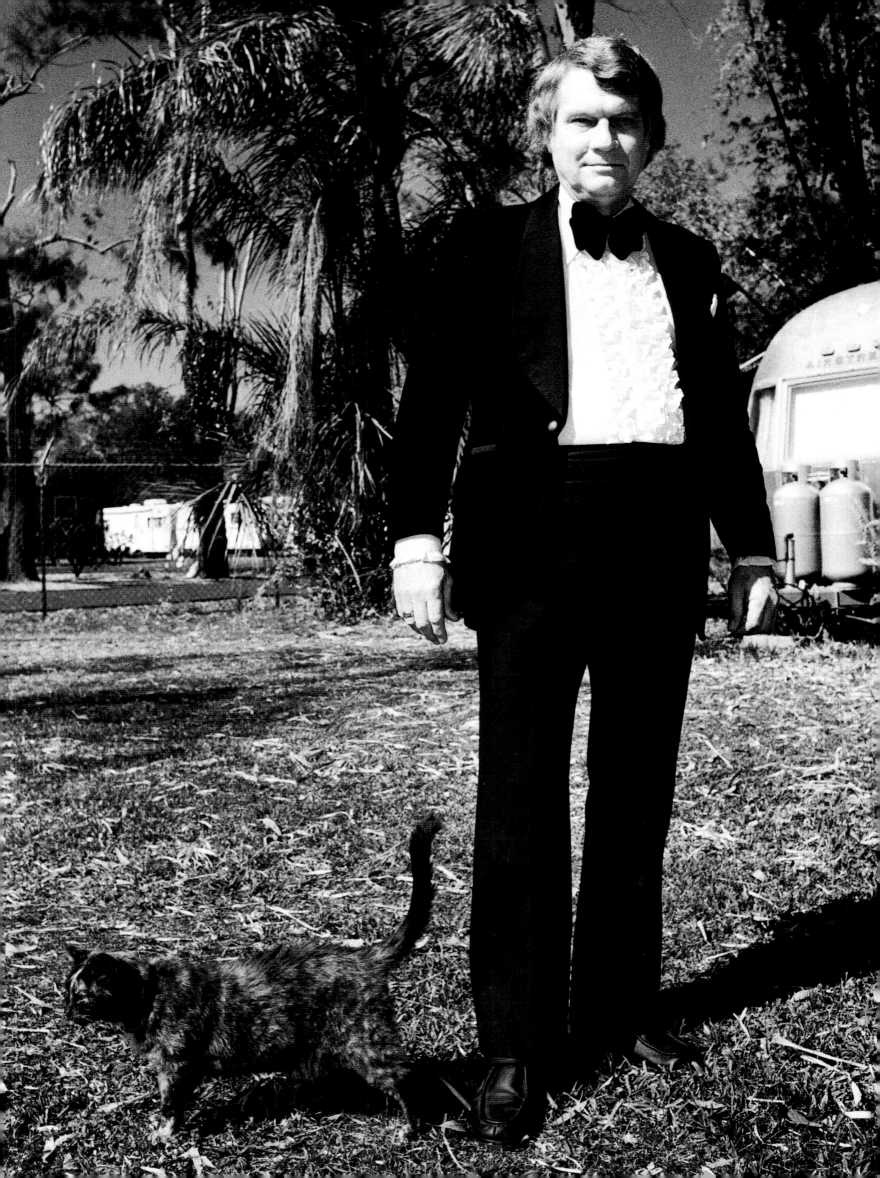

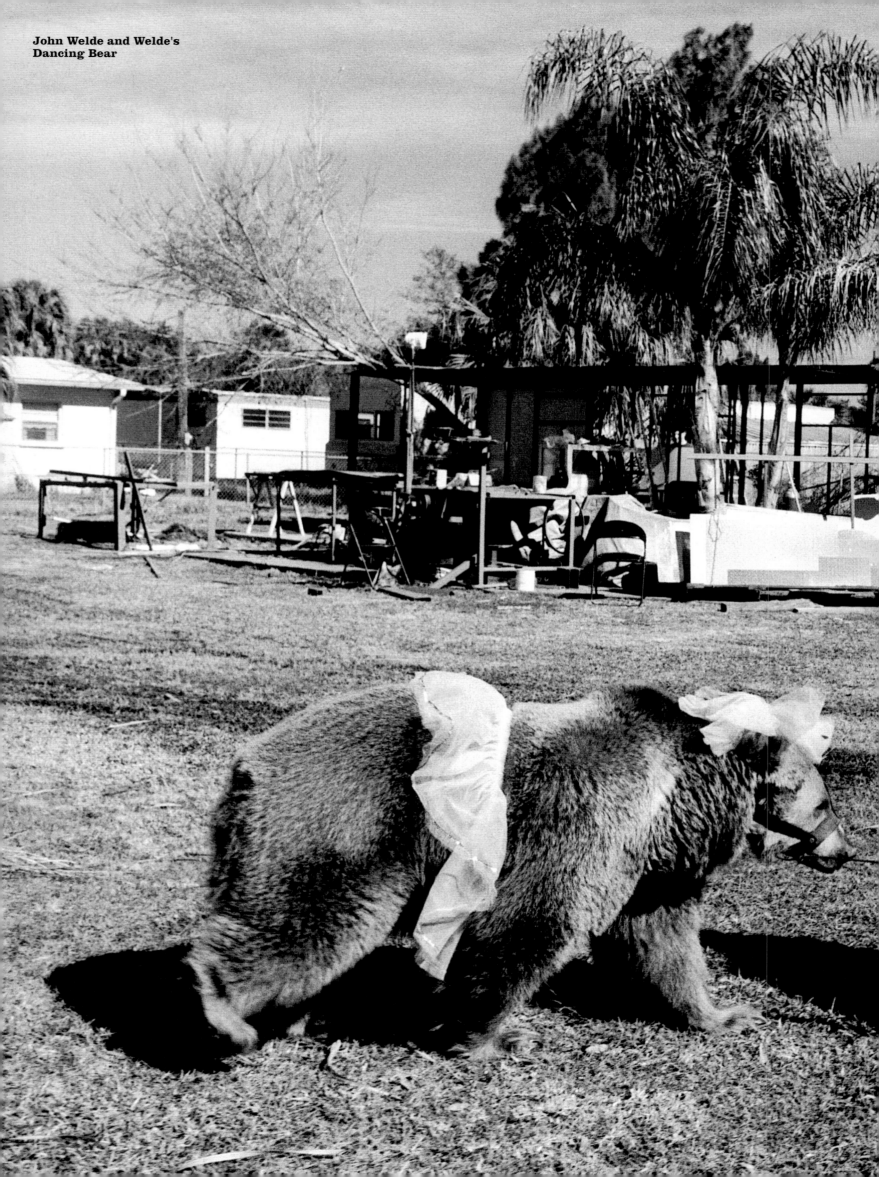

John Welde and Welde's
Dancing Bear

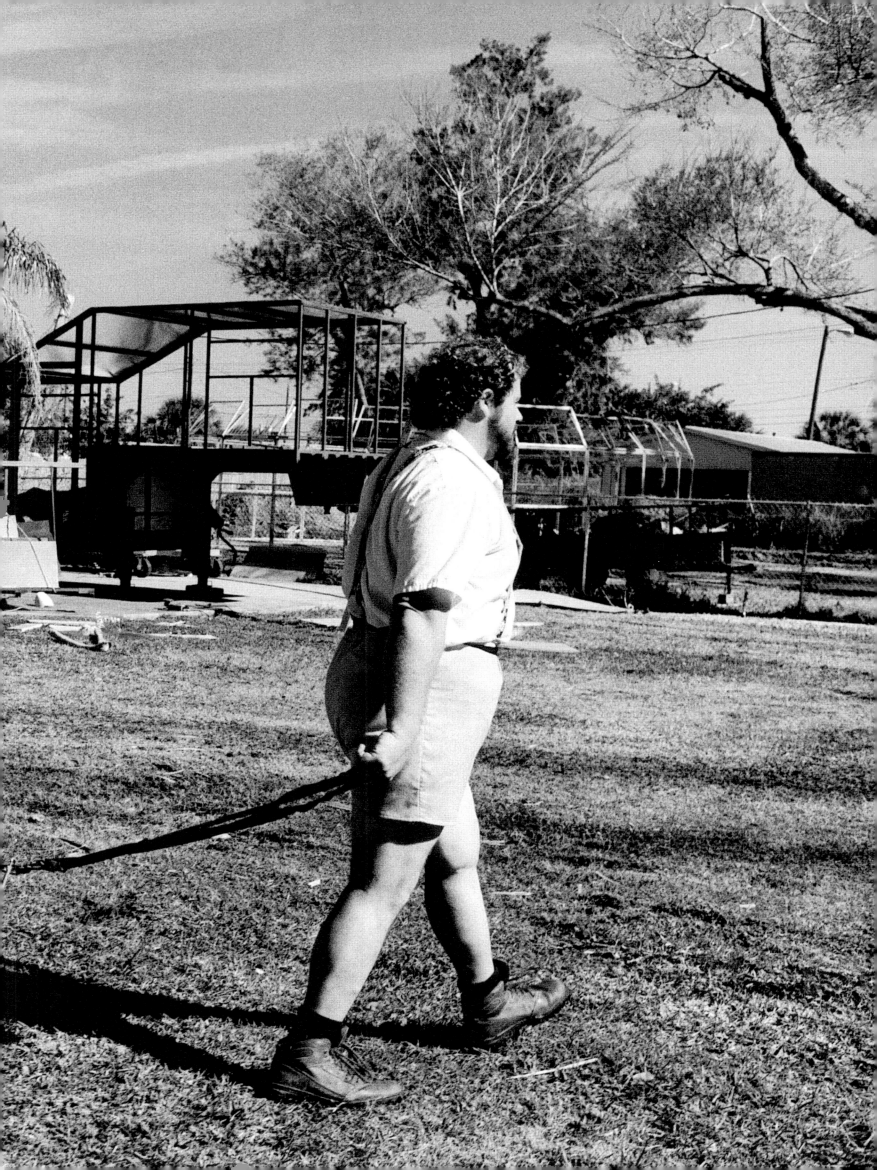

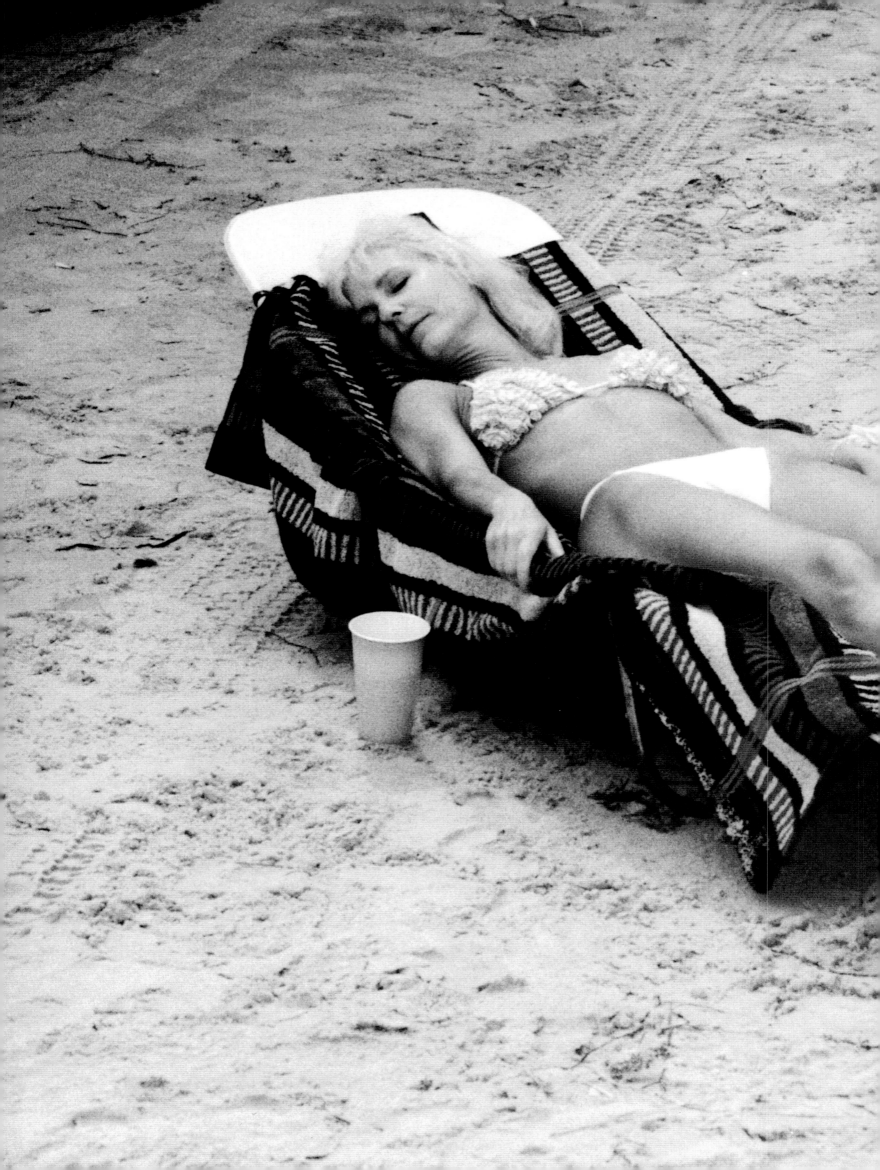

"The Carnies came to Gib'town because the fishing was good."

Chris Christ, Sideshow Promoter and Production Manager

29

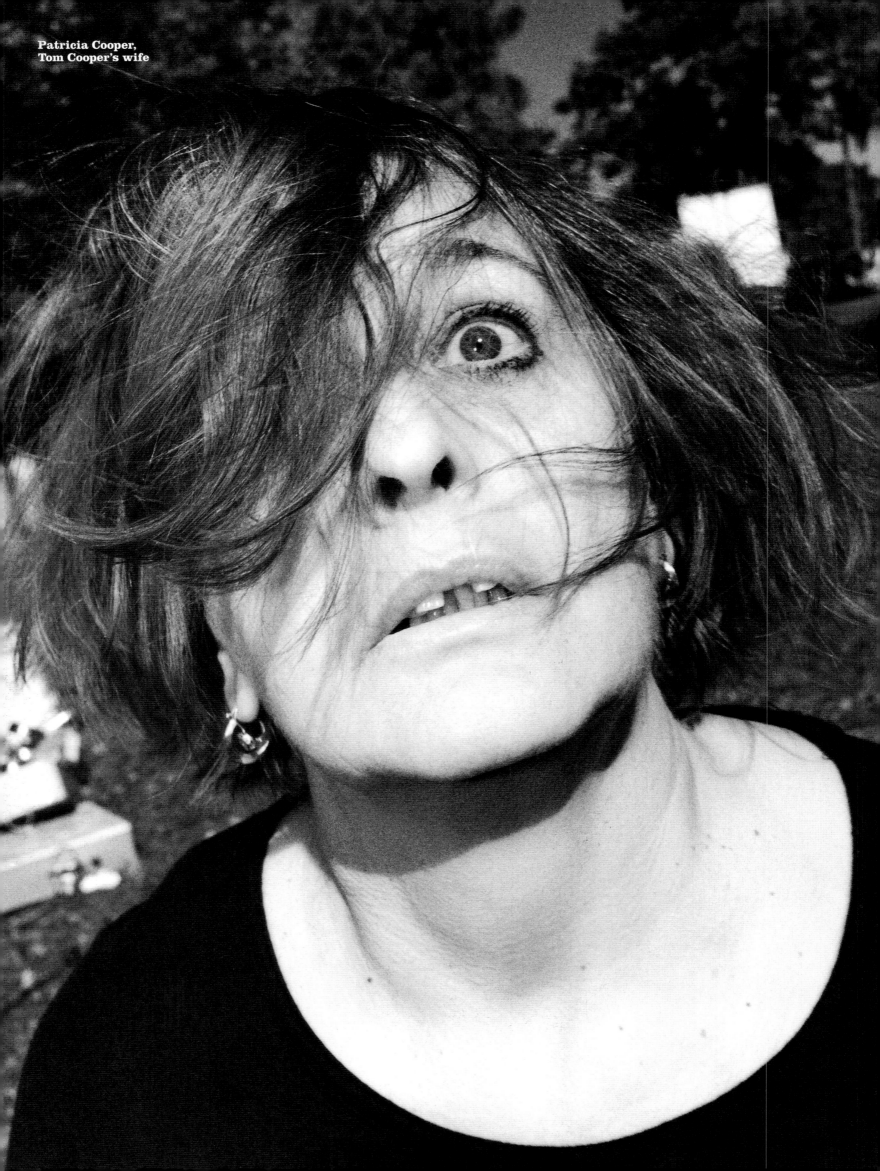

Patricia Cooper,
Tom Cooper's wife

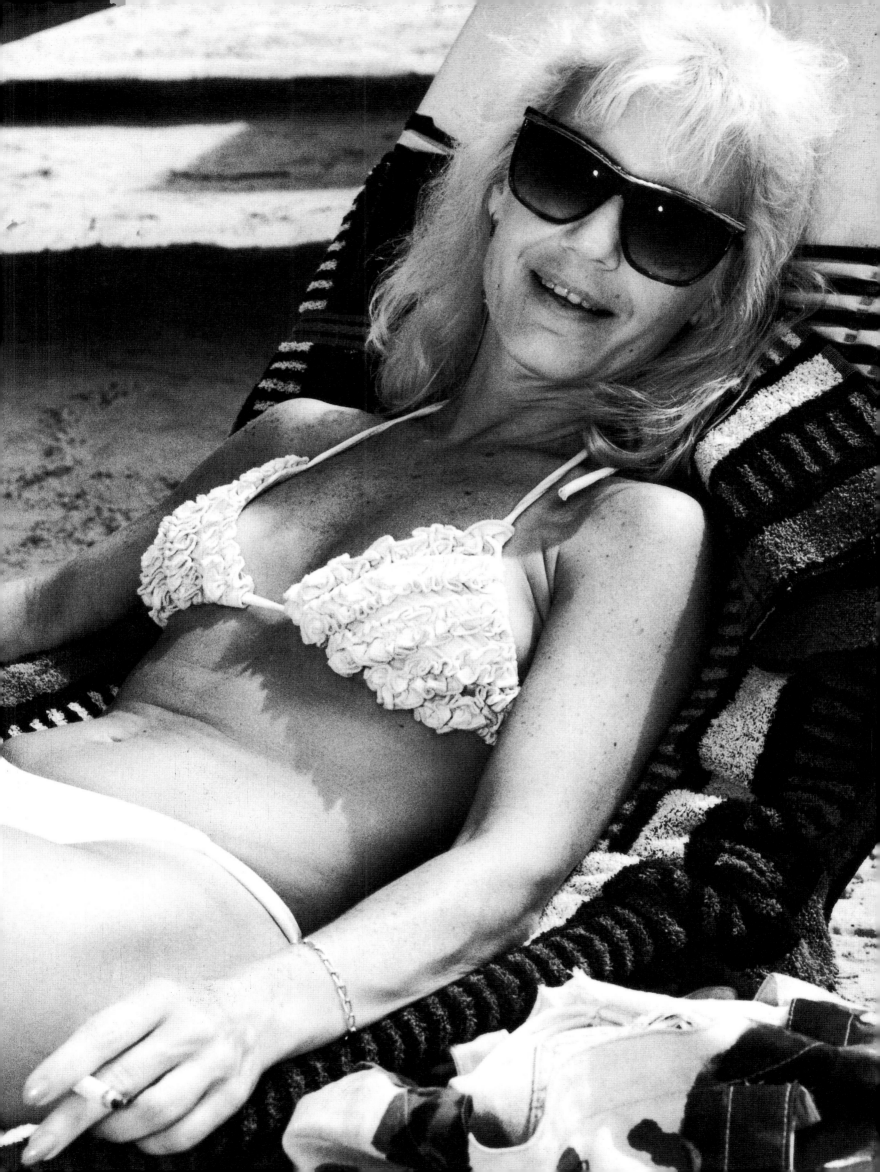

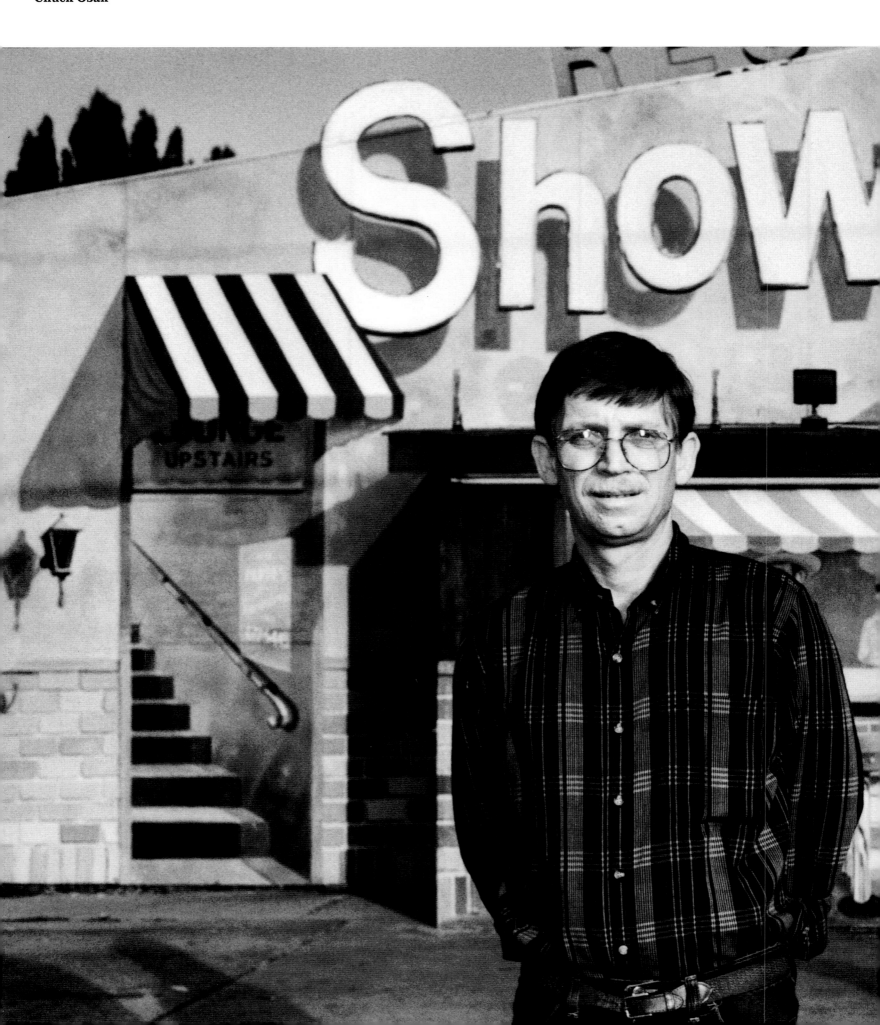

"My dream is that someday you come across that bridge and there's a big sign overhead that says 'Welcome to Showtown USA'."

Chuck Osak

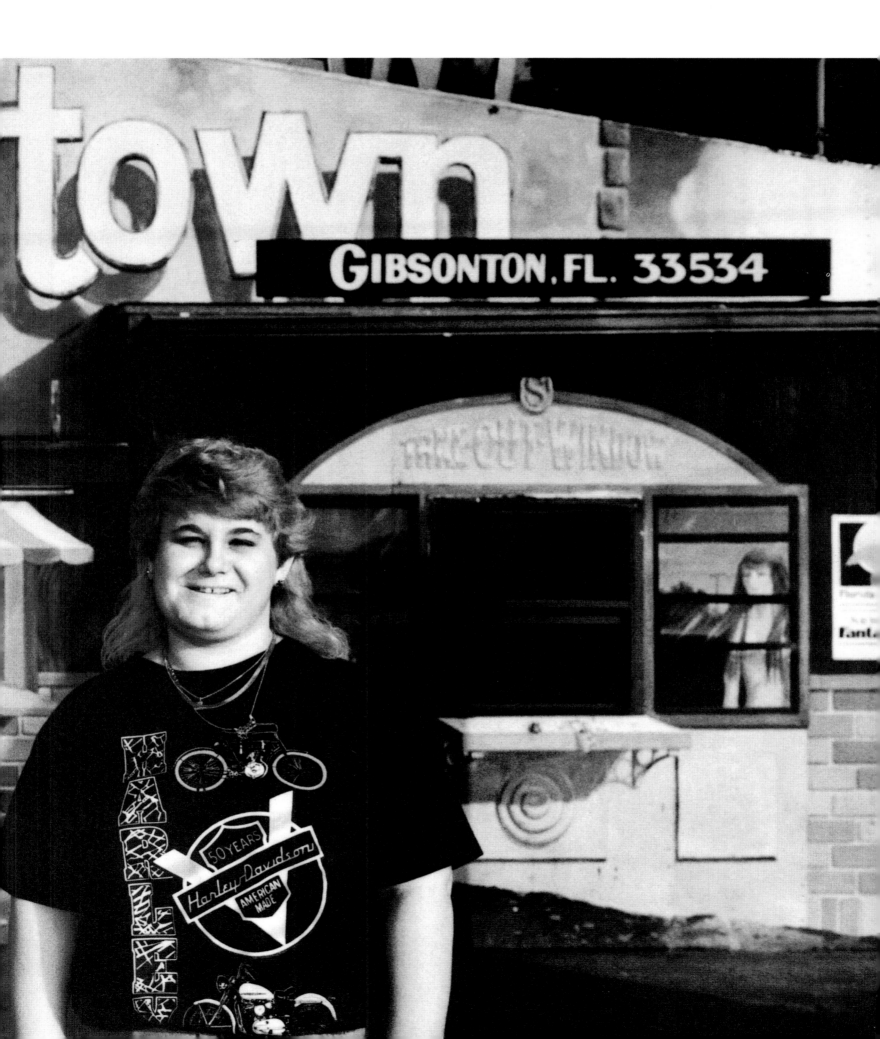

"If you're sitting here long enough everybody will come through this door. It's like one of those old Western saloons. You come in and it gets real quiet."

Chris Christ

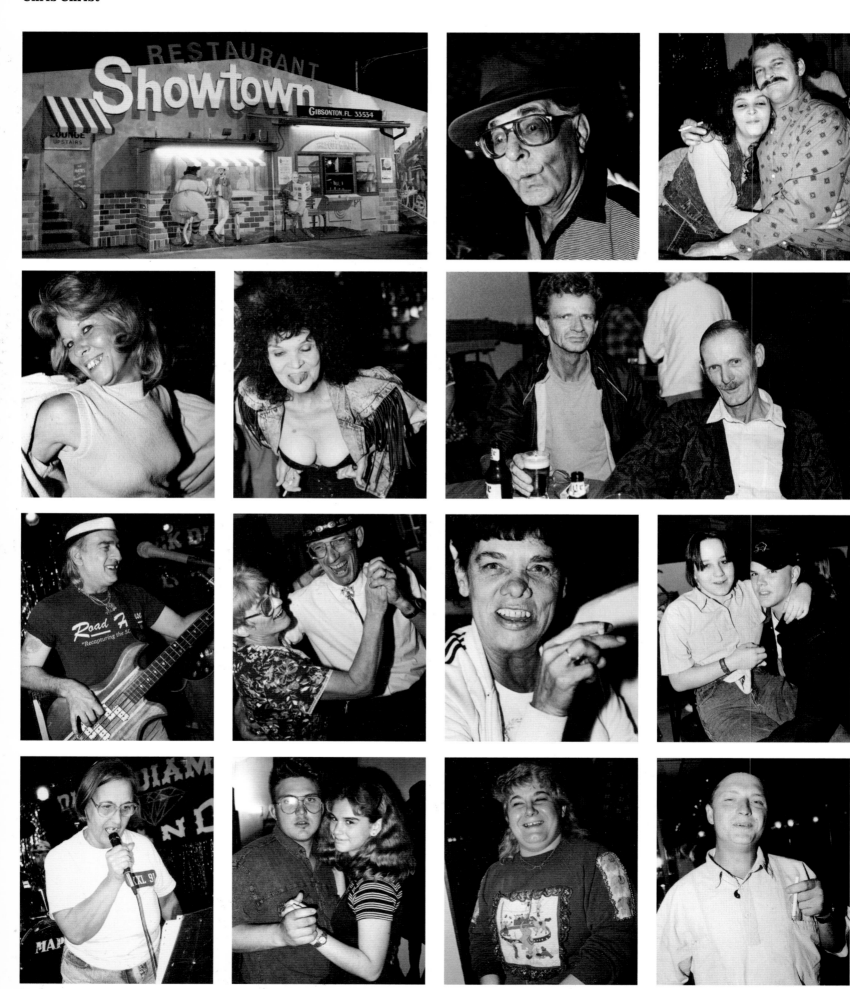

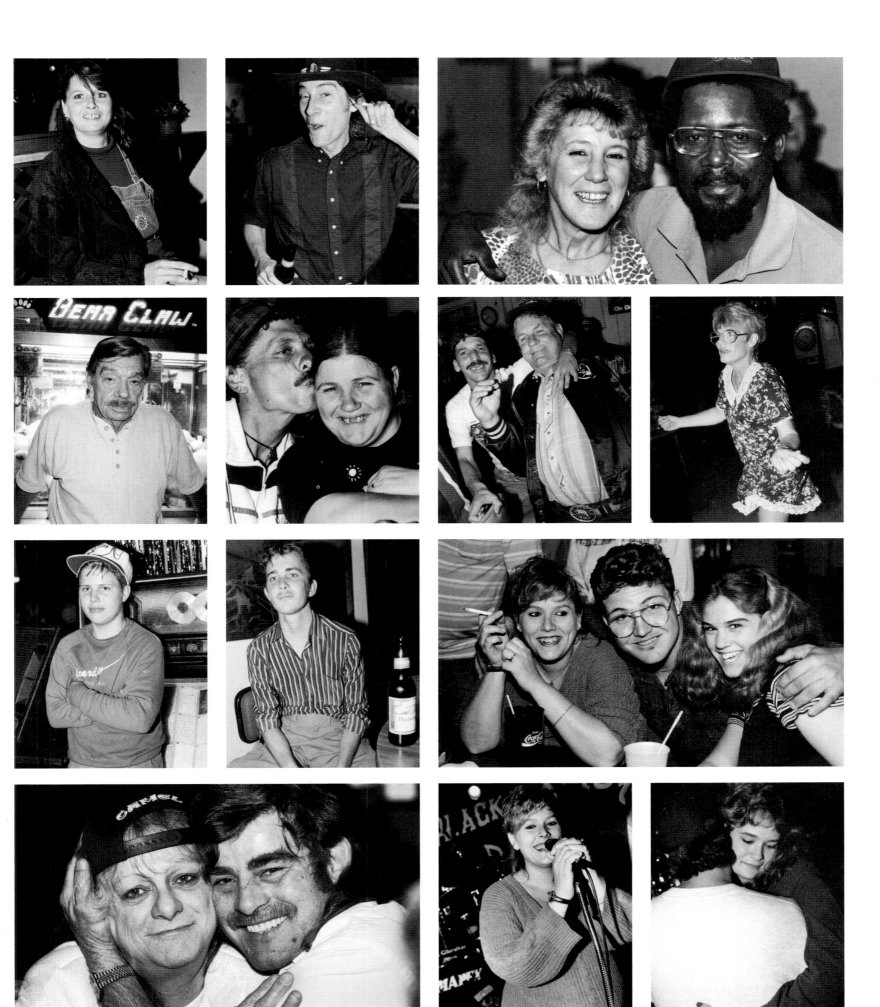

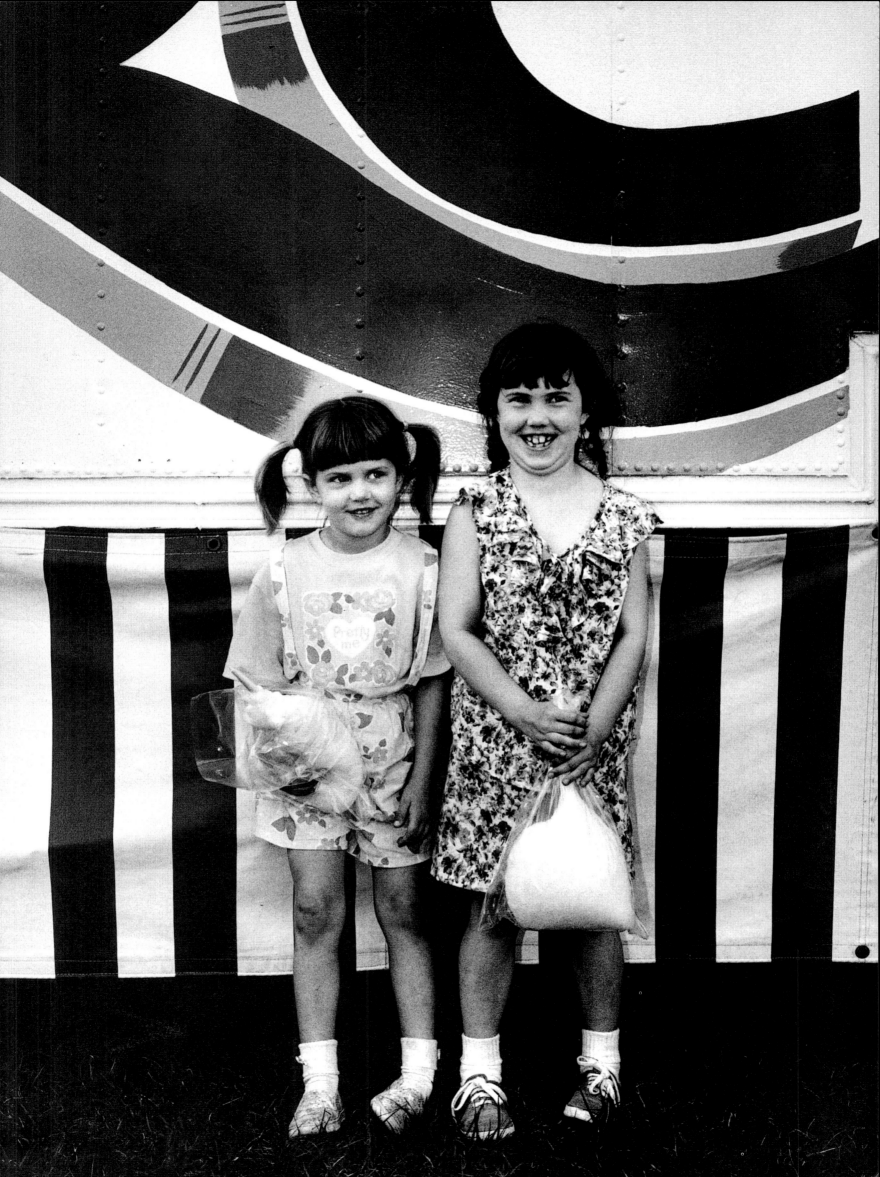

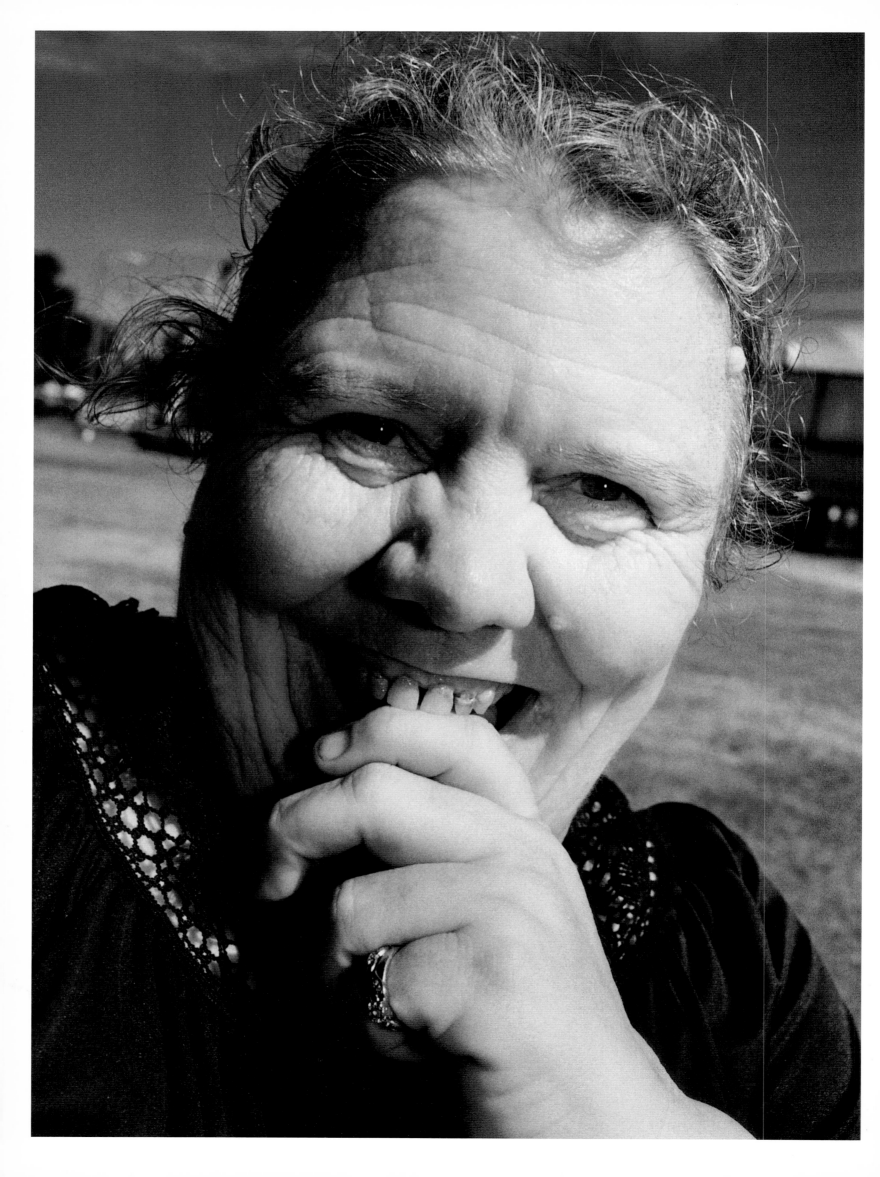

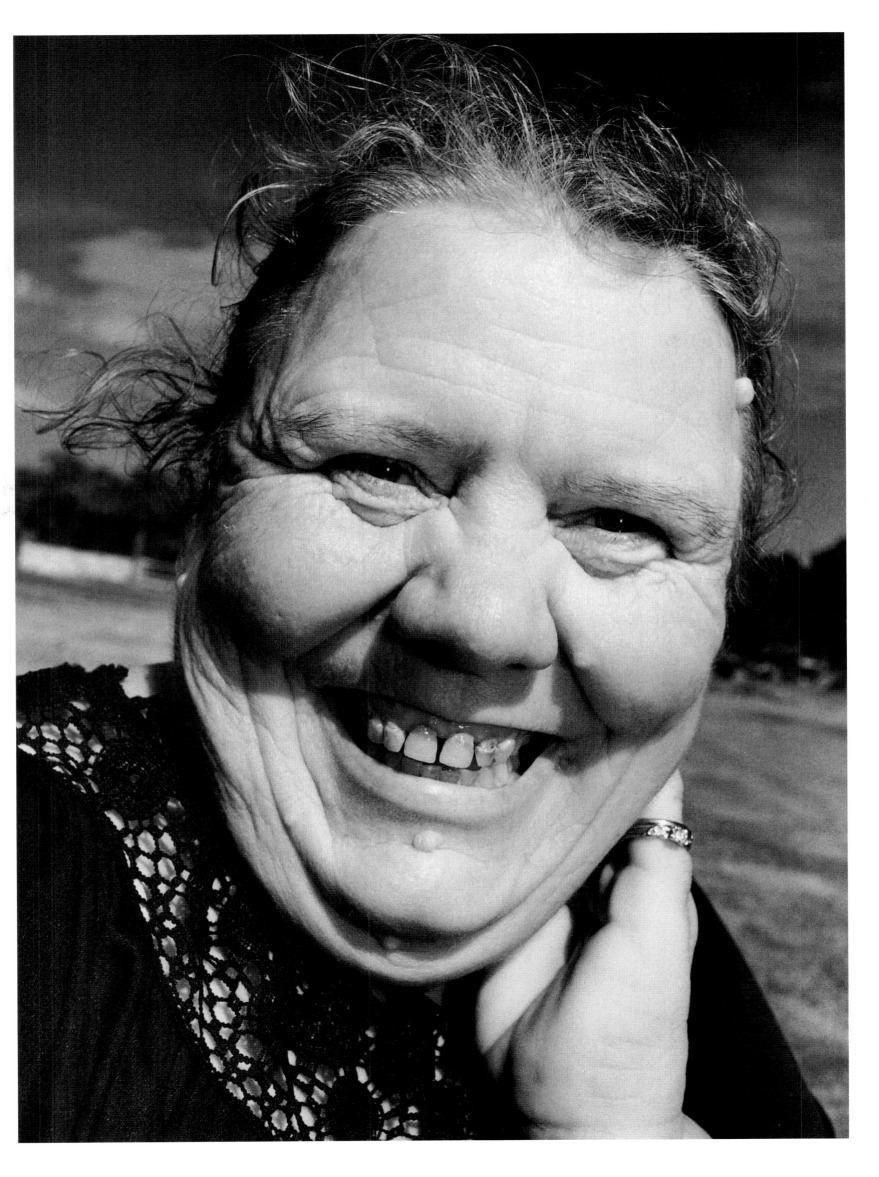

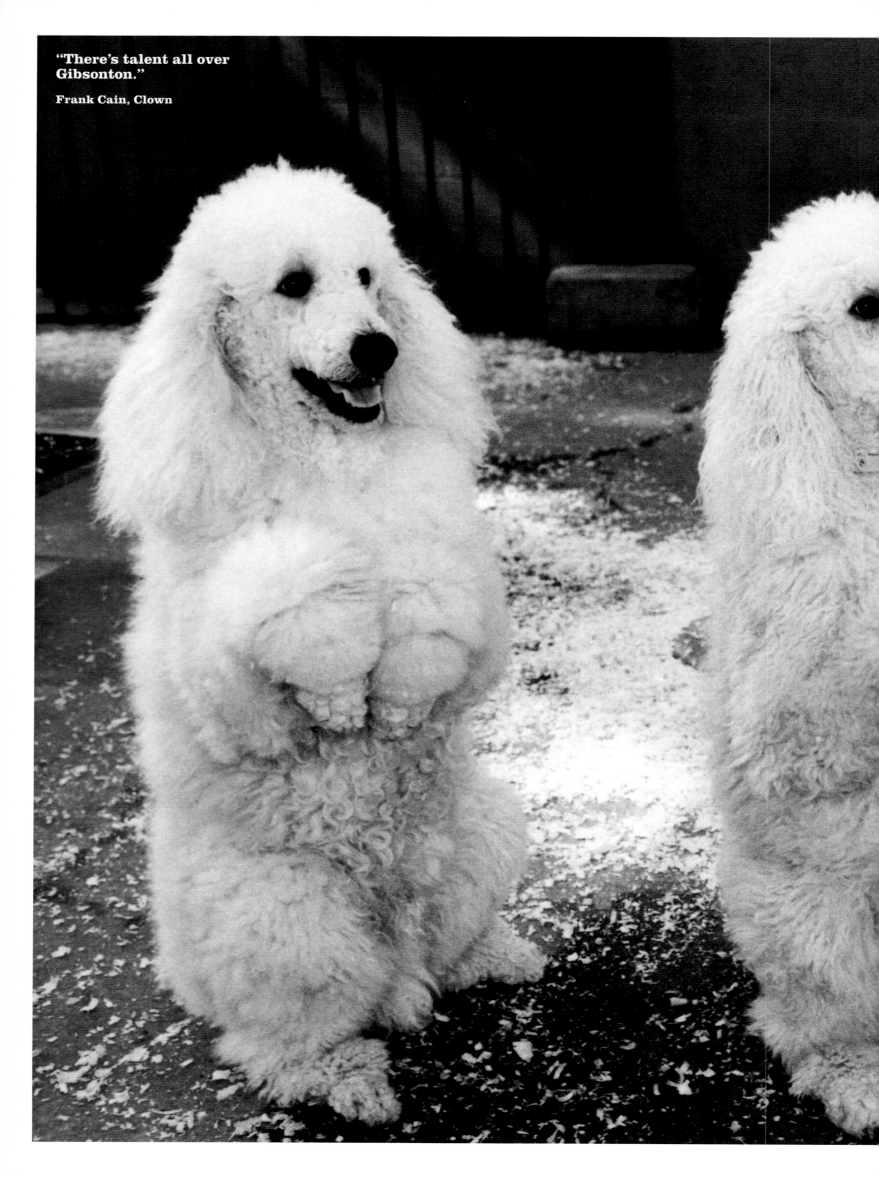

"There's talent all over Gibsonton."

Frank Cain, Clown

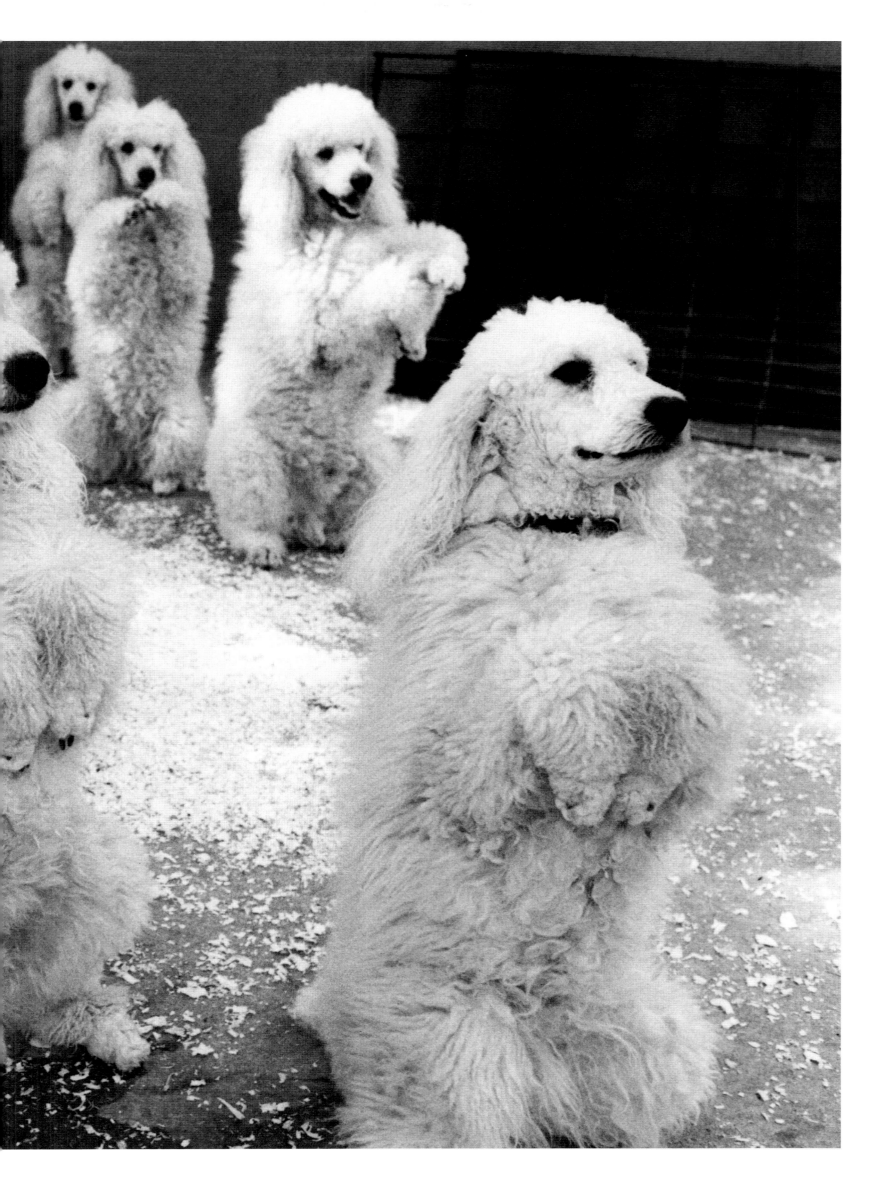

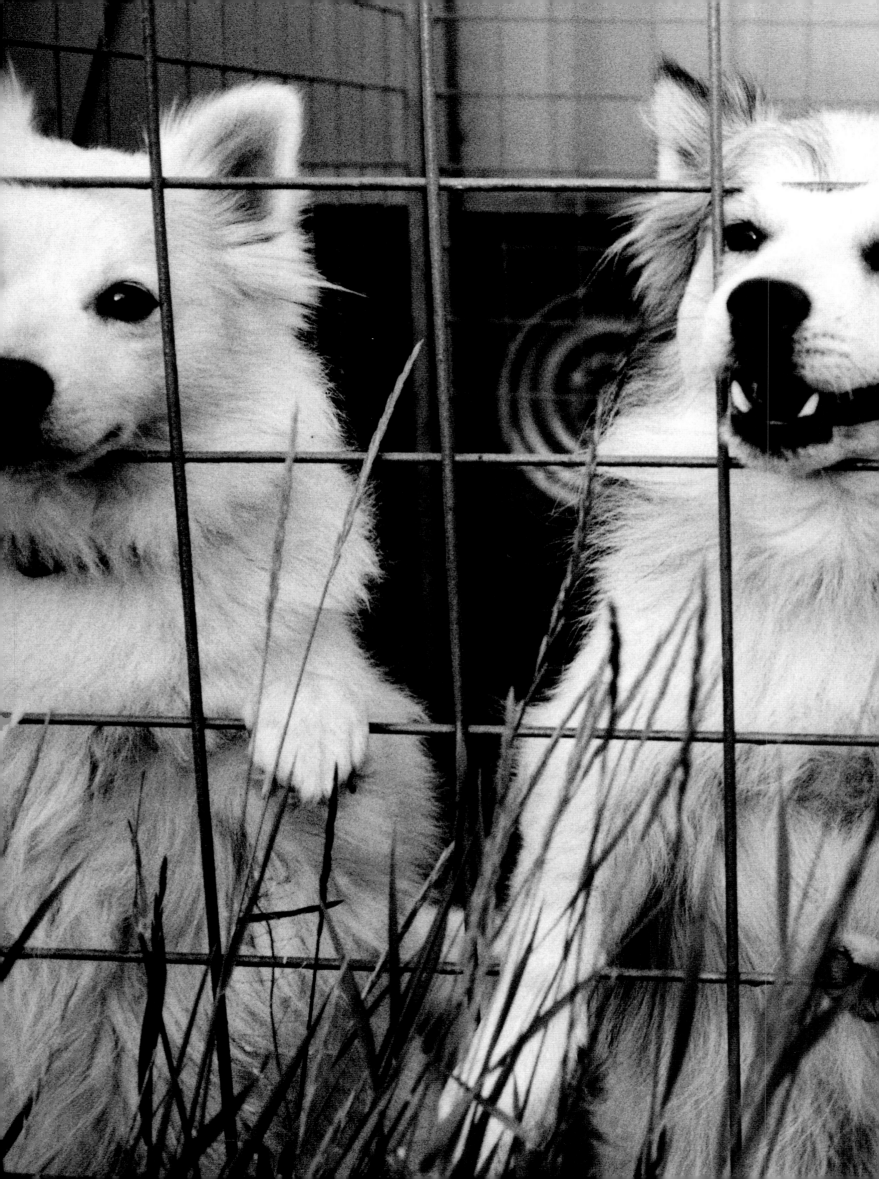

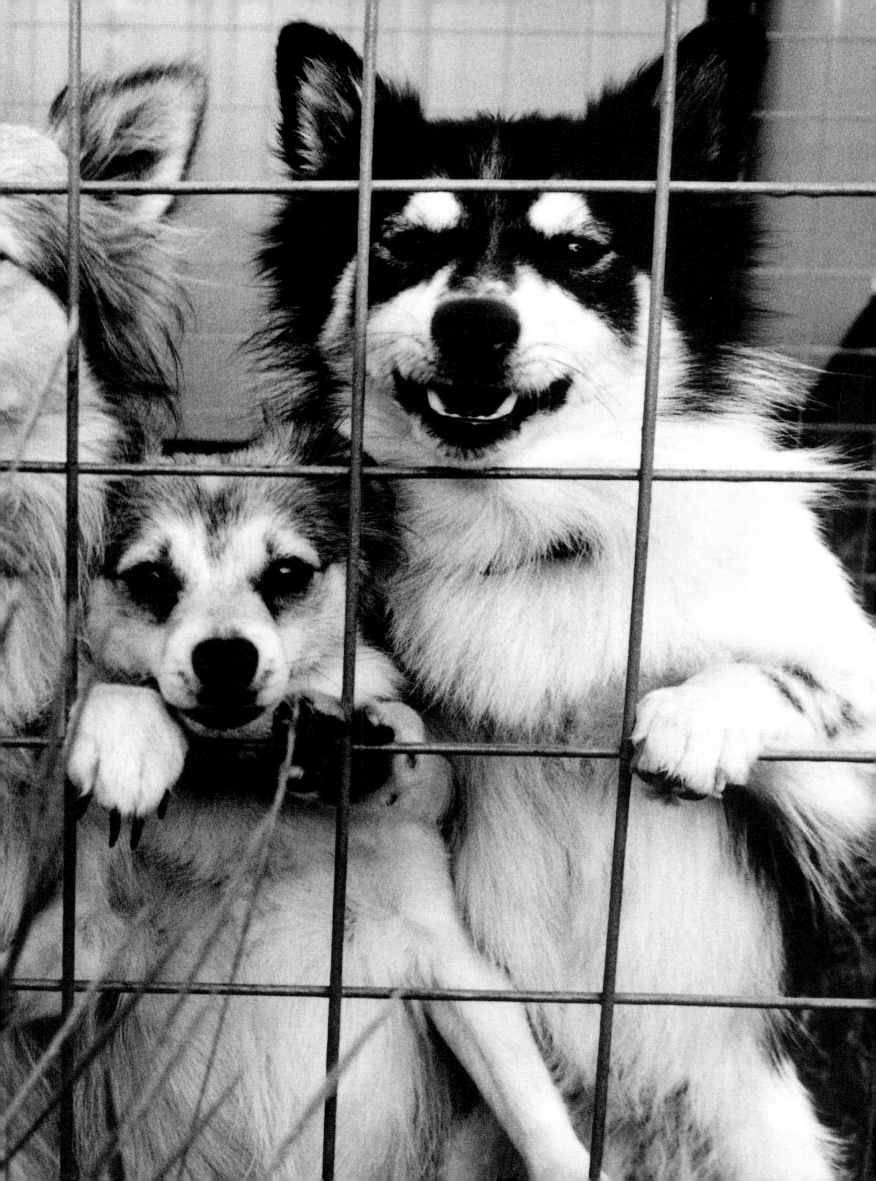

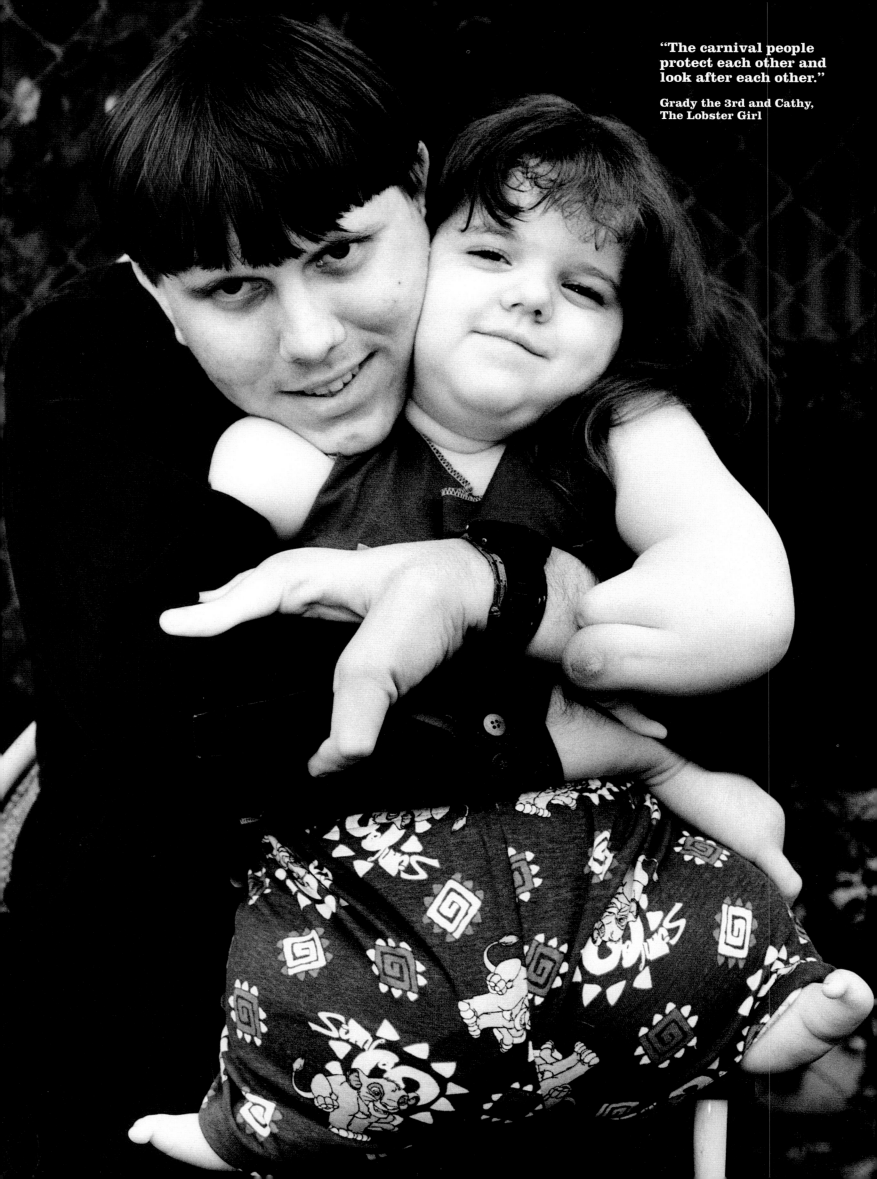

"The carnival people protect each other and look after each other."

Grady the 3rd and Cathy, The Lobster Girl

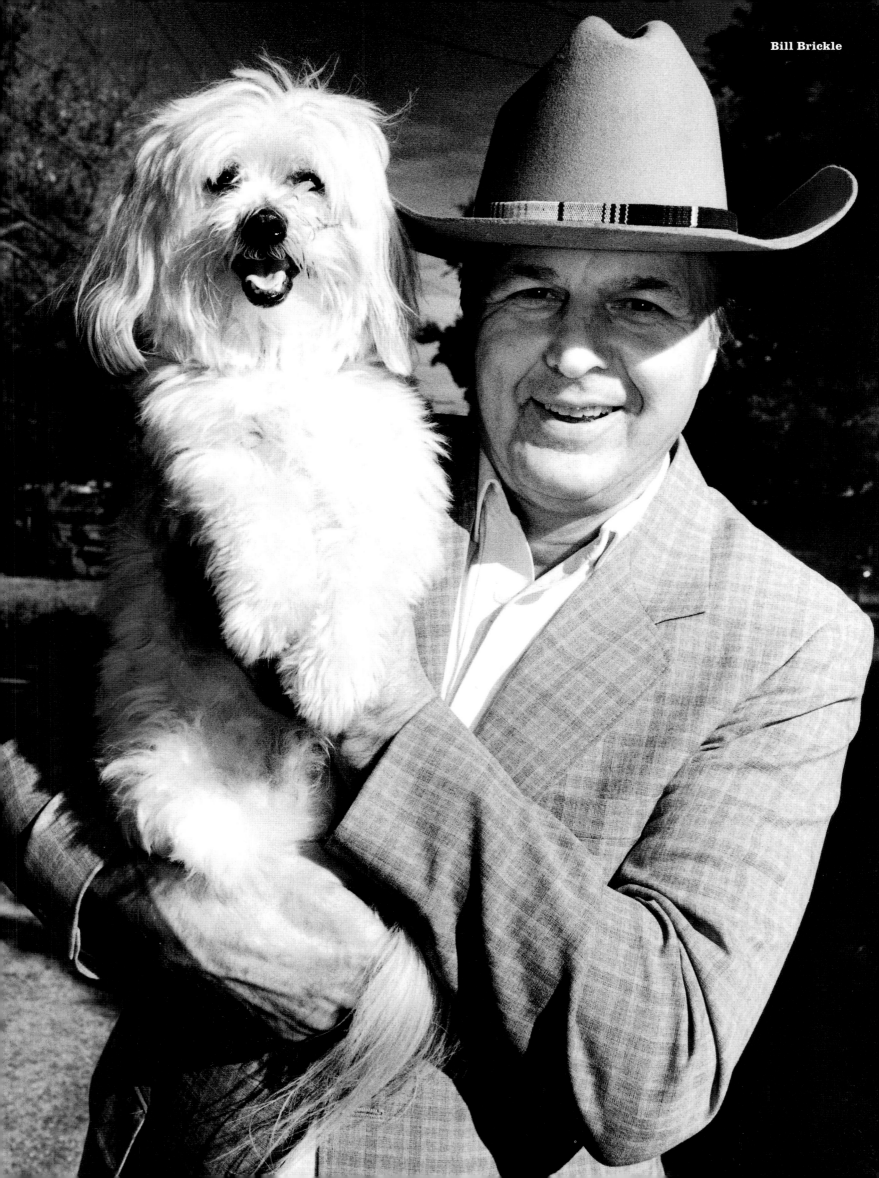

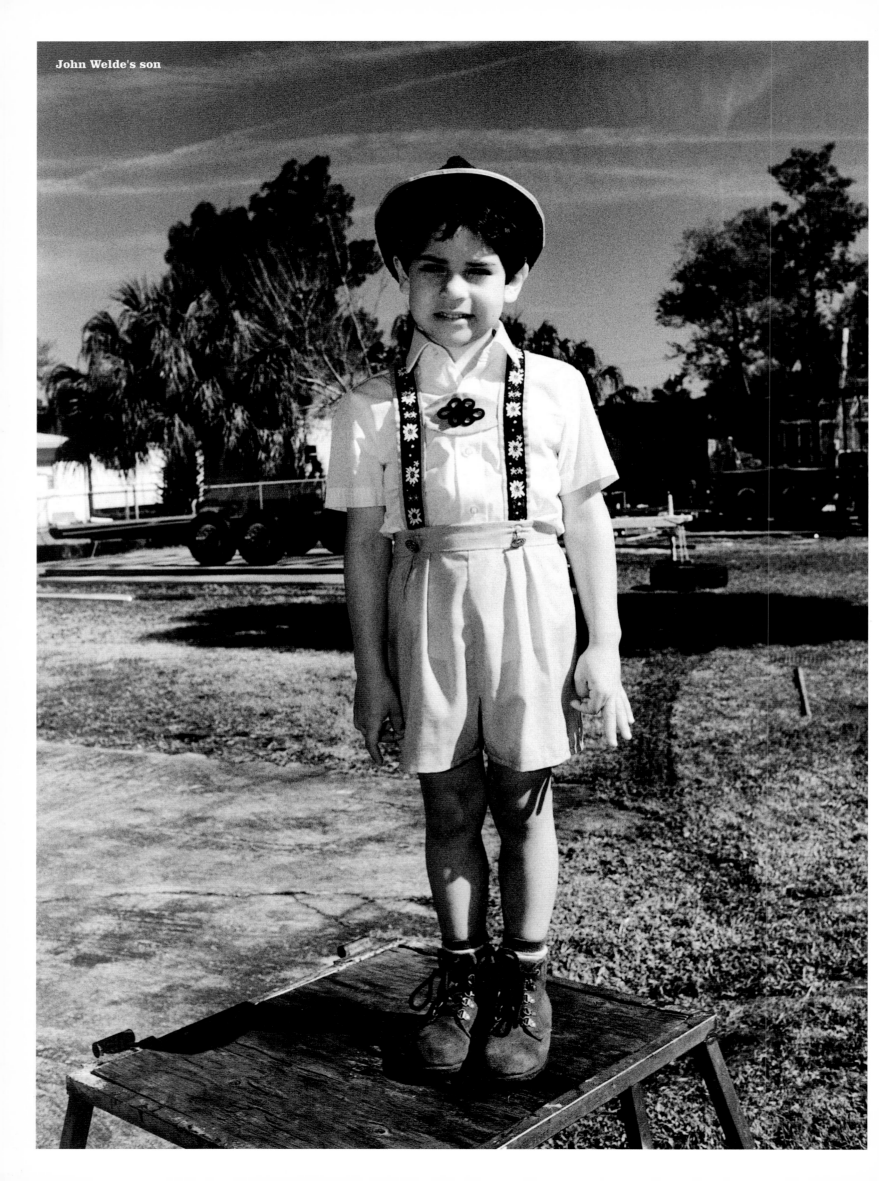

John Welde's son

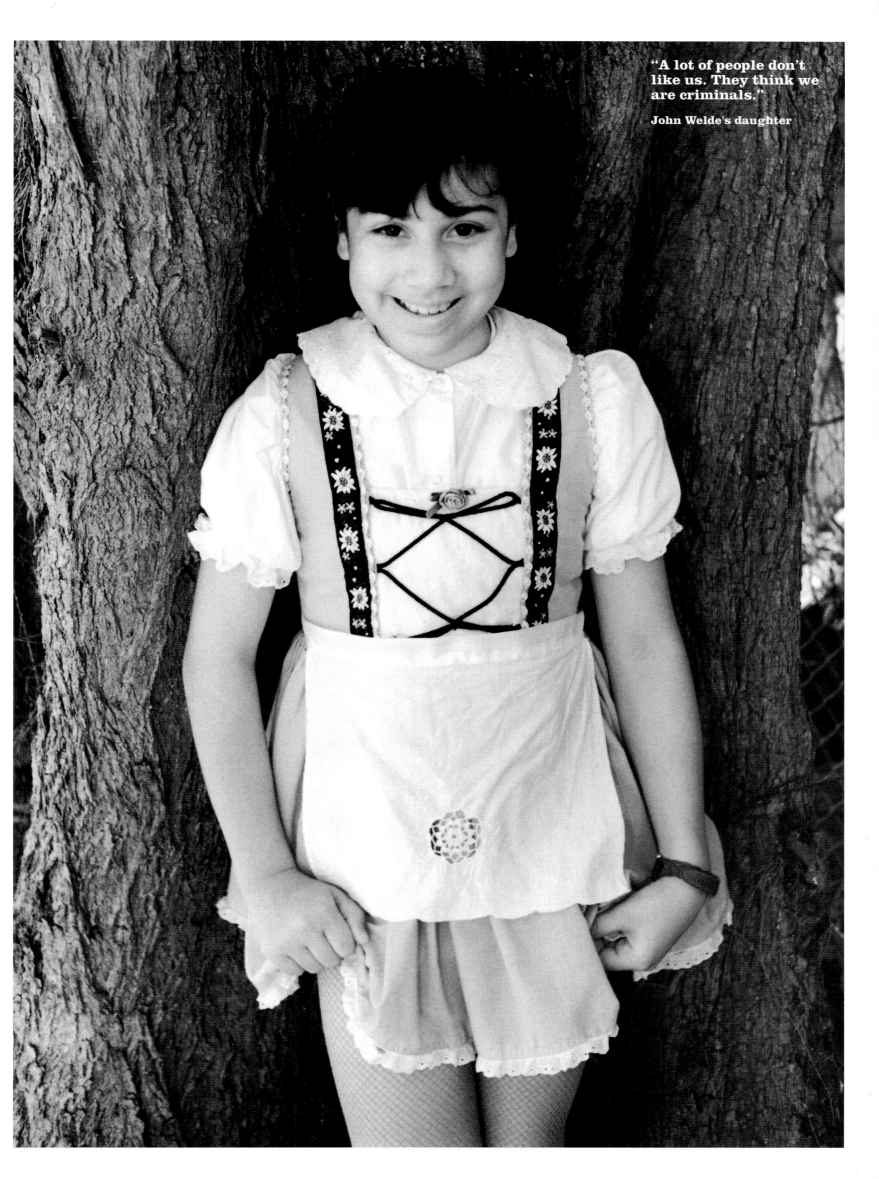

"A lot of people don't like us. They think we are criminals."

John Welde's daughter

HAMPSHIRE **96**
158998

TMAN

E FREE OR DIE

"Until you've sat up all night with the Fatman in a hospital emergency room, you can't be a Sideshow expert."

Ward Hall, Sideshow Promoter and Production Manager and author of My Very Unusual Friends

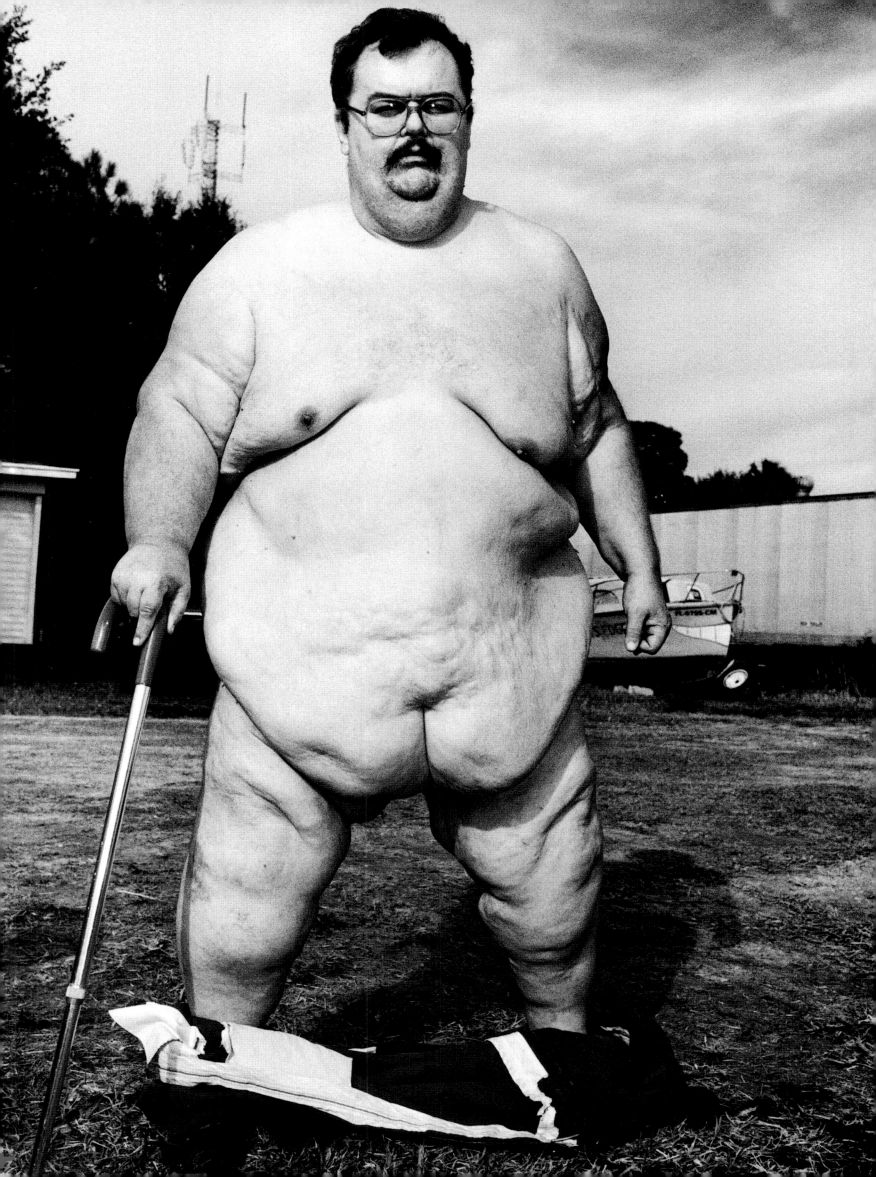

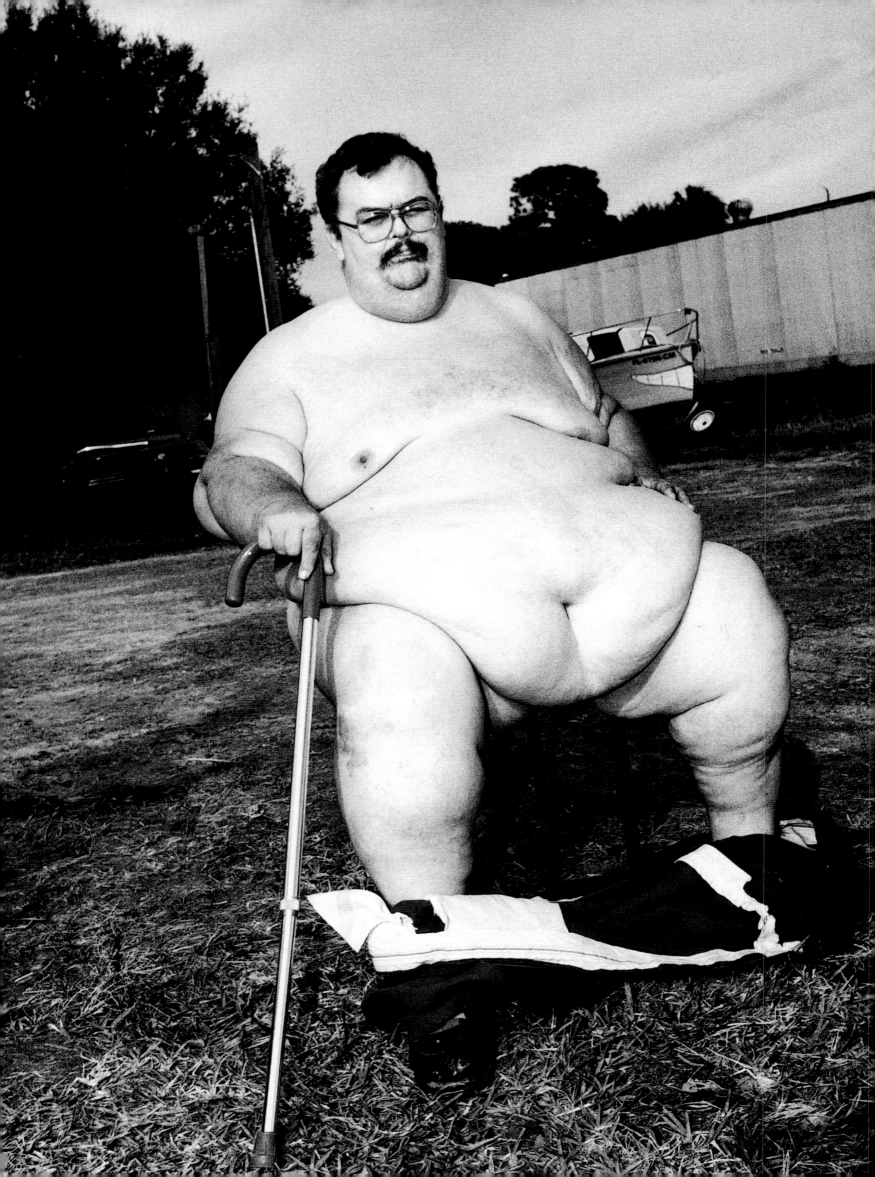

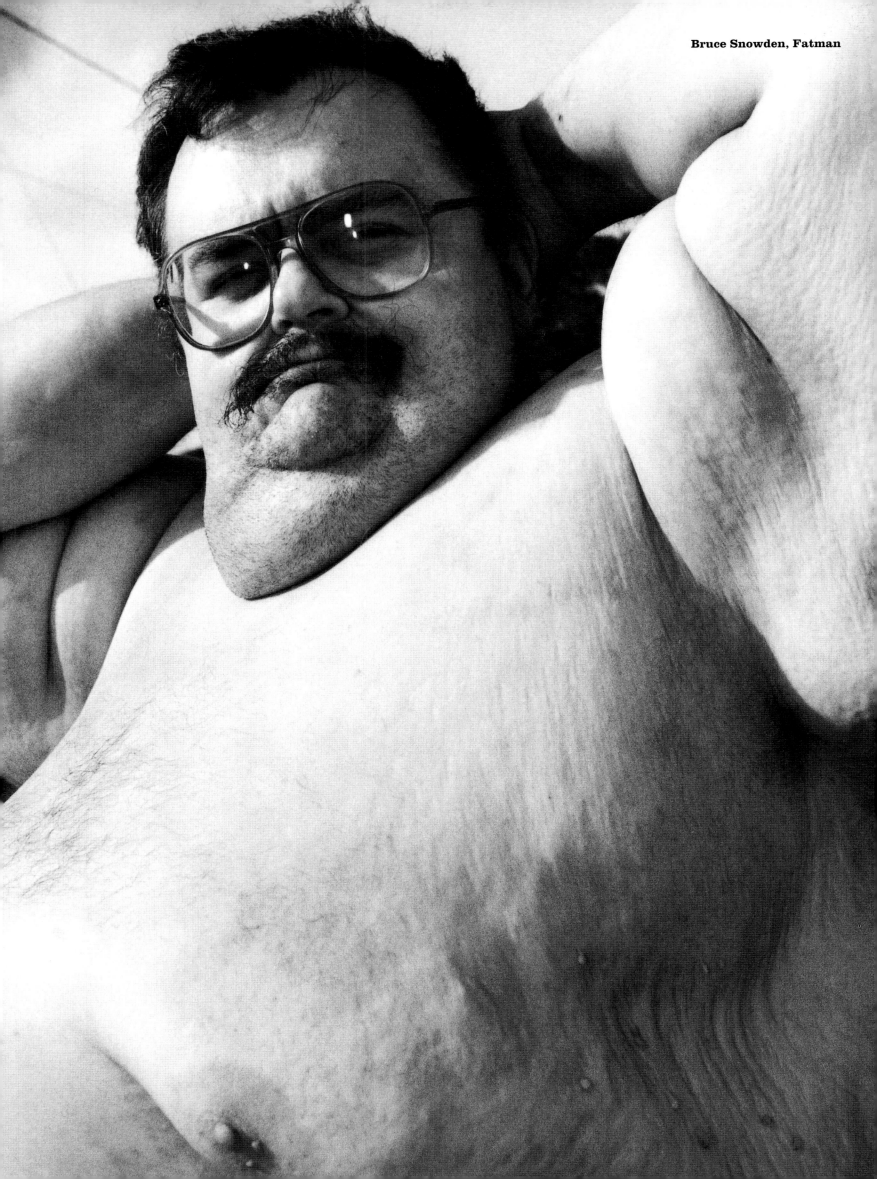

Bruce Snowden, Fatman

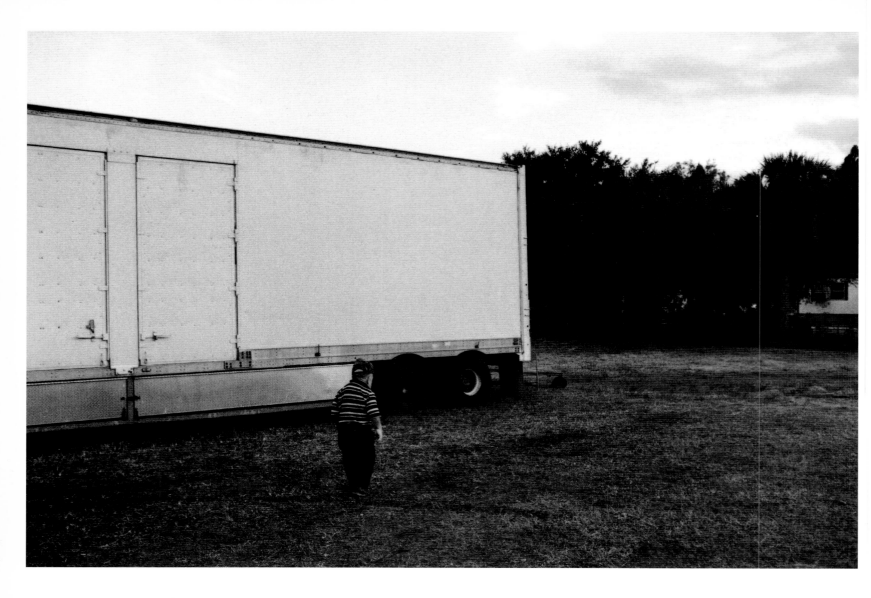
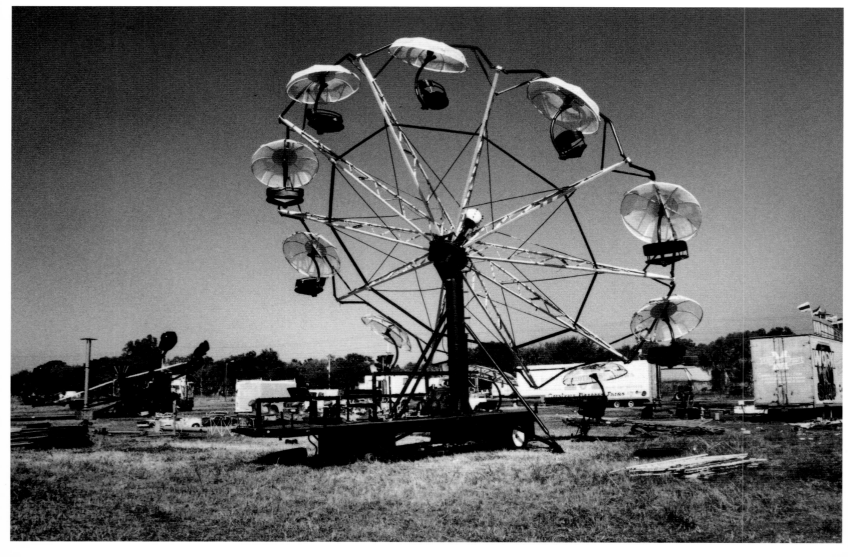

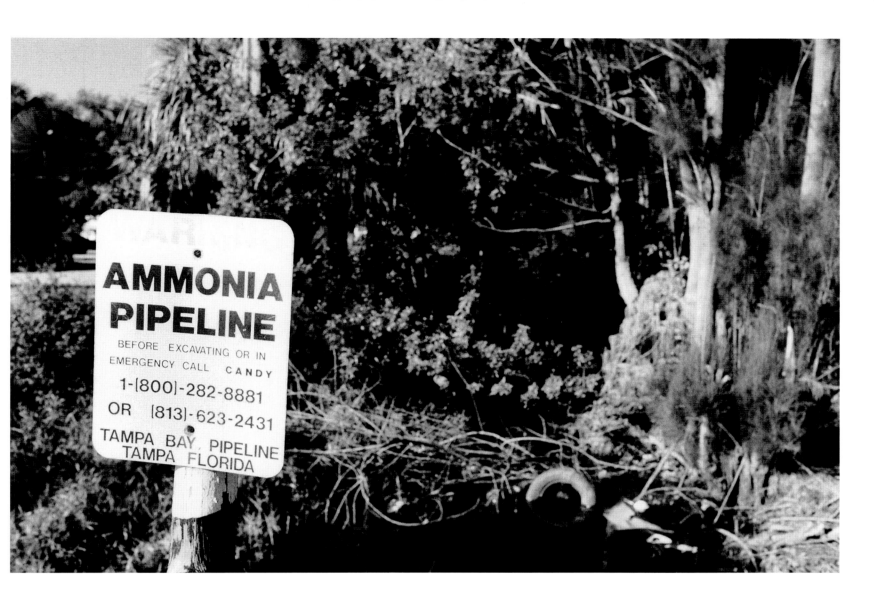

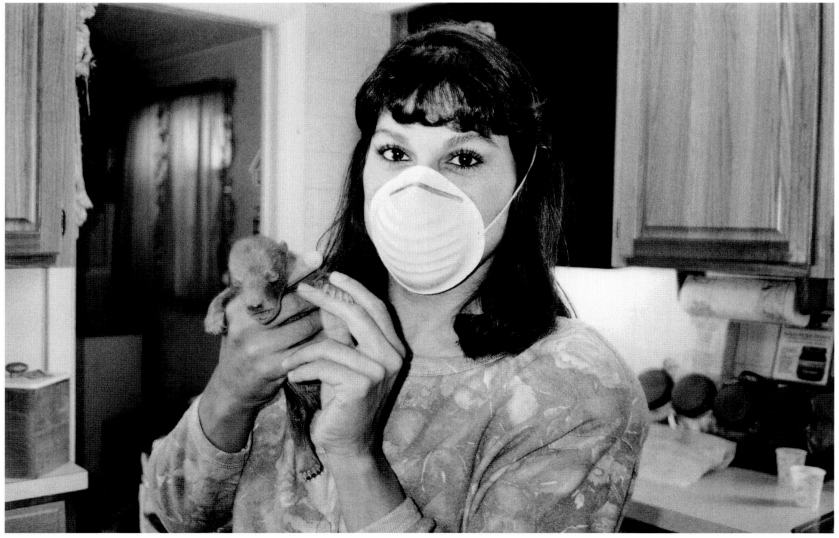

Garland Parnell,
Monkey Show

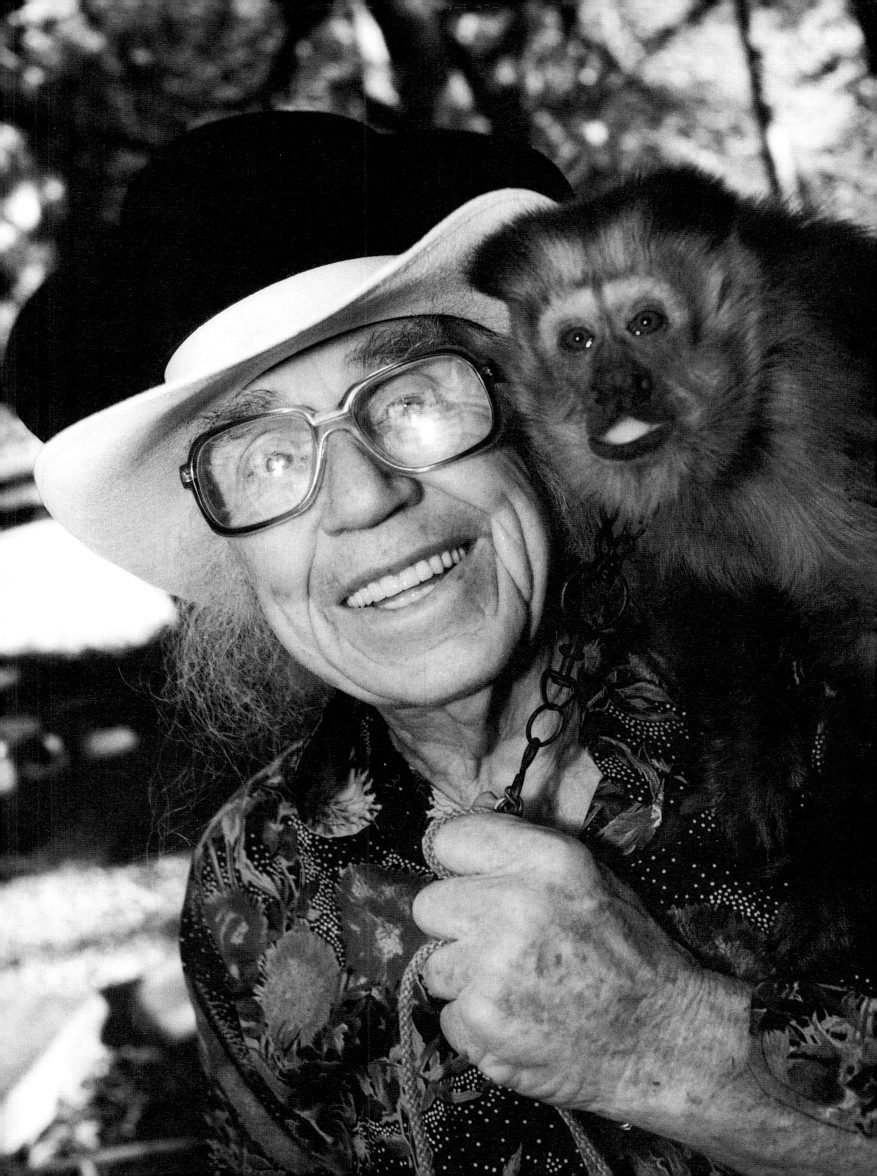

"Everybody is in his own
little world here."

Chuck Mosher

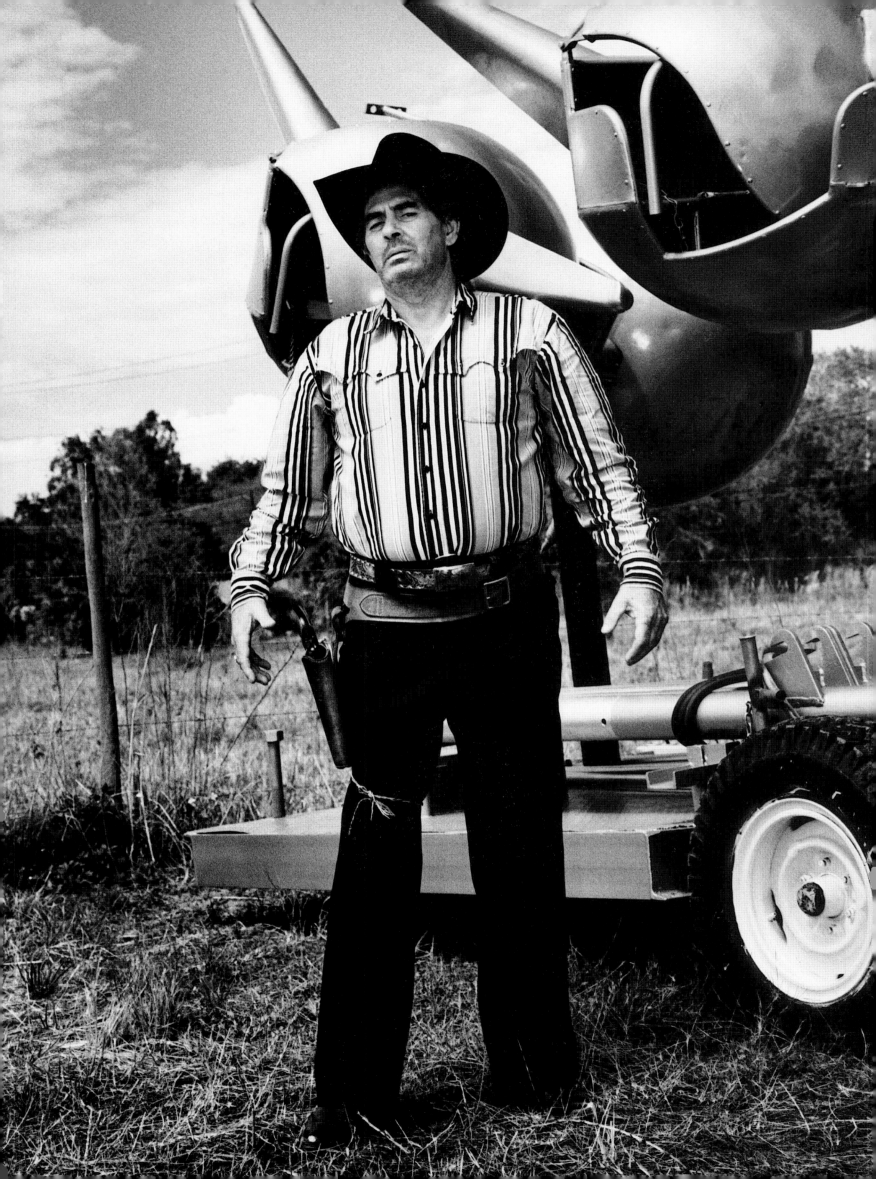

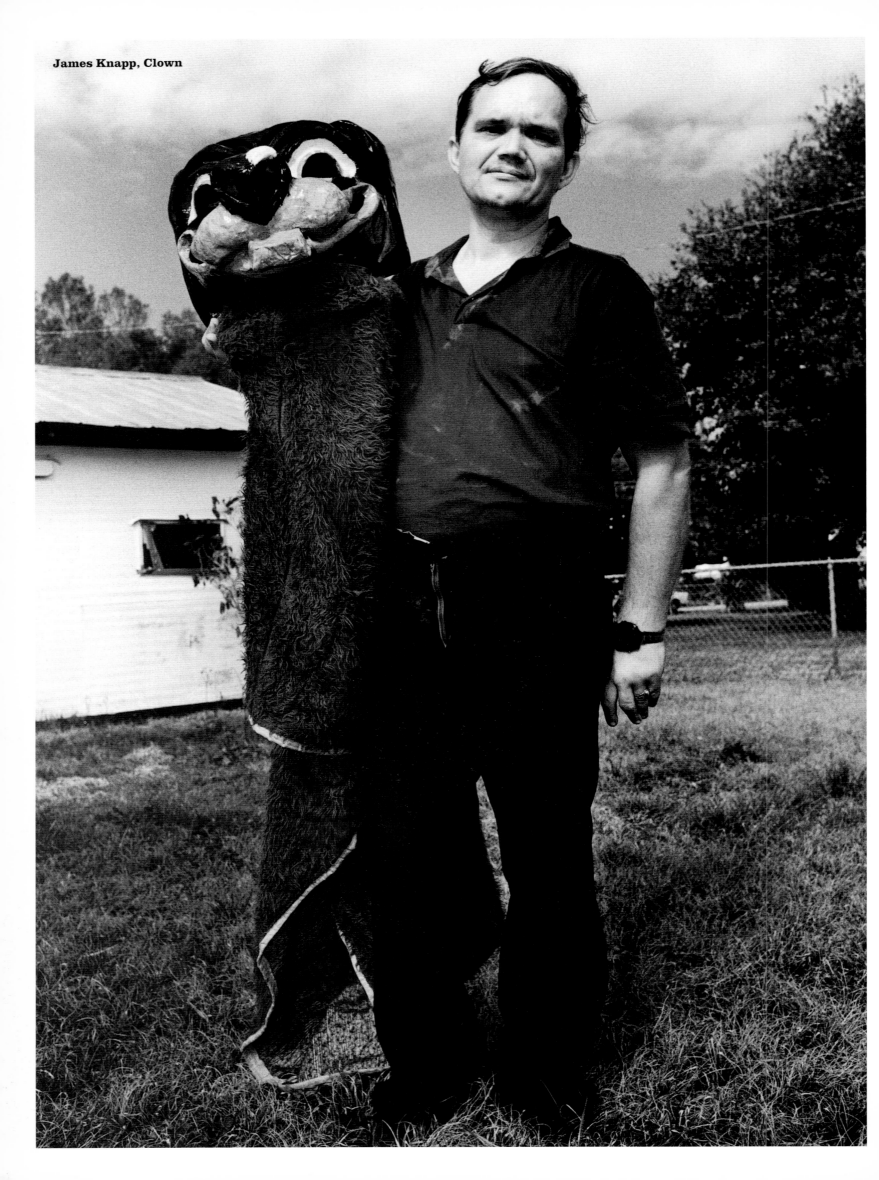

James Knapp, Clown

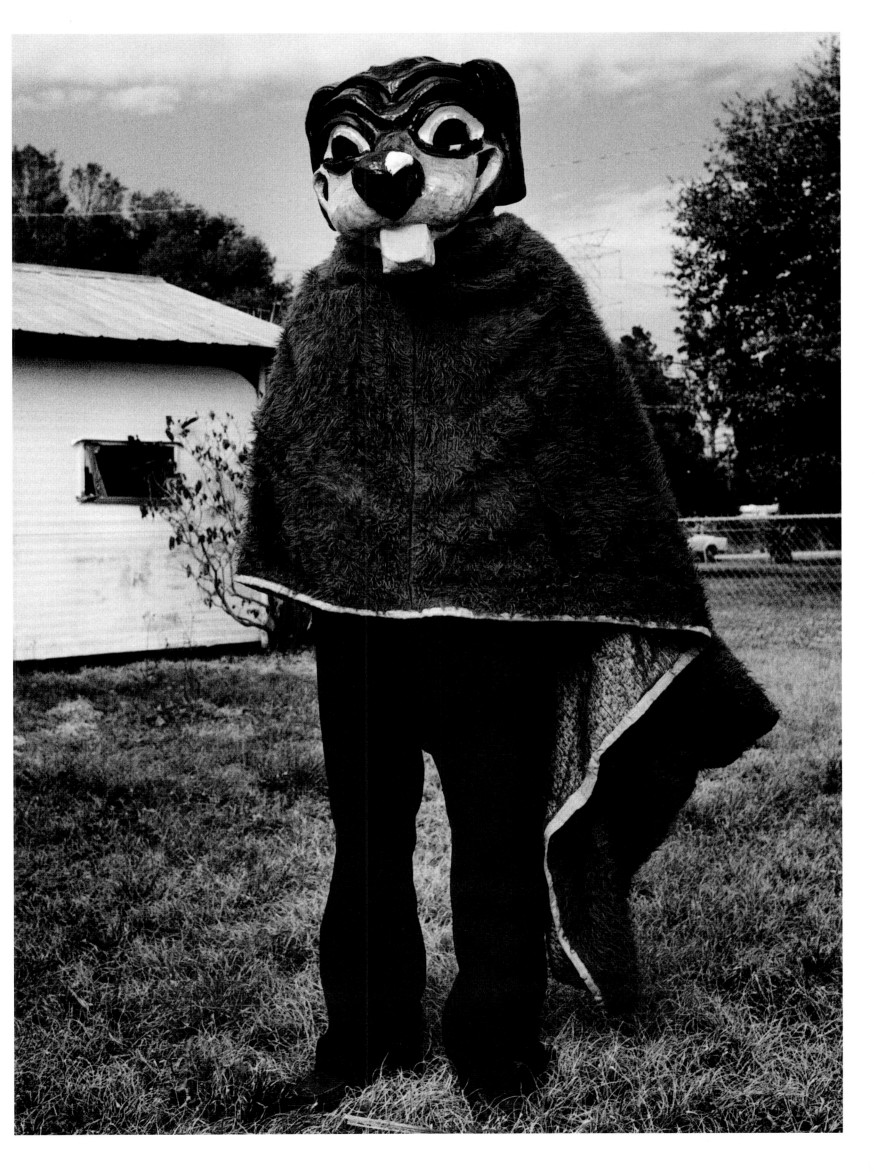

"Nowadays you have to be a very good businessman to do what we do. You have to be a carpenter, a mechanic, a truck driver and a vetinarian."

Chris Christ, Sideshow Promoter and Production Manager

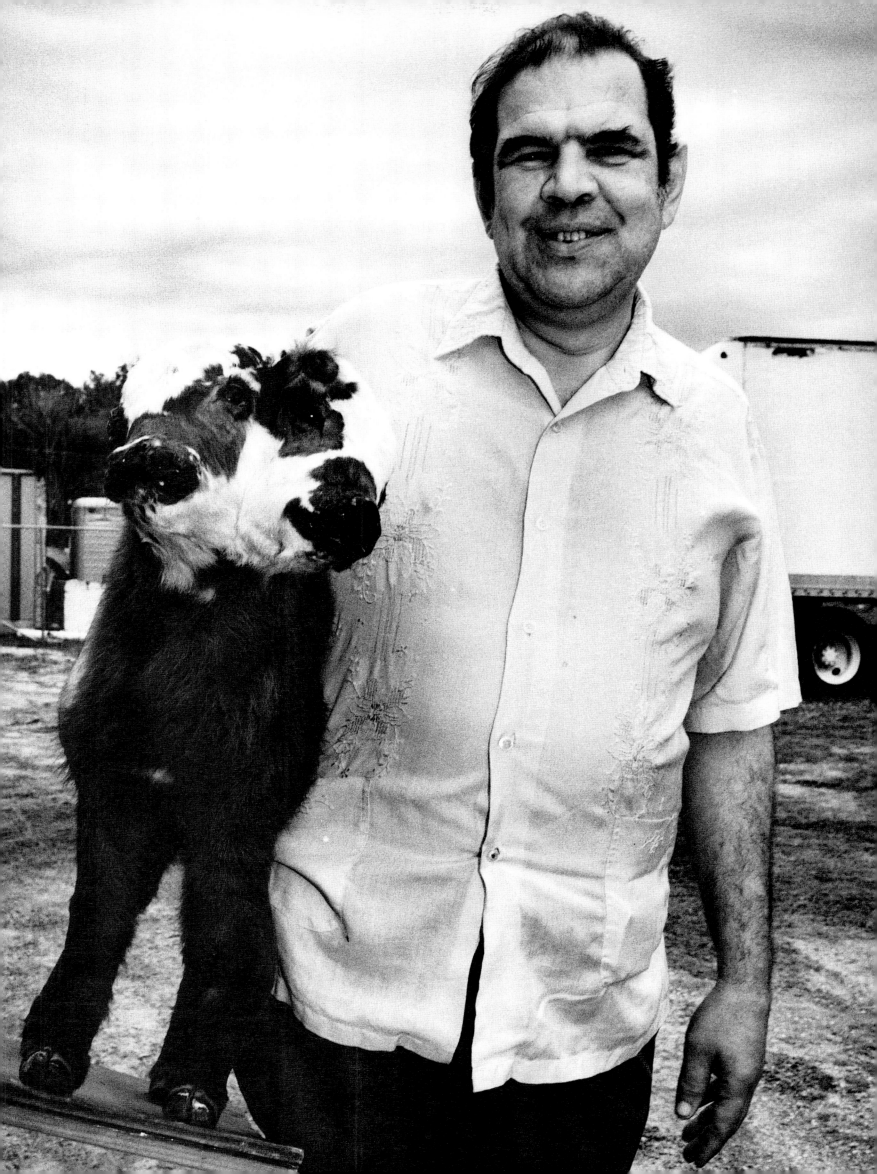

"I gave up trying to
become a movie star
when I realised I couldn't
sing or tell stories."

**Melvin Burkhardt, Human
Blockhead and Anatomical
Wonder**

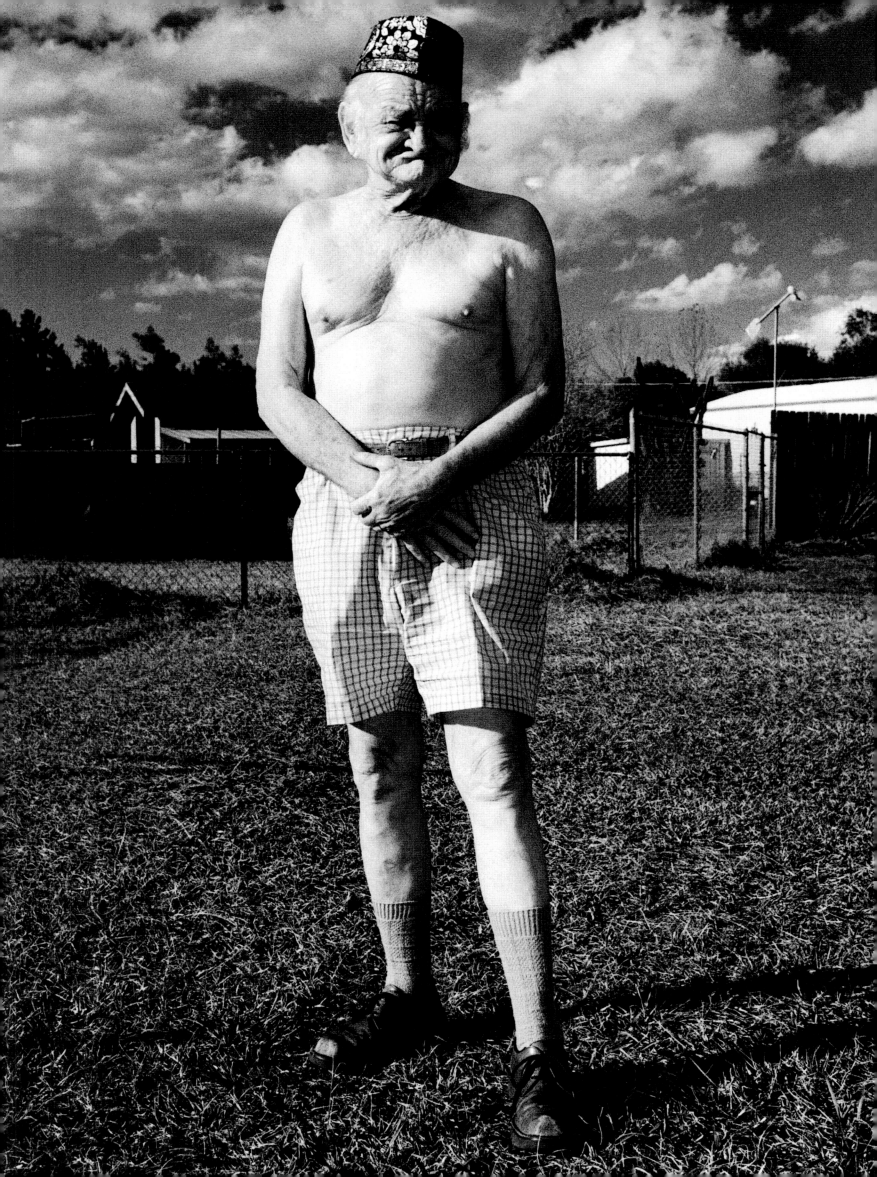

"There are real hermaphrodites, but here is a method for a fake which can pass close inspection when prepared and presented correctly.

This must be done by a male actor who is a convincing female impersonator, and who can pass as a beautiful woman. The abdomen should be free of hair – do not remove the pubic hair. The costume should be an elegant, expensive looking evening gown with a full skirt, split on one side to the waist.

Props and preparation:
All that is needed is a piece of narrow flesh-coloured elastic with a loop on one end and a cork fastened to the other end. The performer should stand in front of one mirror while stradling another on the floor. The performer must have a penis at least six inches in length. Put the loop of the elastic around the penis about three inches from the head. Pull the penis down and back so that the shaft between the elastic loop and the body has become tight against the scrotum, with a testicle on each side. Insert the cork into the rectum and shorten the elastic so that it is tight. With this arrangement of the penis and scrotum it will appear as though the testicles are the lips of a vagina.

Presentation:
"Good evening. I am a true living human hermaphrodite, a double-sexed wonder, sometimes referred to as half man, half woman. This is incorrect. I am all man and I am all woman. I possess the sexual organs of both male and female. I can legally dress as a man or a woman. I could legally marry a man or a woman, because I could become the mother or the father of children. I prefer to allow the female side of my personality to prevail. I am happily married to a loving man and I am the mother of two children: a boy of four and a boy of six. Preferring to live as a female does have some difficulties. I must shave every day and as you see my feet are the size of a man's - if my feet were any larger I couldn't wear these shoes, I'd have to wear the boxes! However as you see I have the fully developed breasts of a female (fondle the breasts) and my babies were breast fed. (Slowly open the skirt by lifting it to the side from the slit. Spread the legs slightly and insert a finger in the vagina - the divison of the testicles - moving it in and out.)

Having a normal human vagina of course I undergo the usual periods of menstruation. (Because of it being tied back the penis is not readily seen - reach under and grasp it just above the head and pull it down a little) I have a male penis which is somewhat underdeveloped and my testicles are up in the pelvic area, as I do not have a normal scrotum. However I can have an erection and I can ejaculate. During intercourse with my husband the penis usually does become erect. (drop the skirt.) Thank you for attending my demonstration."

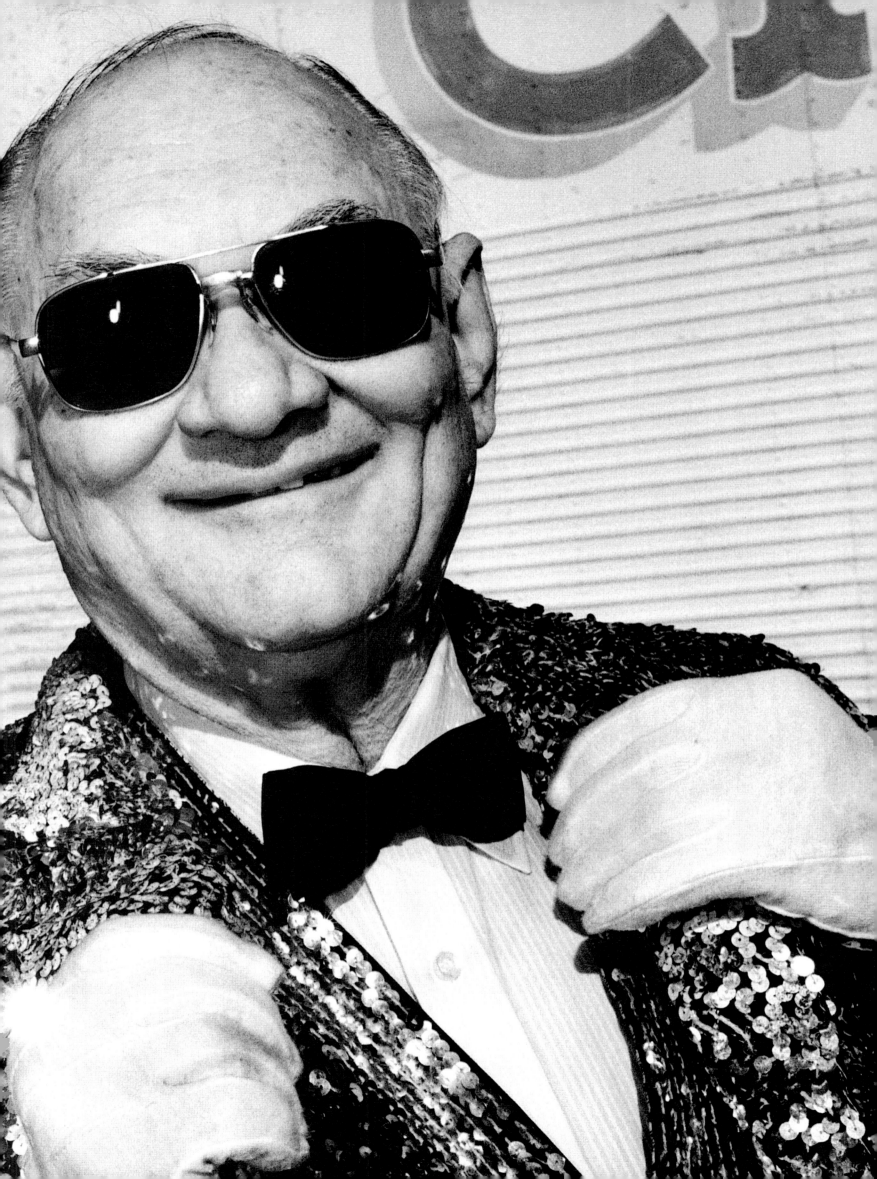

Connie Welde, Miss Constancia,
mother of John Welde

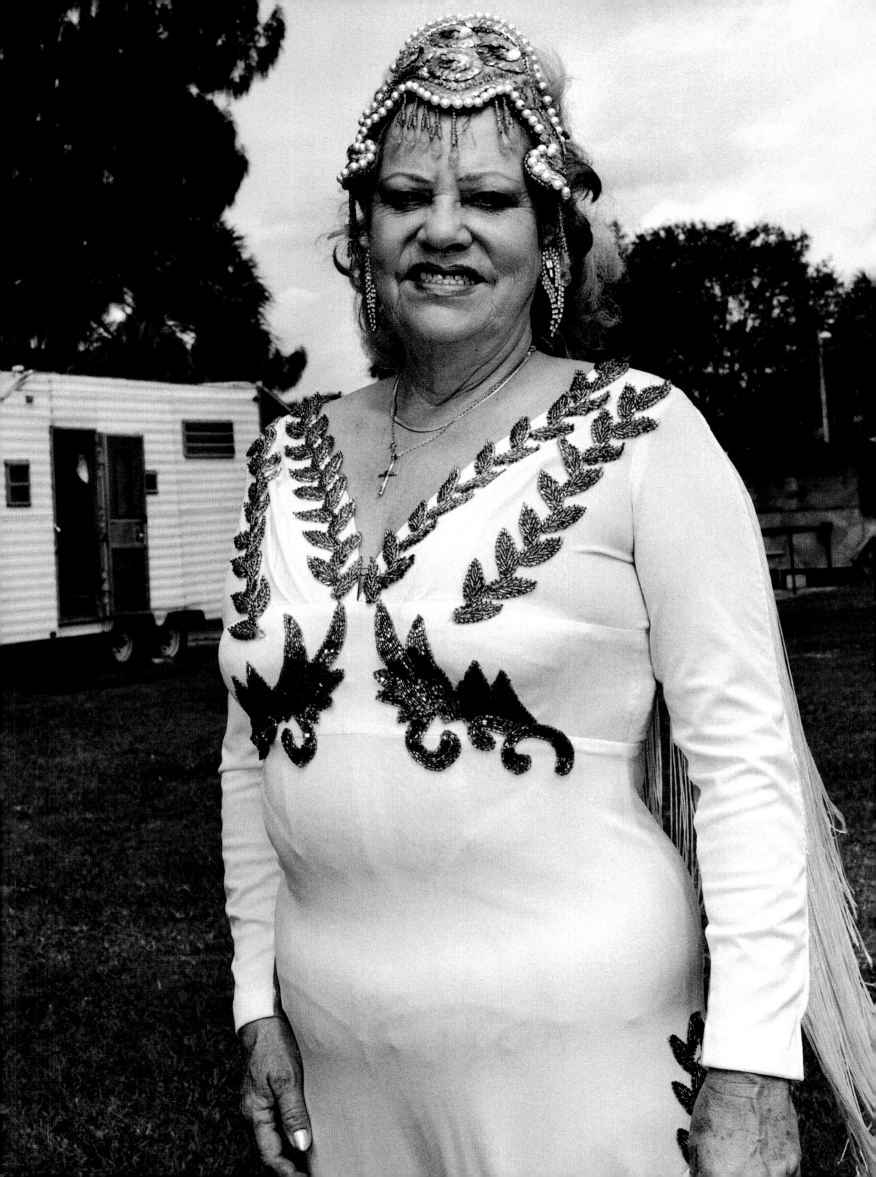

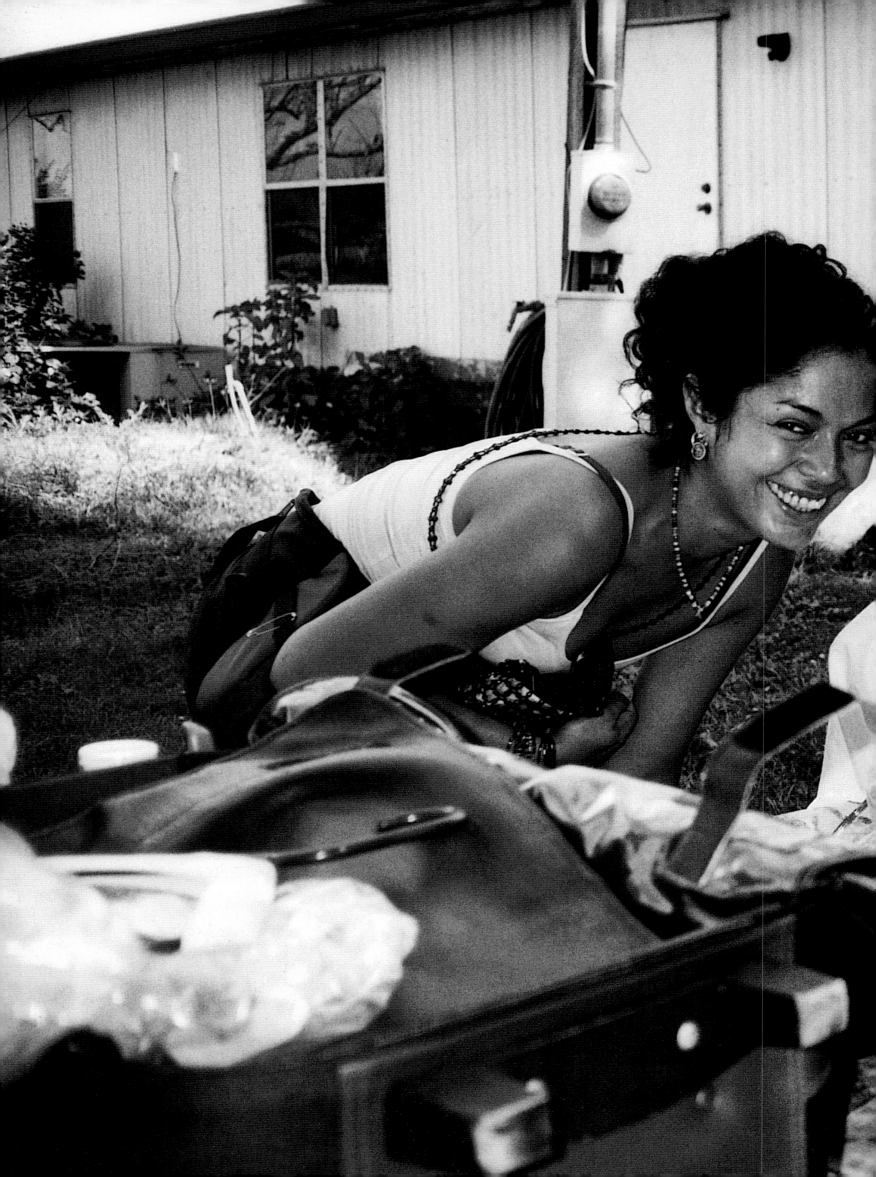

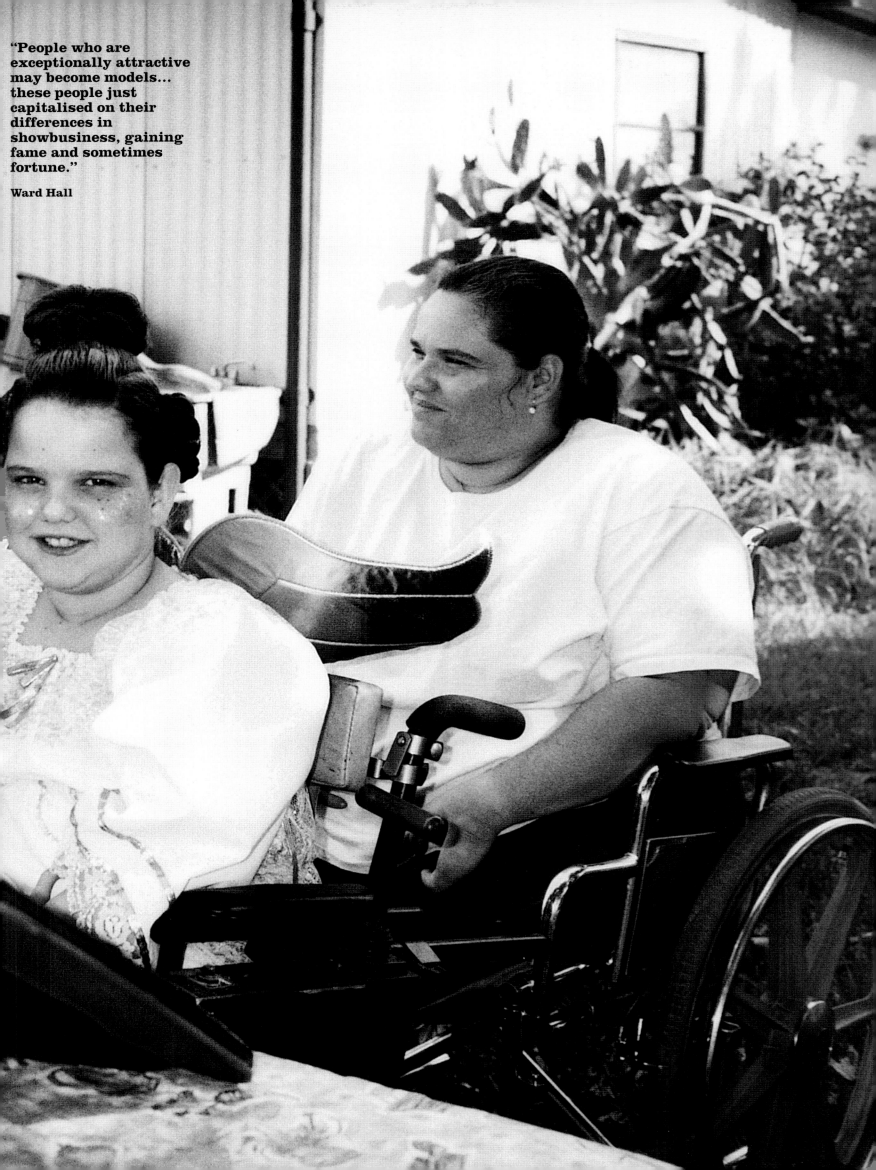

"People who are
exceptionally attractive
may become models...
these people just
capitalised on their
differences in
showbusiness, gaining
fame and sometimes
fortune."

Ward Hall

**Christele, Model, with Cathy,
The Lobster Girl**

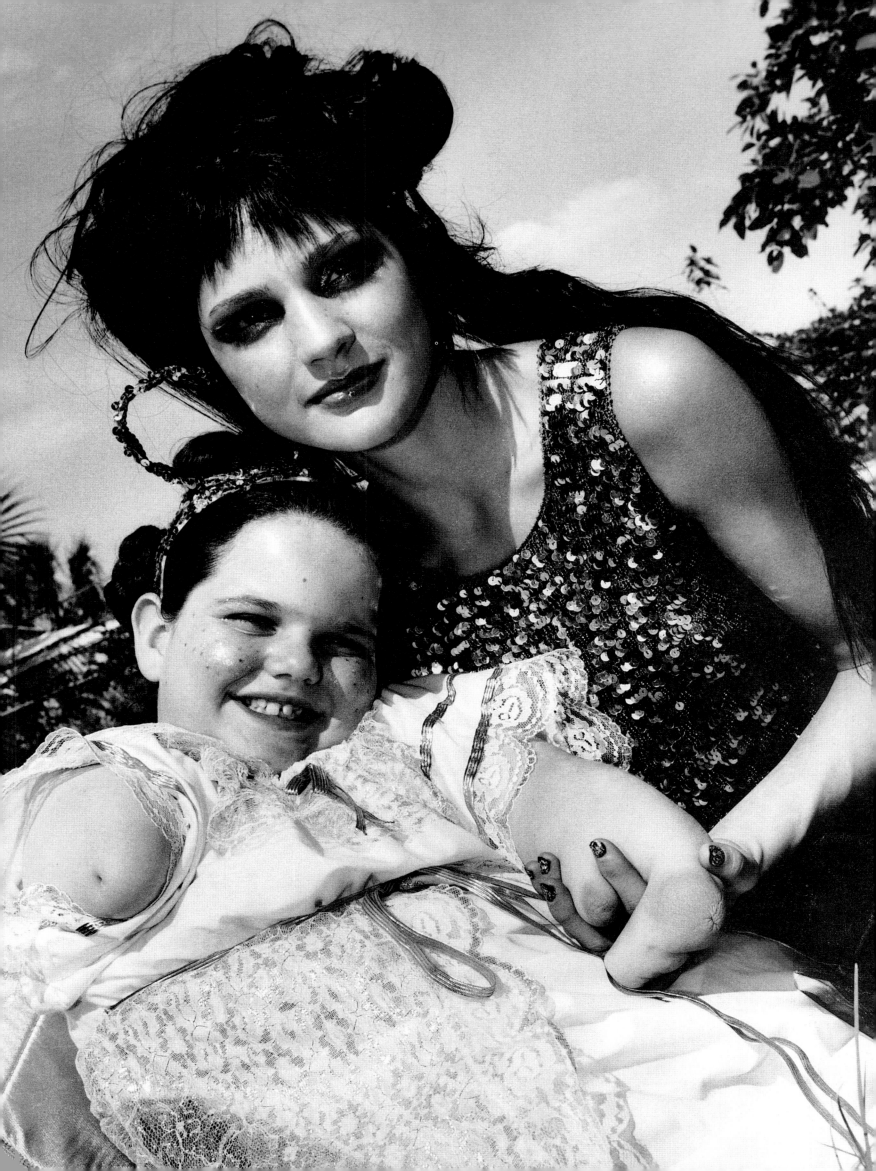

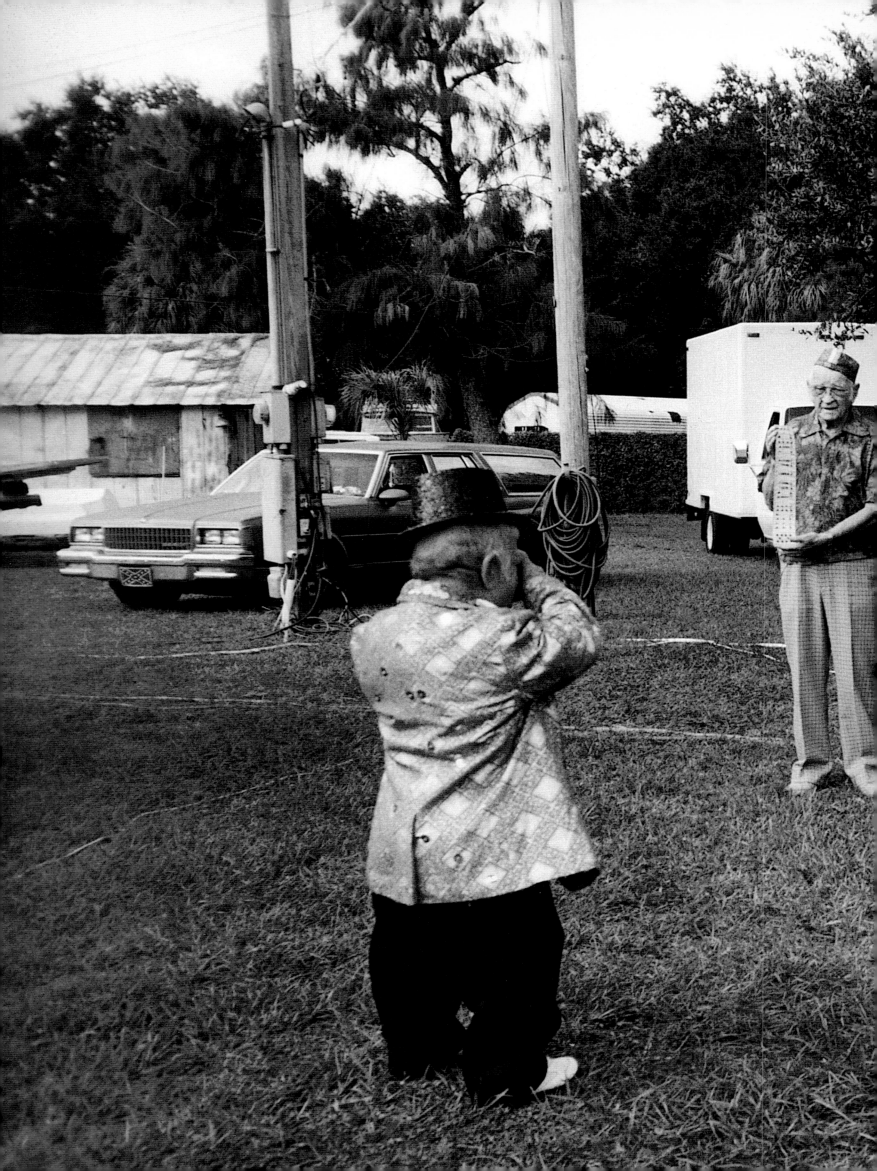

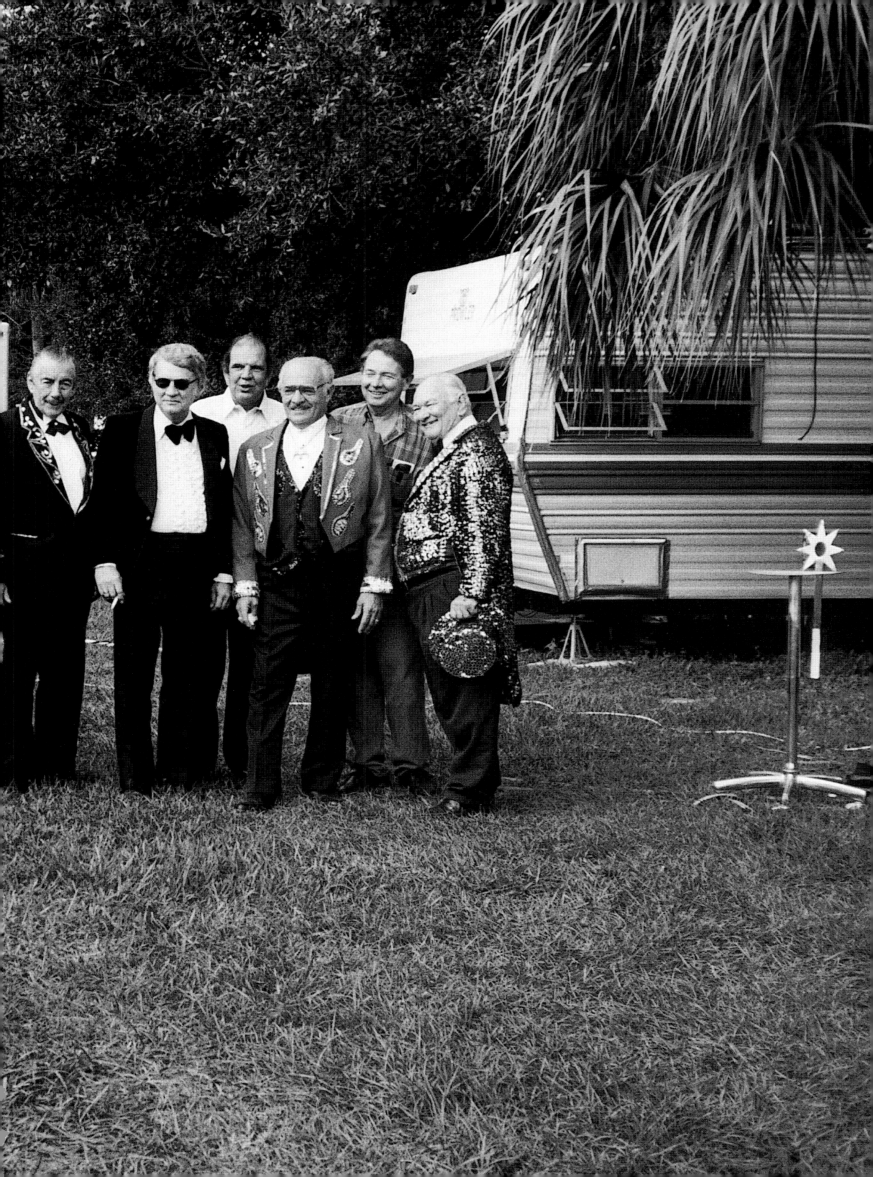

"Show business is not
like showbusiness.
It's a way of life."

Ward Hall

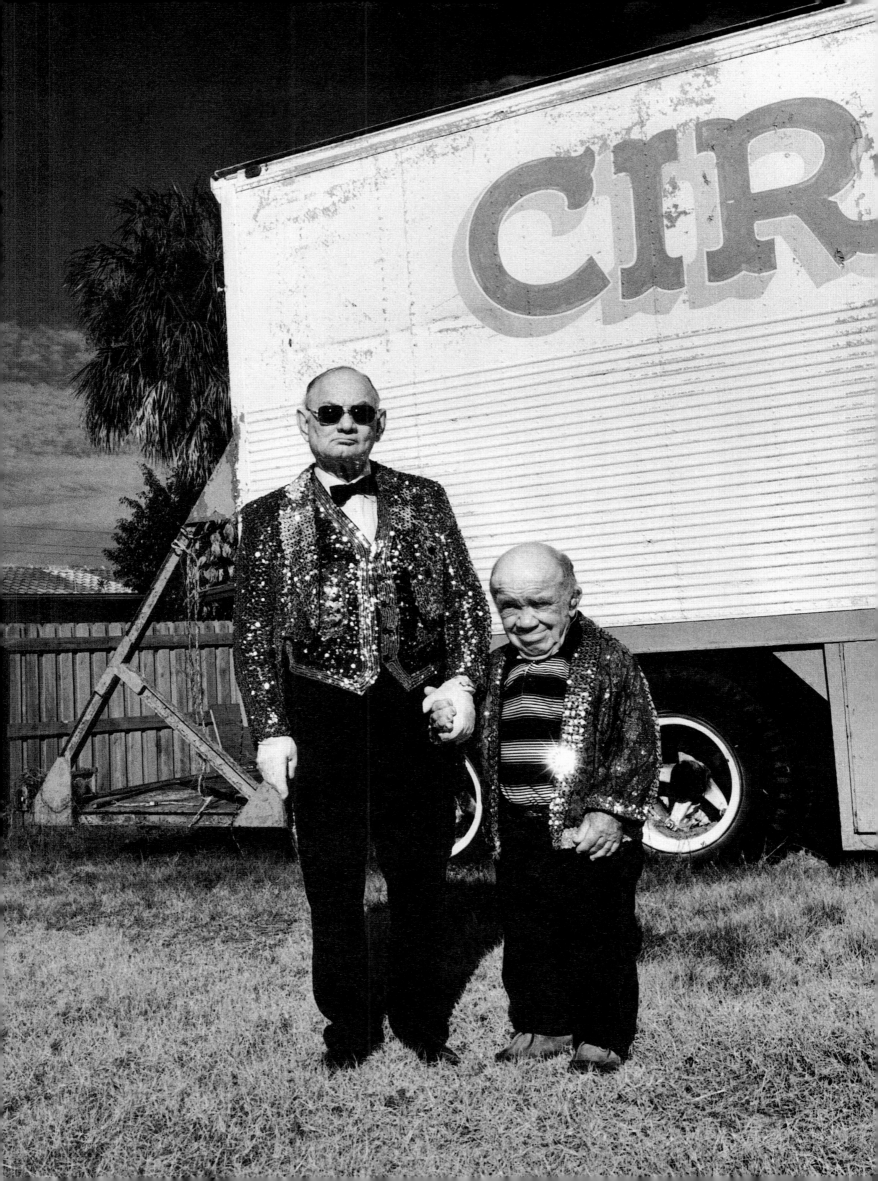

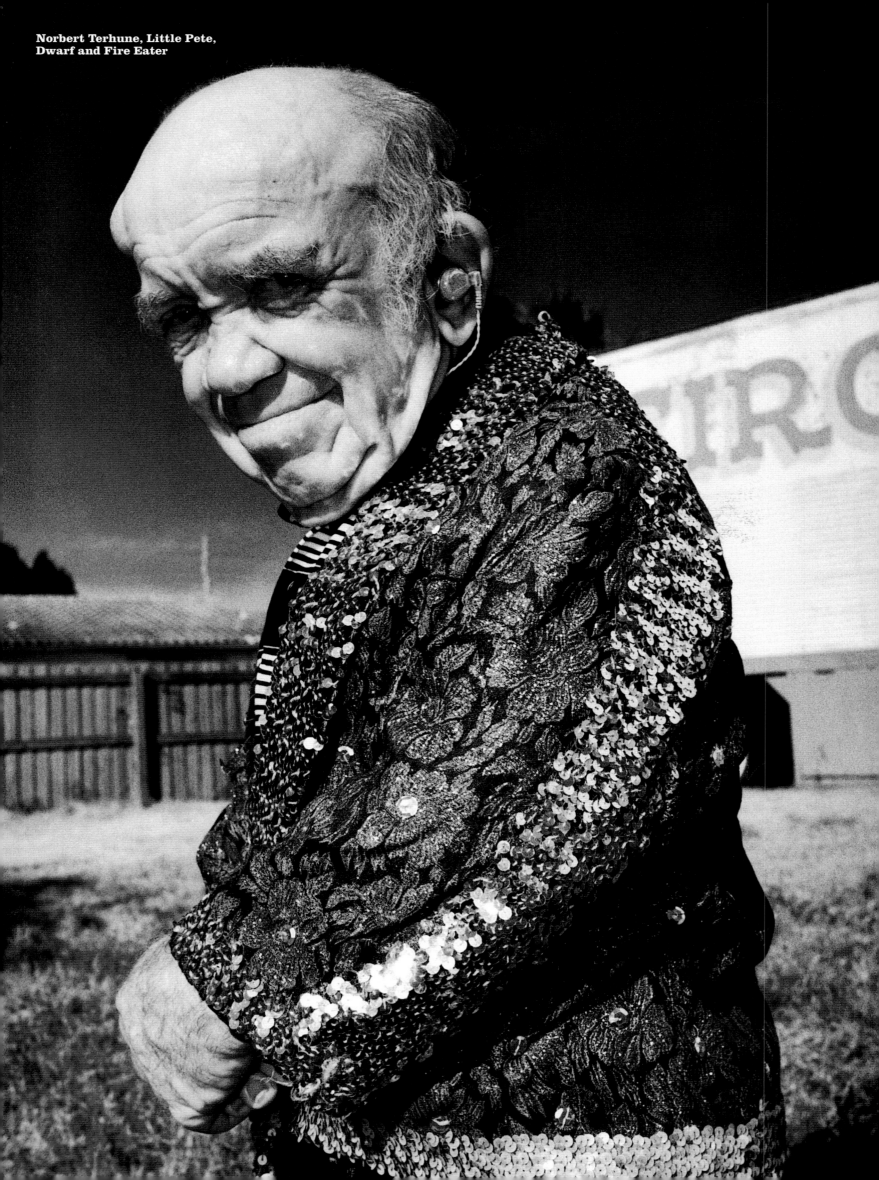

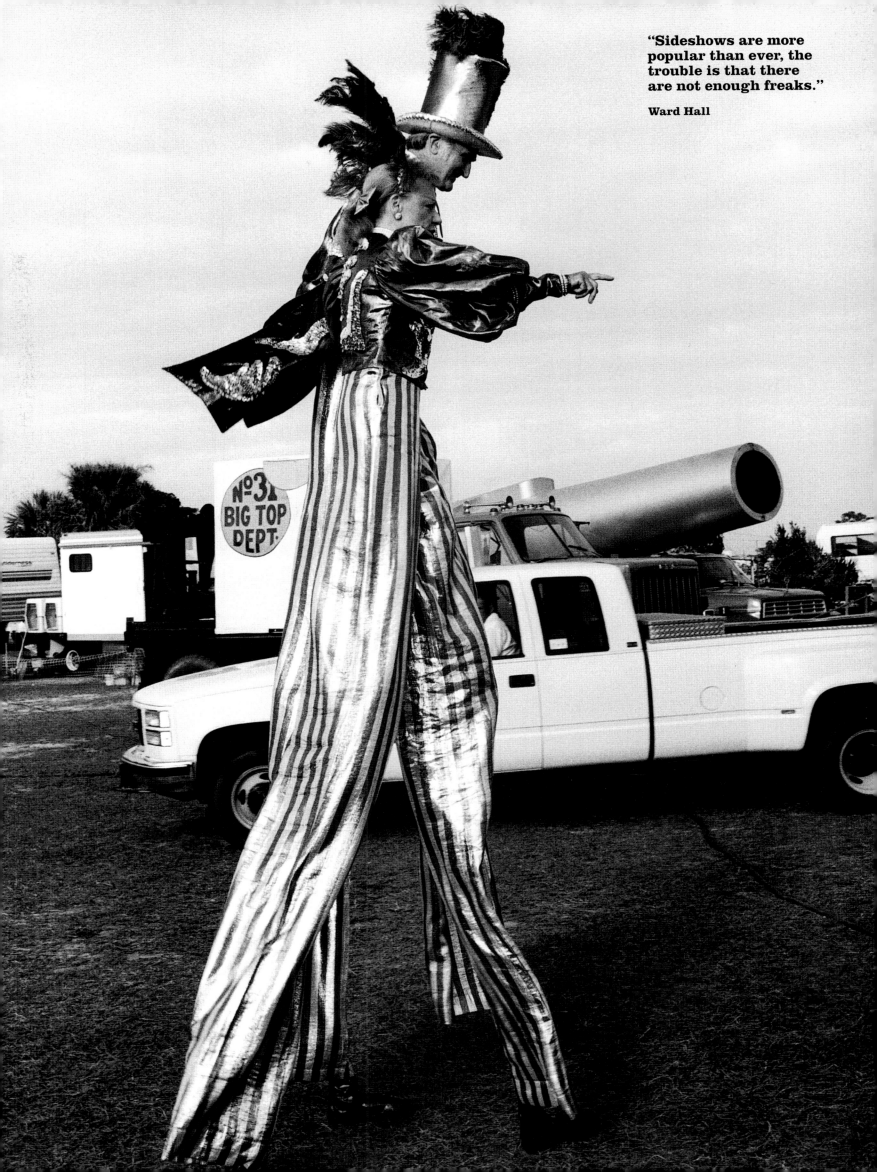

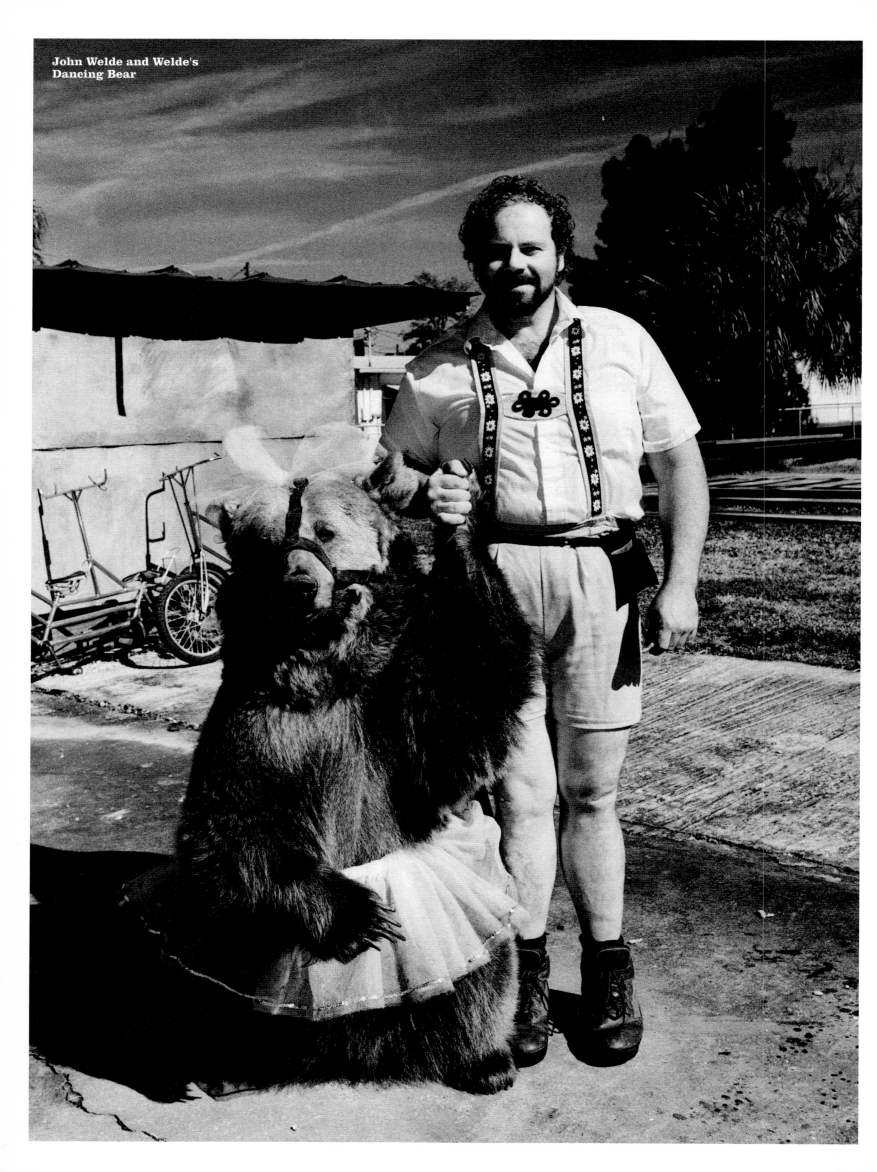

John Welde and Welde's
Dancing Bear

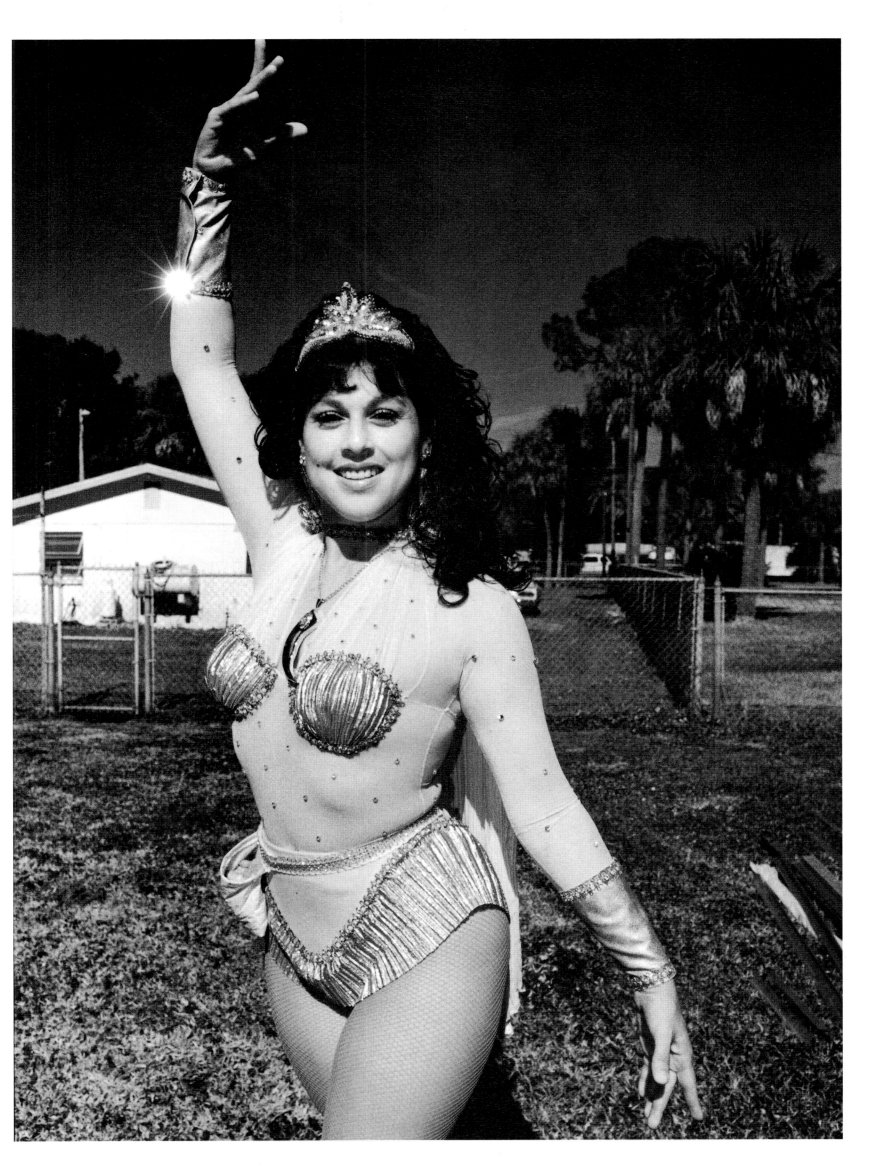

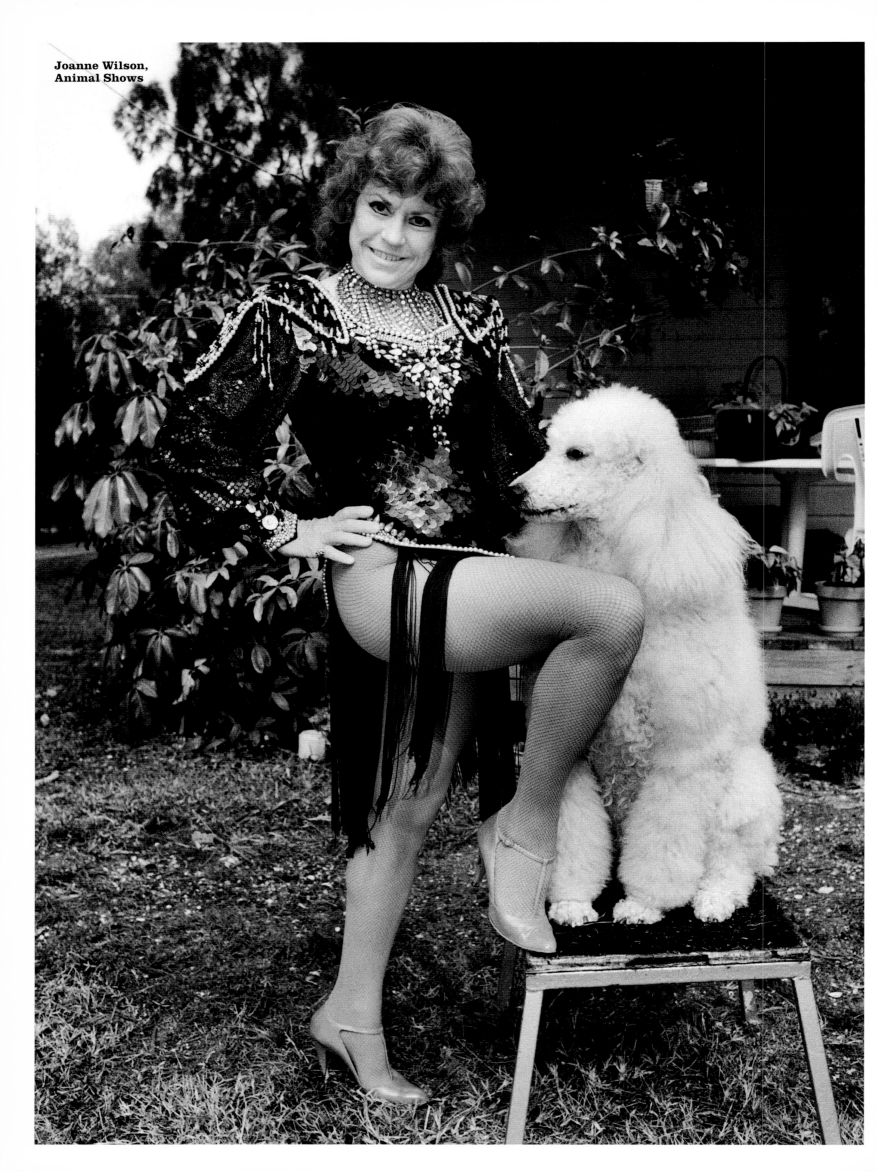

Joanne Wilson,
Animal Shows

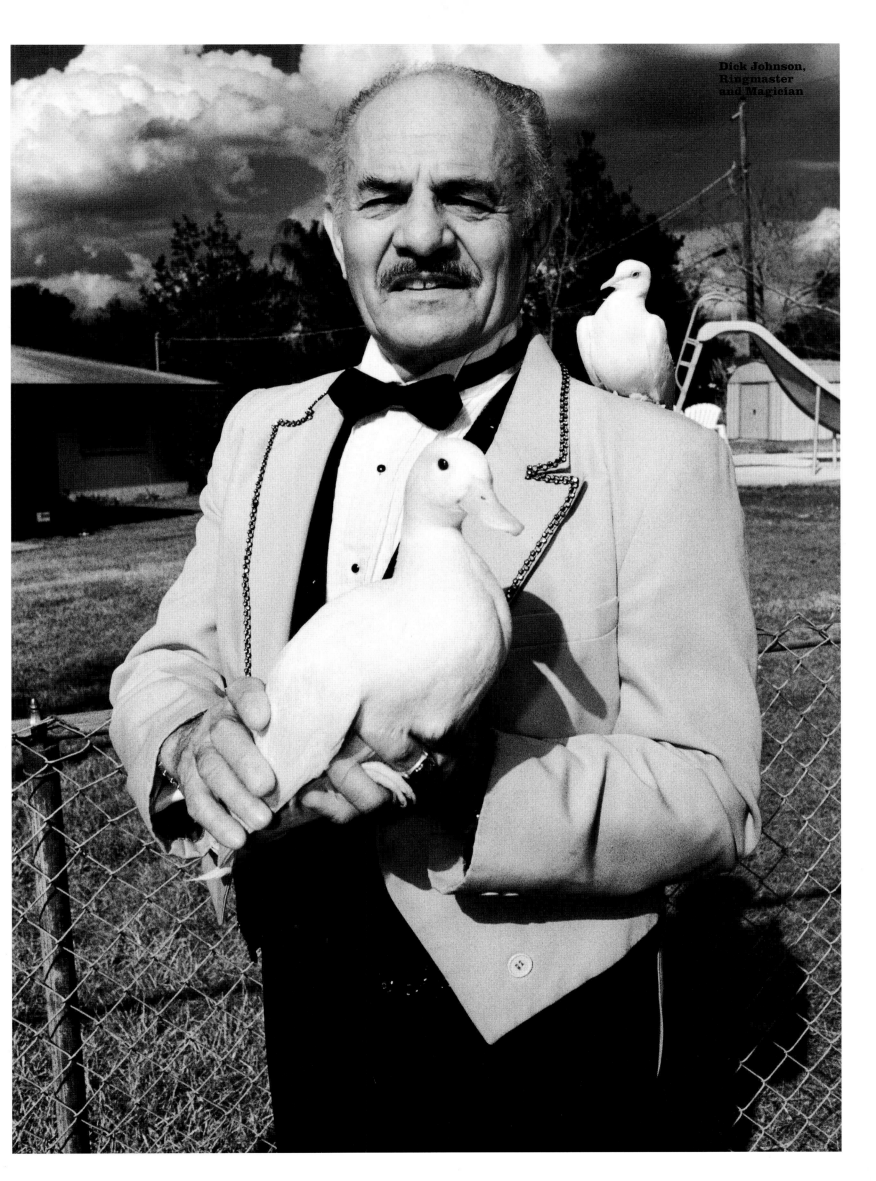

**Lance Gifford,
Snake Charmer
and Magician**

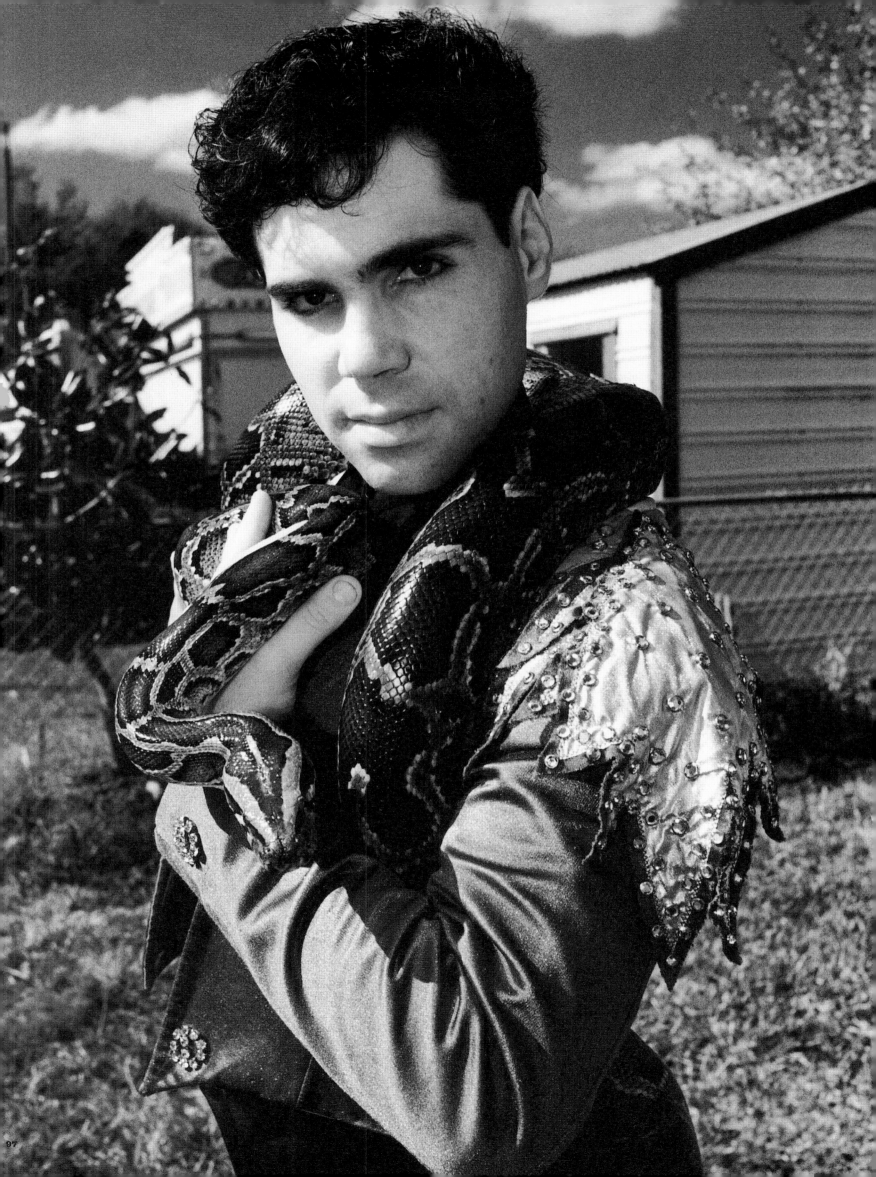

"We are a society apart
from the places we
visited. We didn't know
anybody there. So we
came as strangers and
we left as strangers.
And because of that
we stick together."

**Melvin Burkhardt,
Human Blockhead
and Anatomical Wonder**

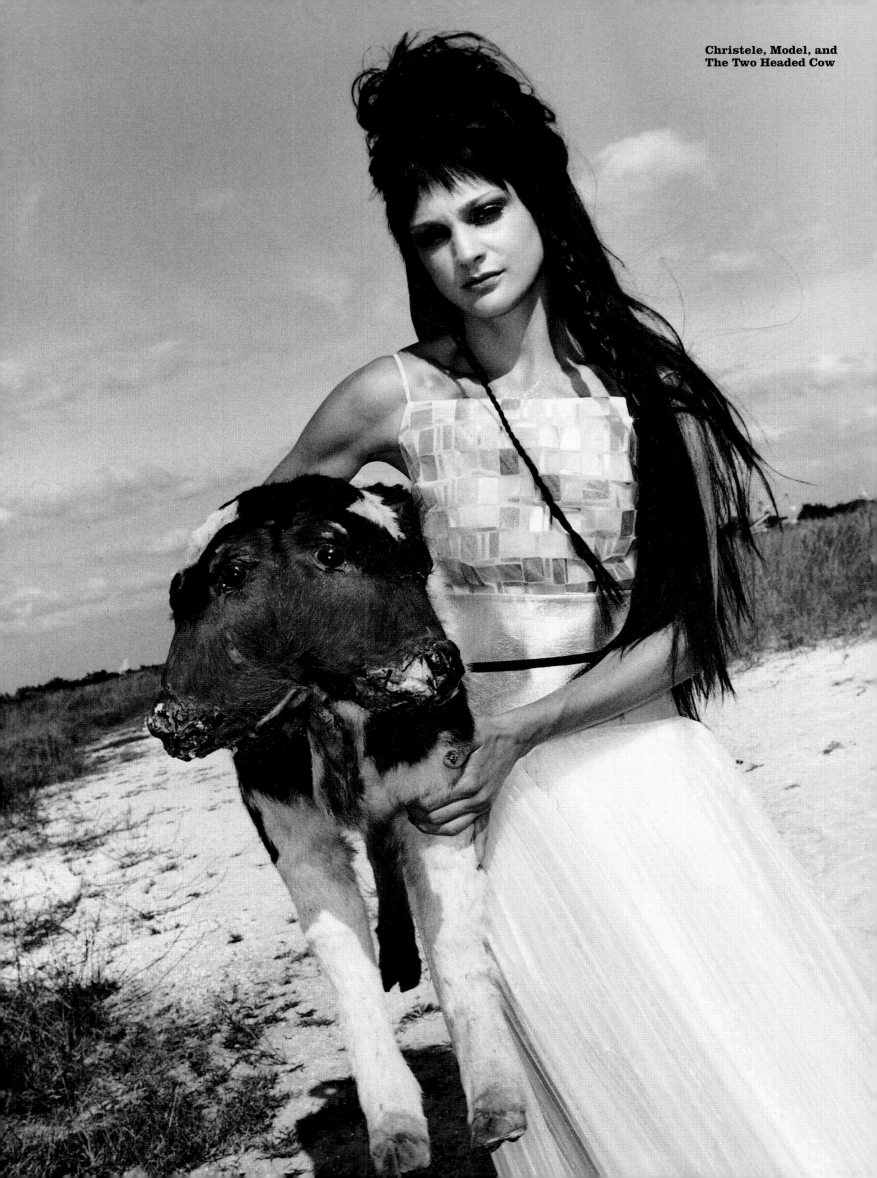

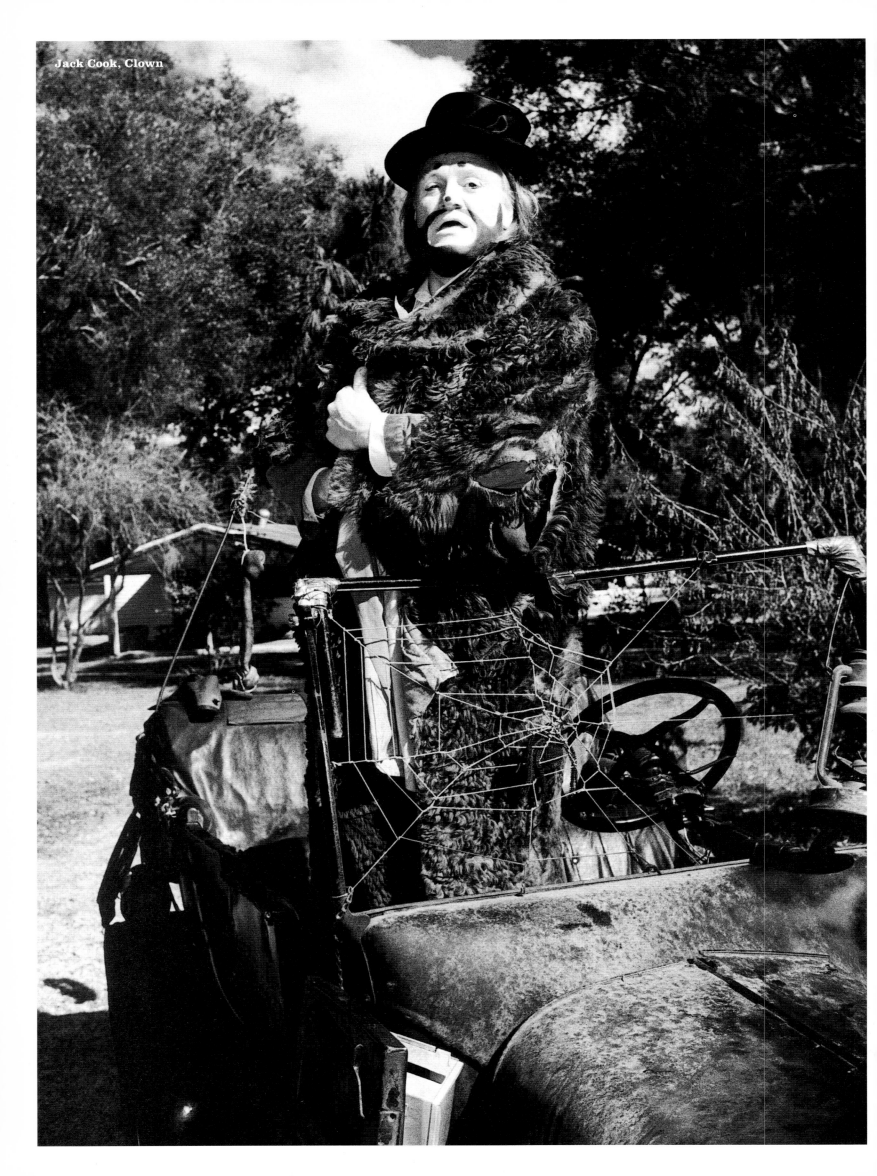

Jack Cook, Clown

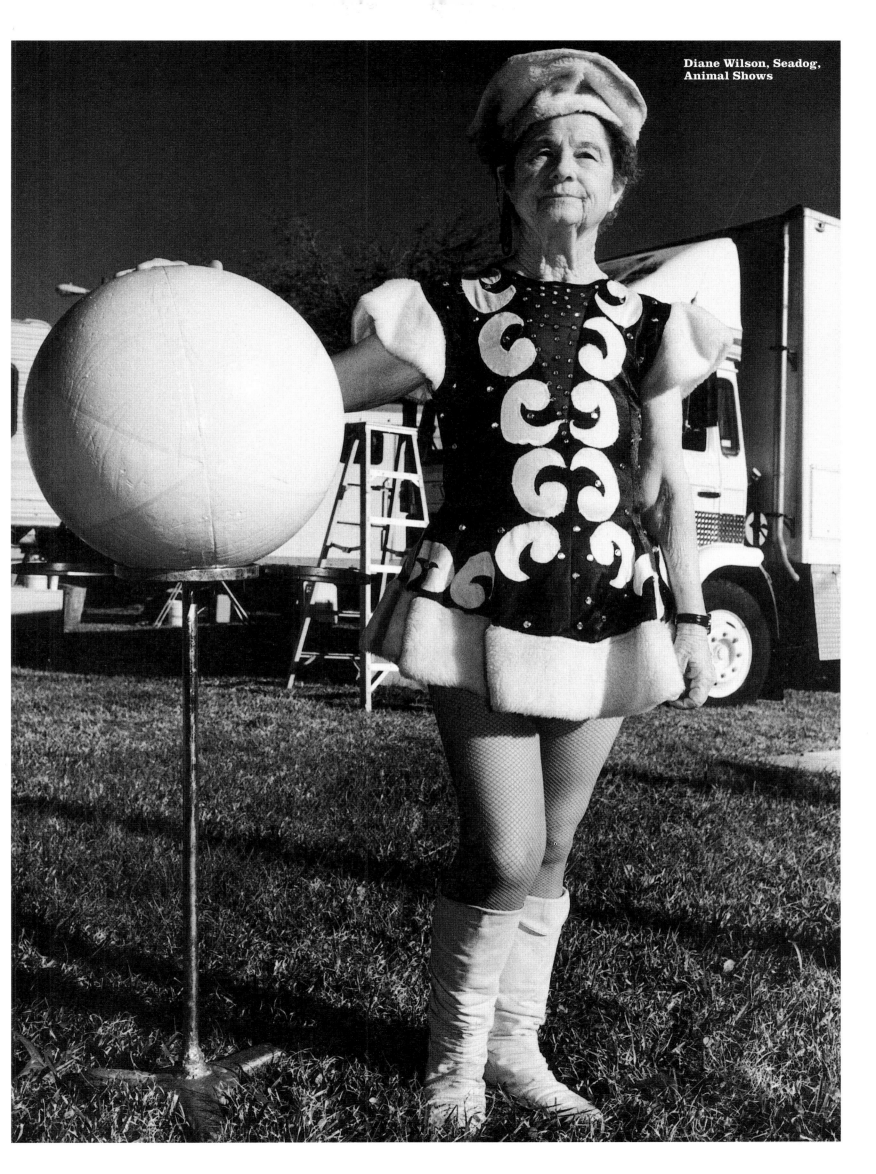

Diane Wilson, Seadog,
Animal Shows

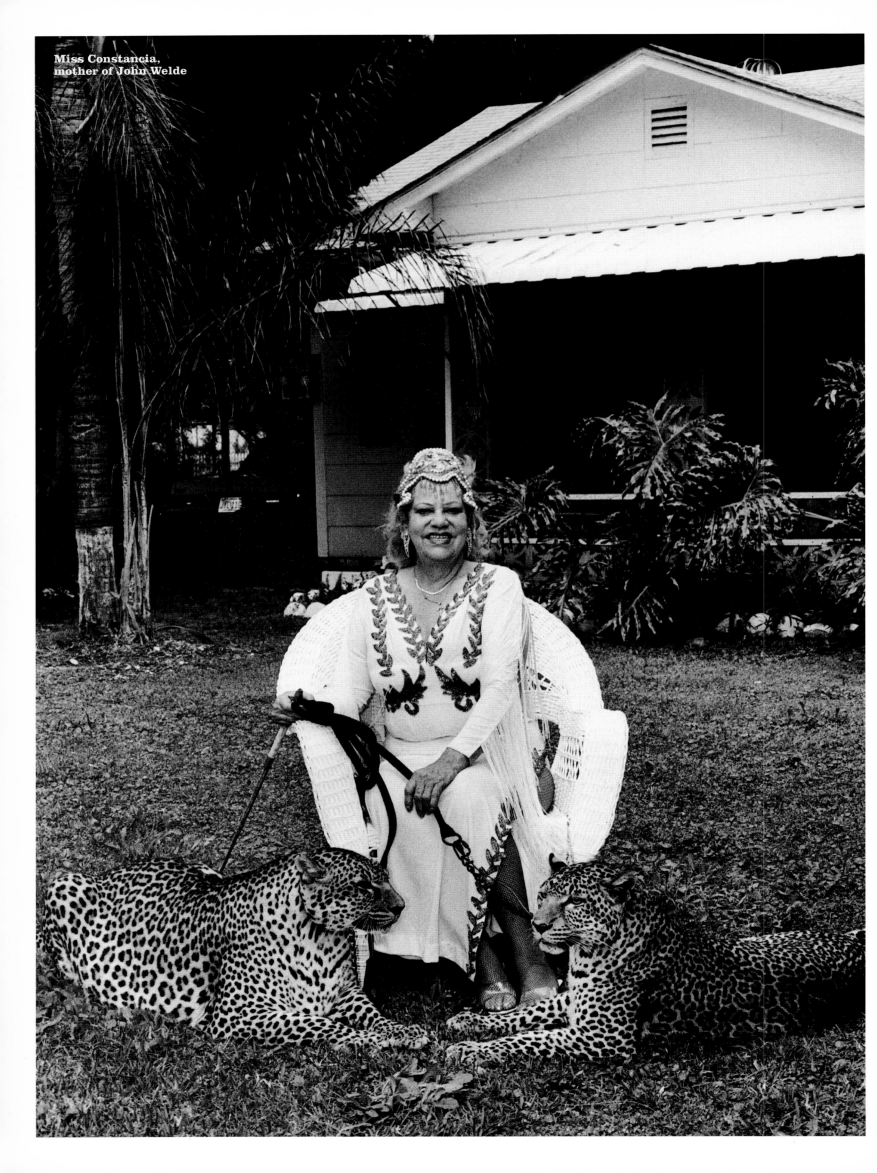

Miss Constancia,
mother of John Welde

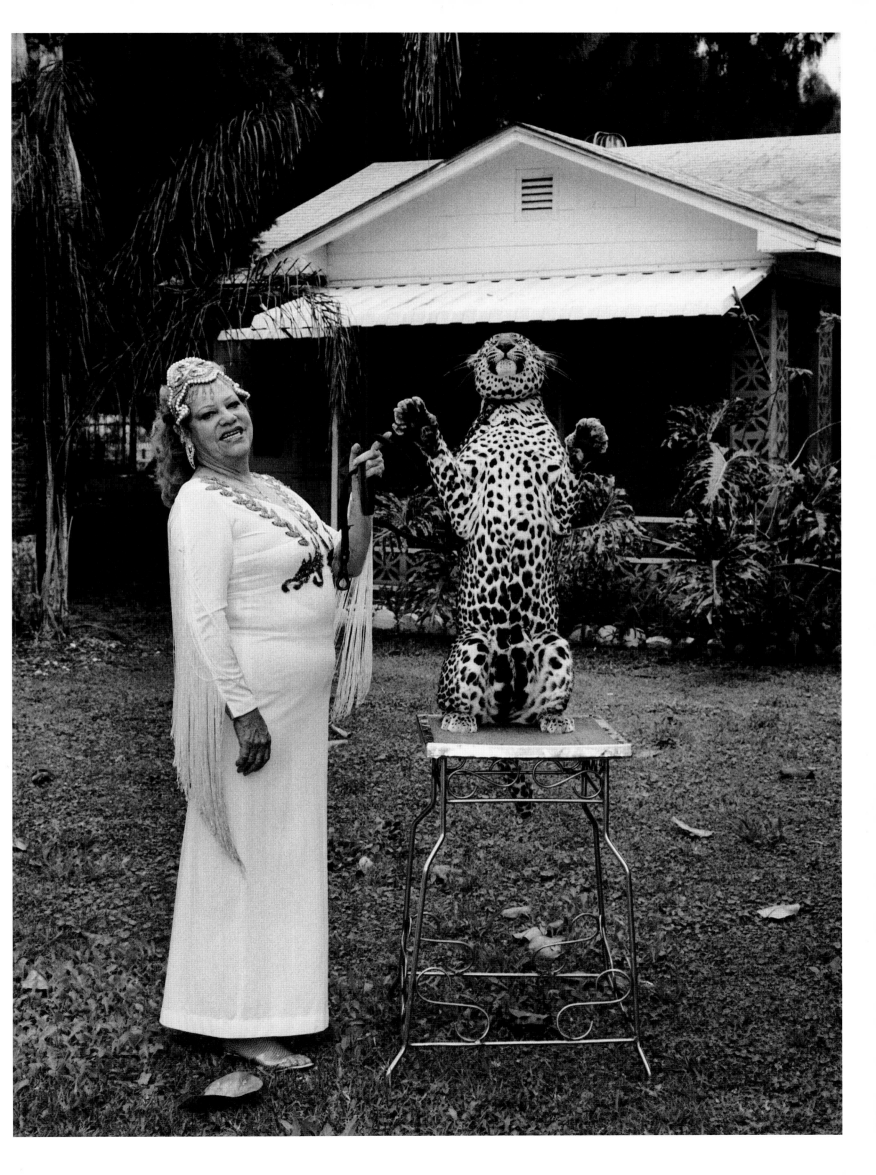

"We can pretty much do what we want here. If I want, I can put a chorus line of elephants dancing in my yard."

Billy Rodgers, Bird Shows

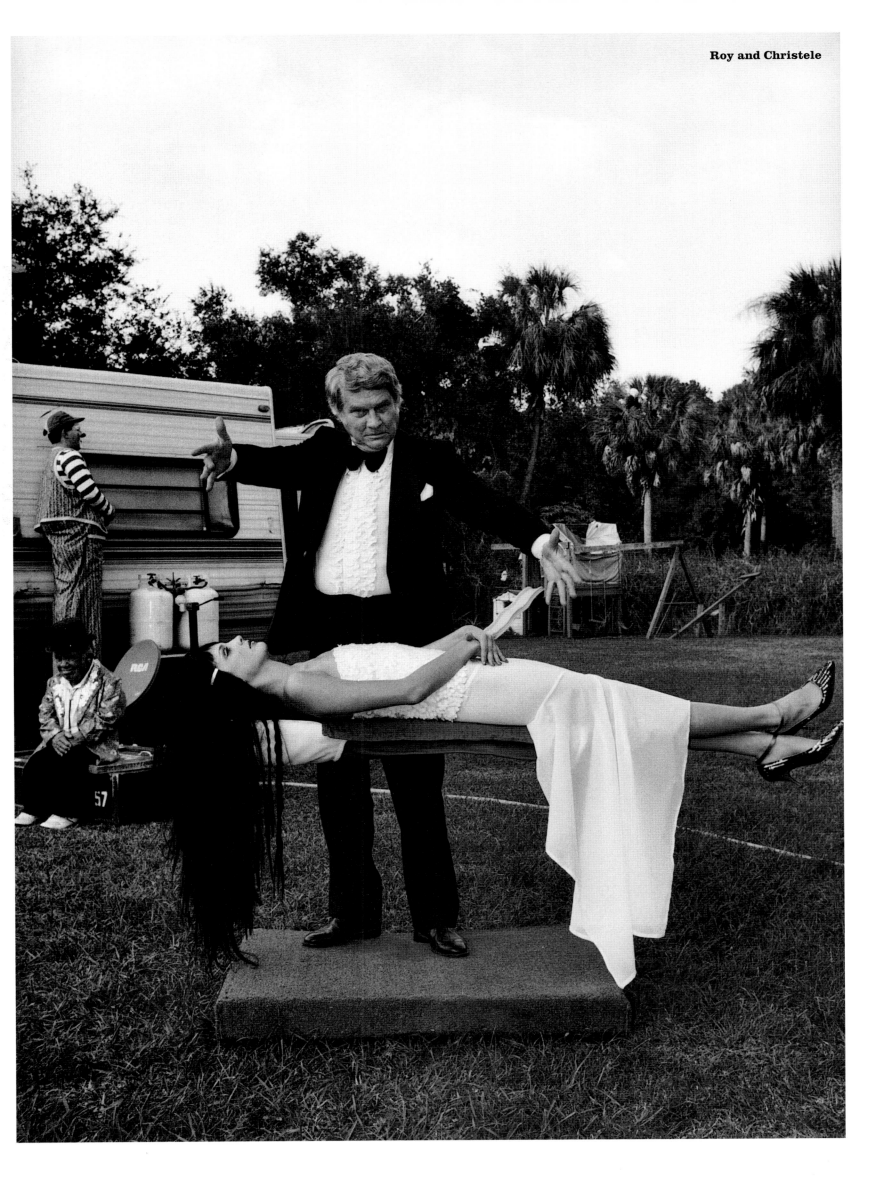

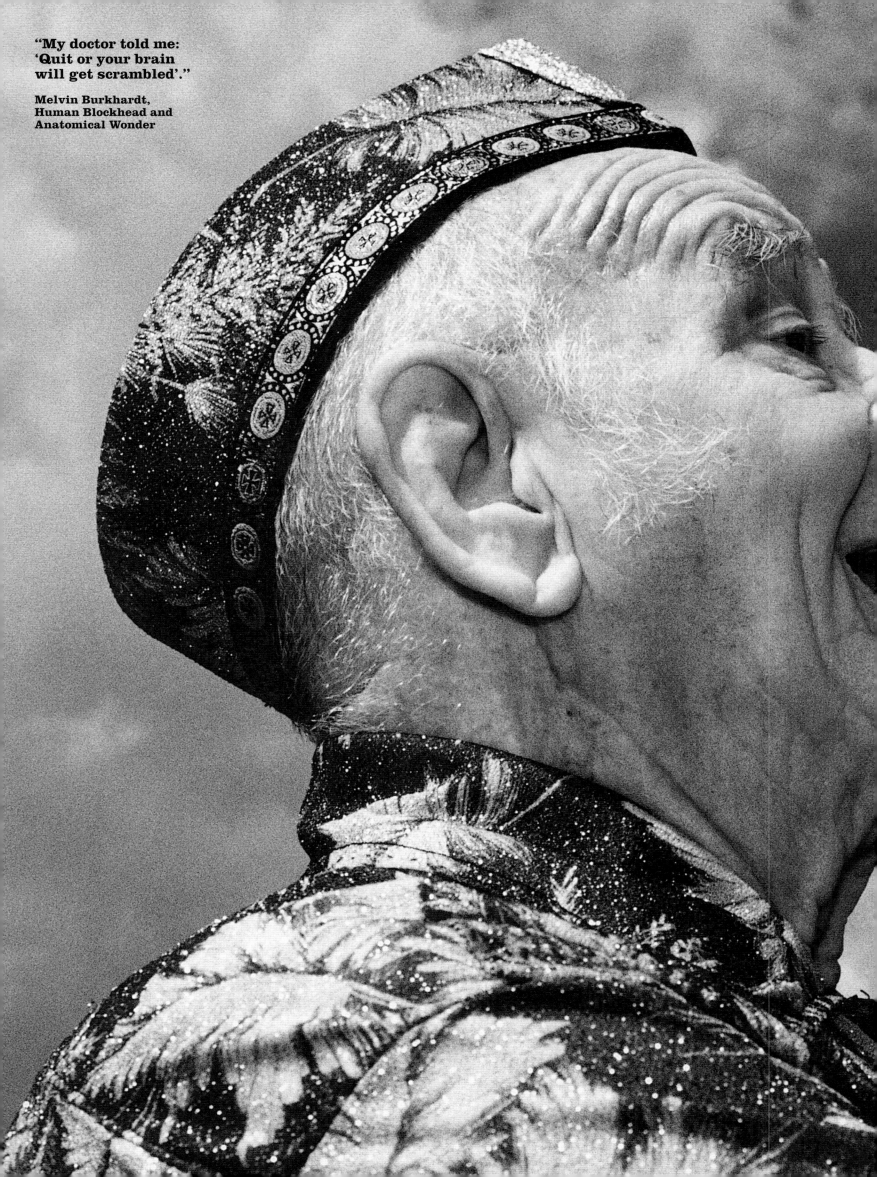

"My doctor told me: 'Quit or your brain will get scrambled'."

Melvin Burkhardt,
Human Blockhead and
Anatomical Wonder

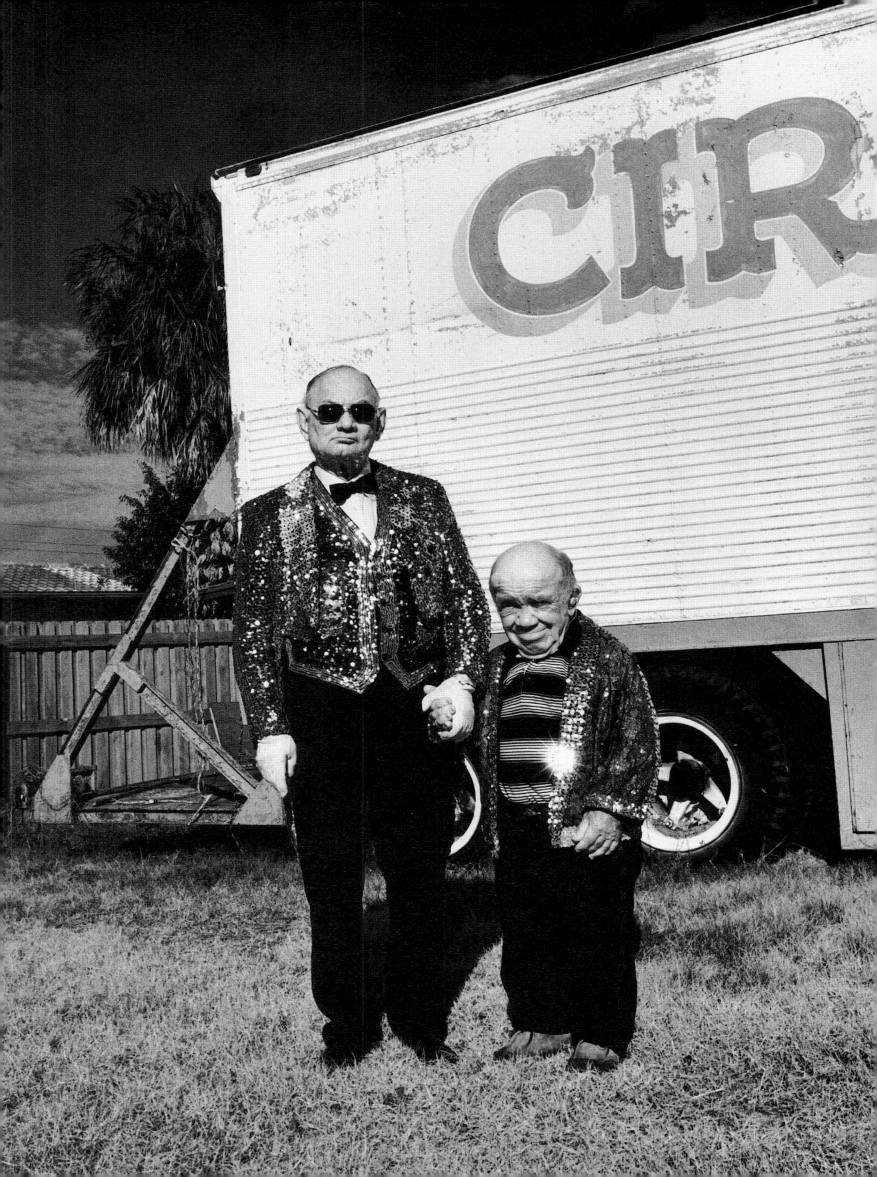

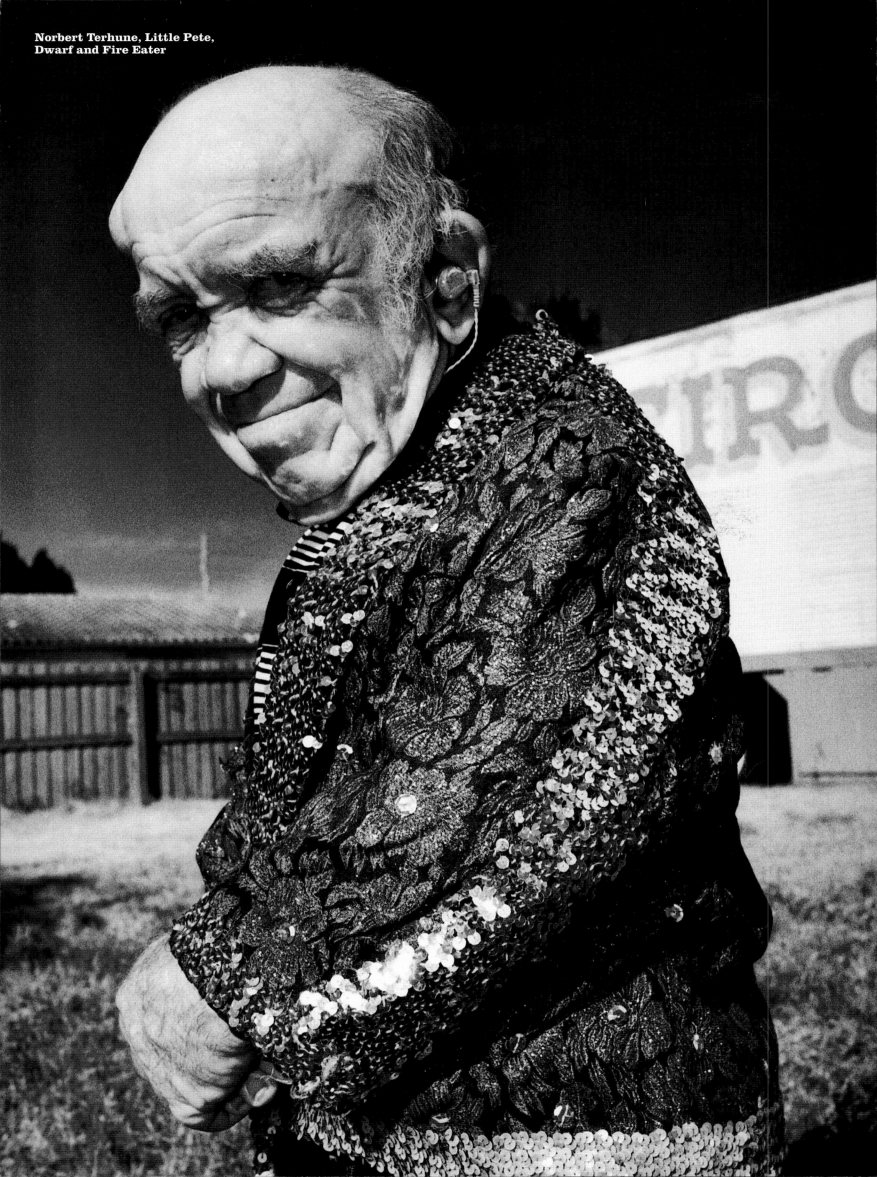

"I like women. Billie Burke, a hermaphrodite, gave me a picture of herself and signed: 'To Melvin with very best wishes, a friend and not another blonde in your life'."

Melvin Burkhardt

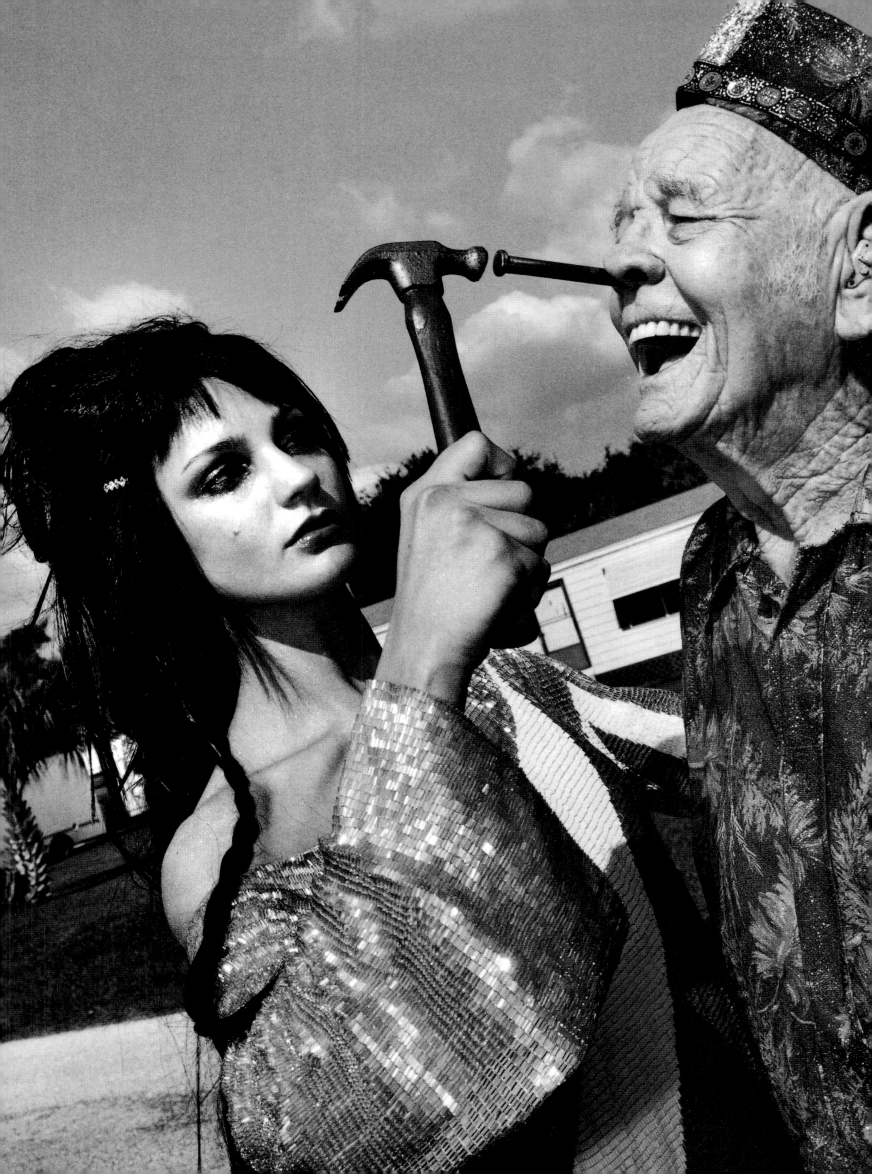

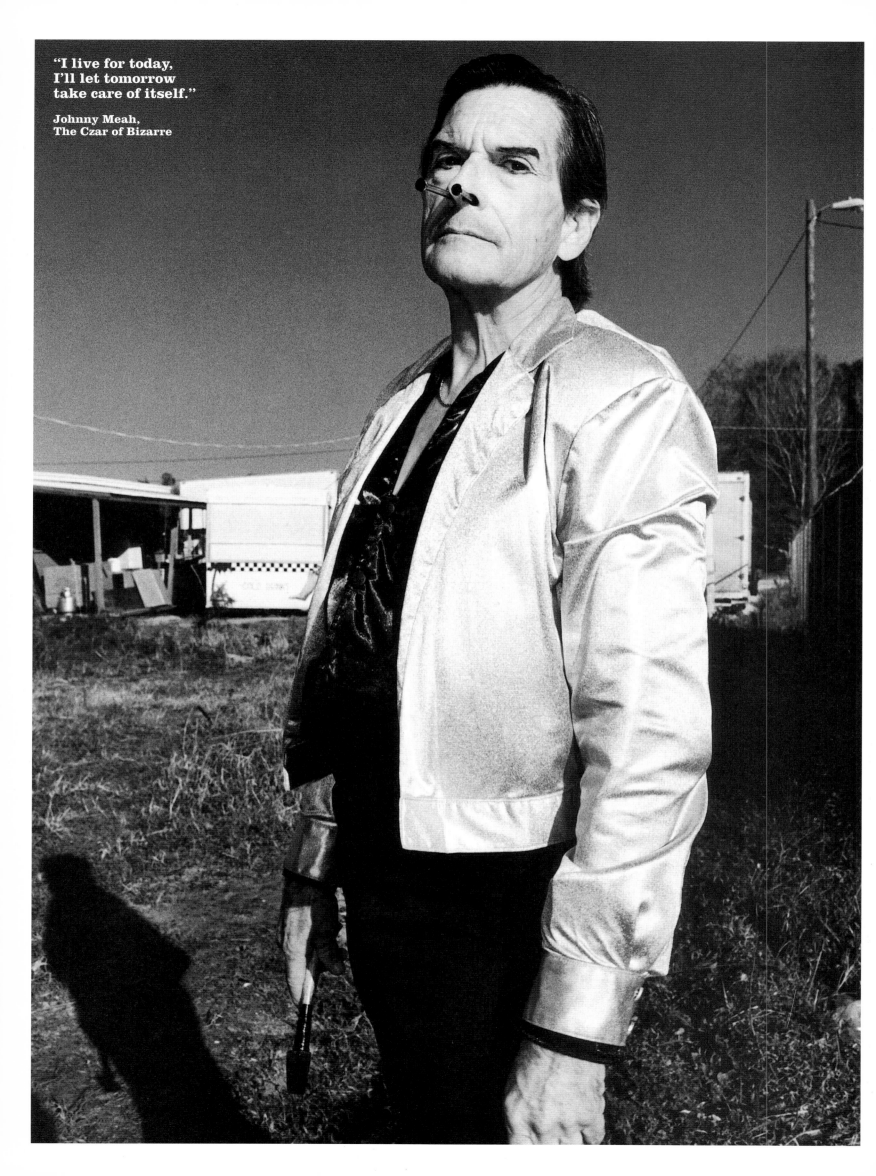

"I live for today,
I'll let tomorrow
take care of itself."

Johnny Meah,
The Czar of Bizarre

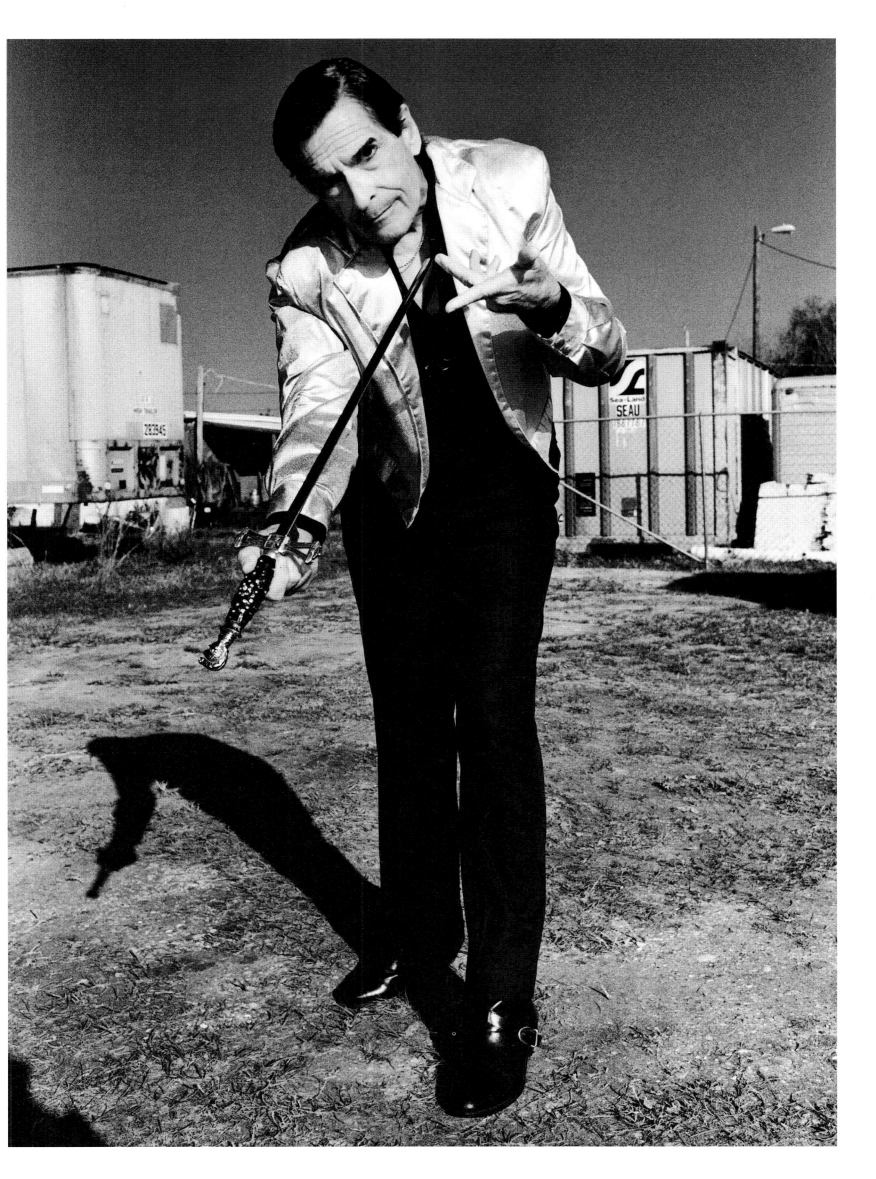

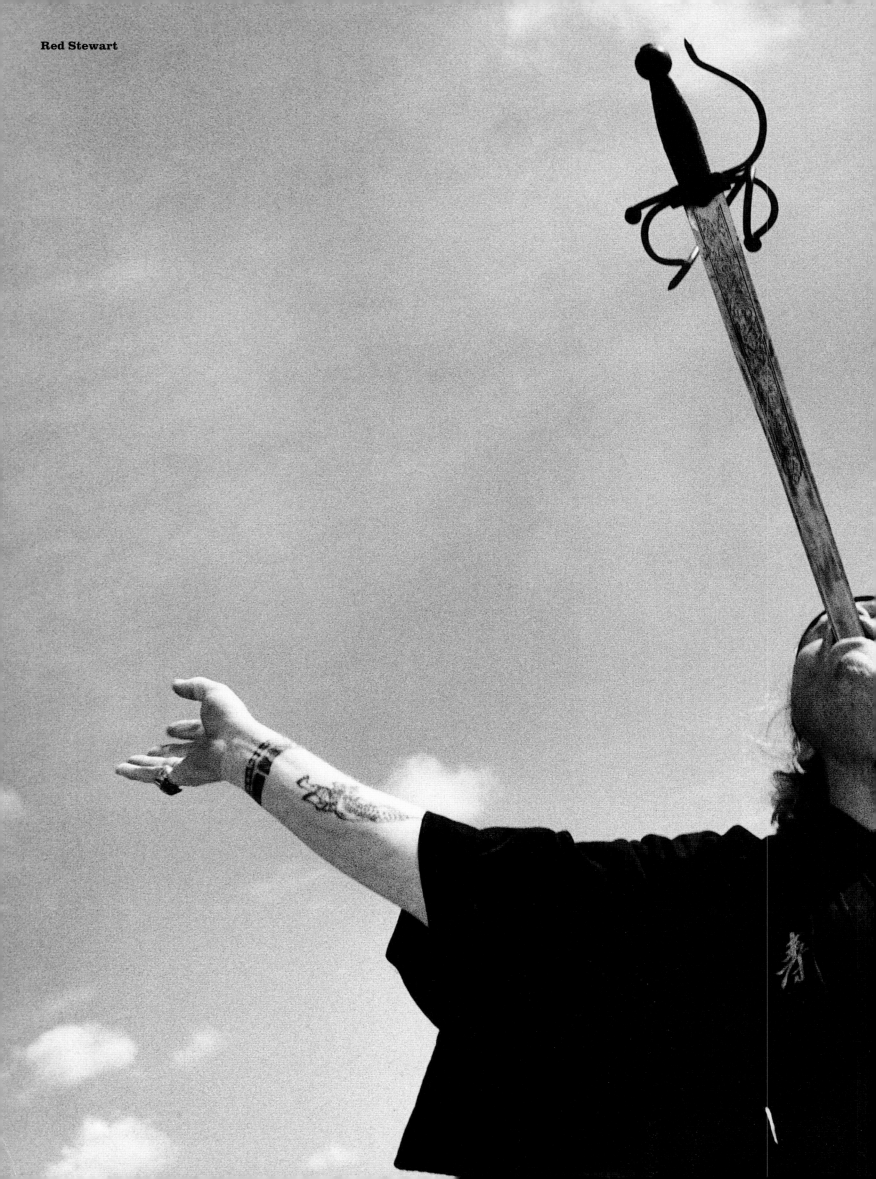

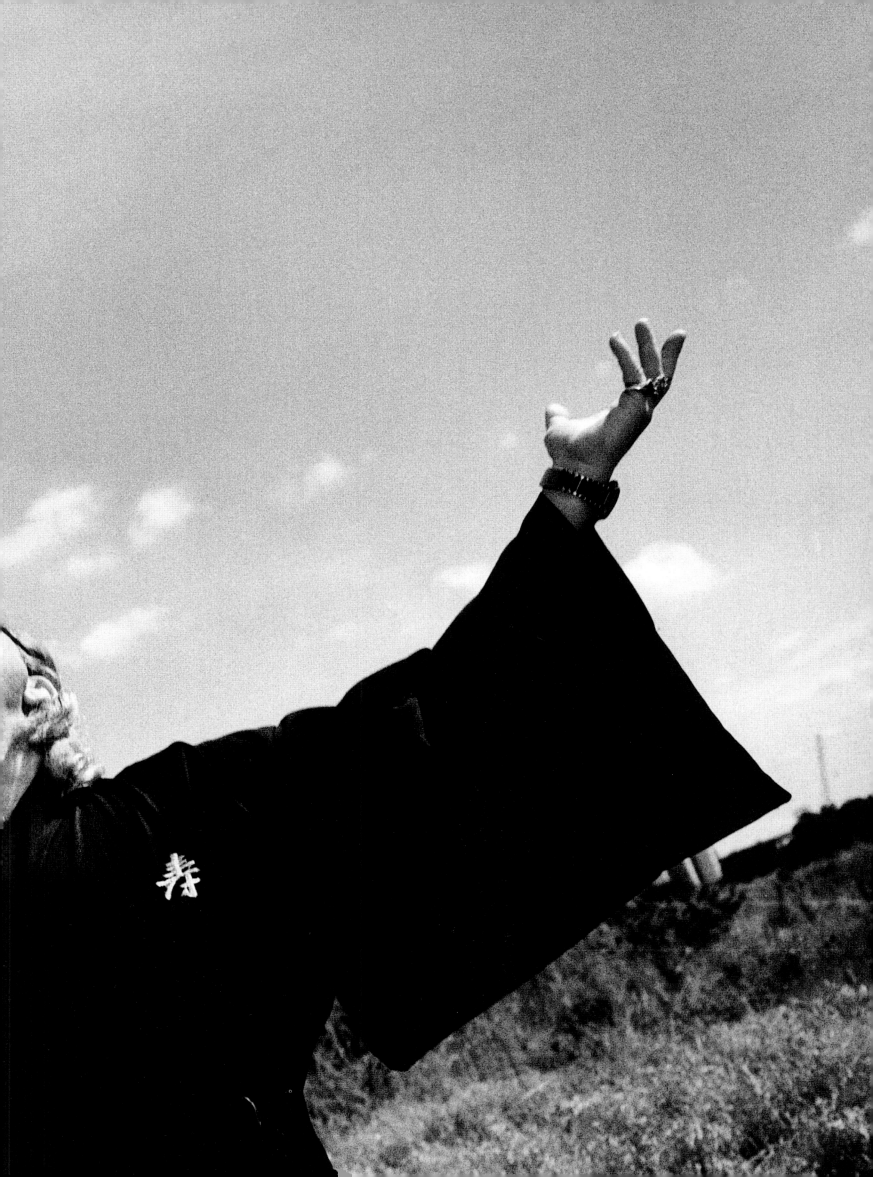

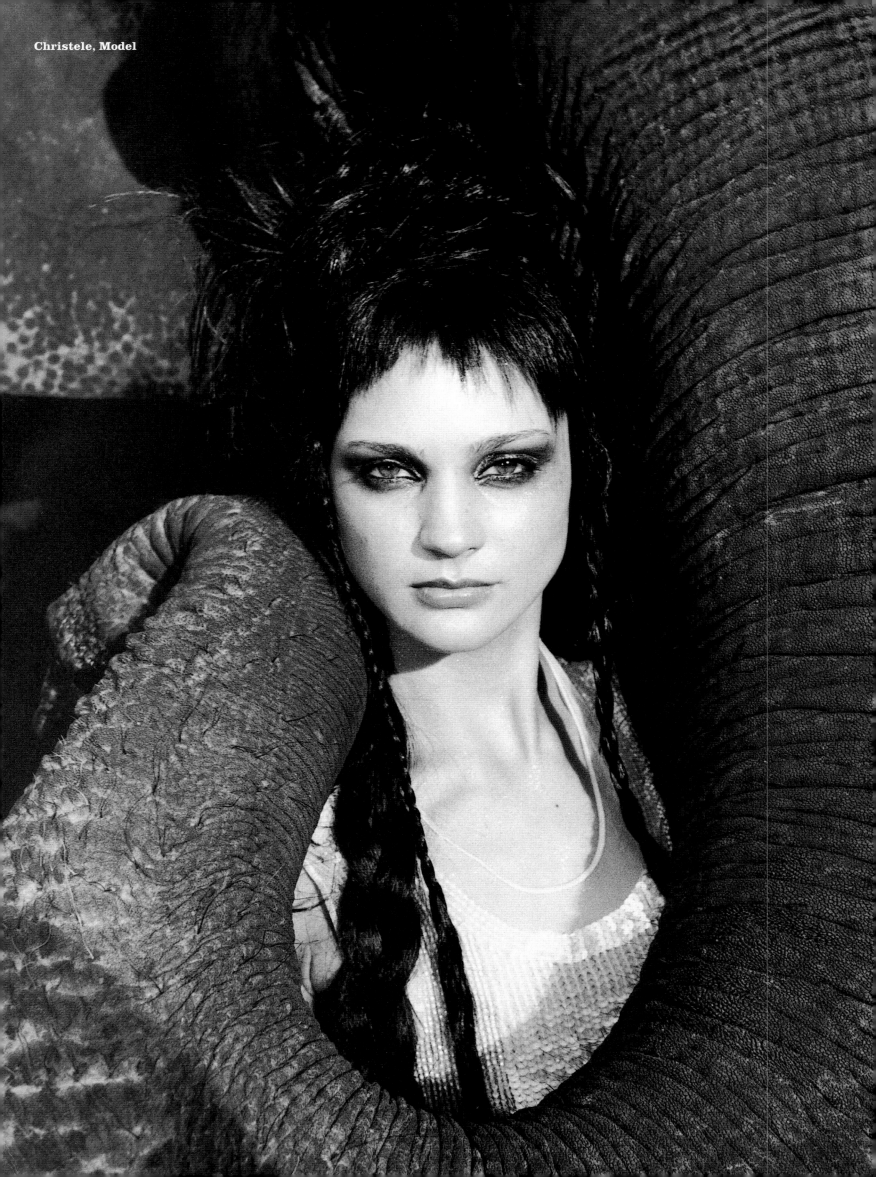

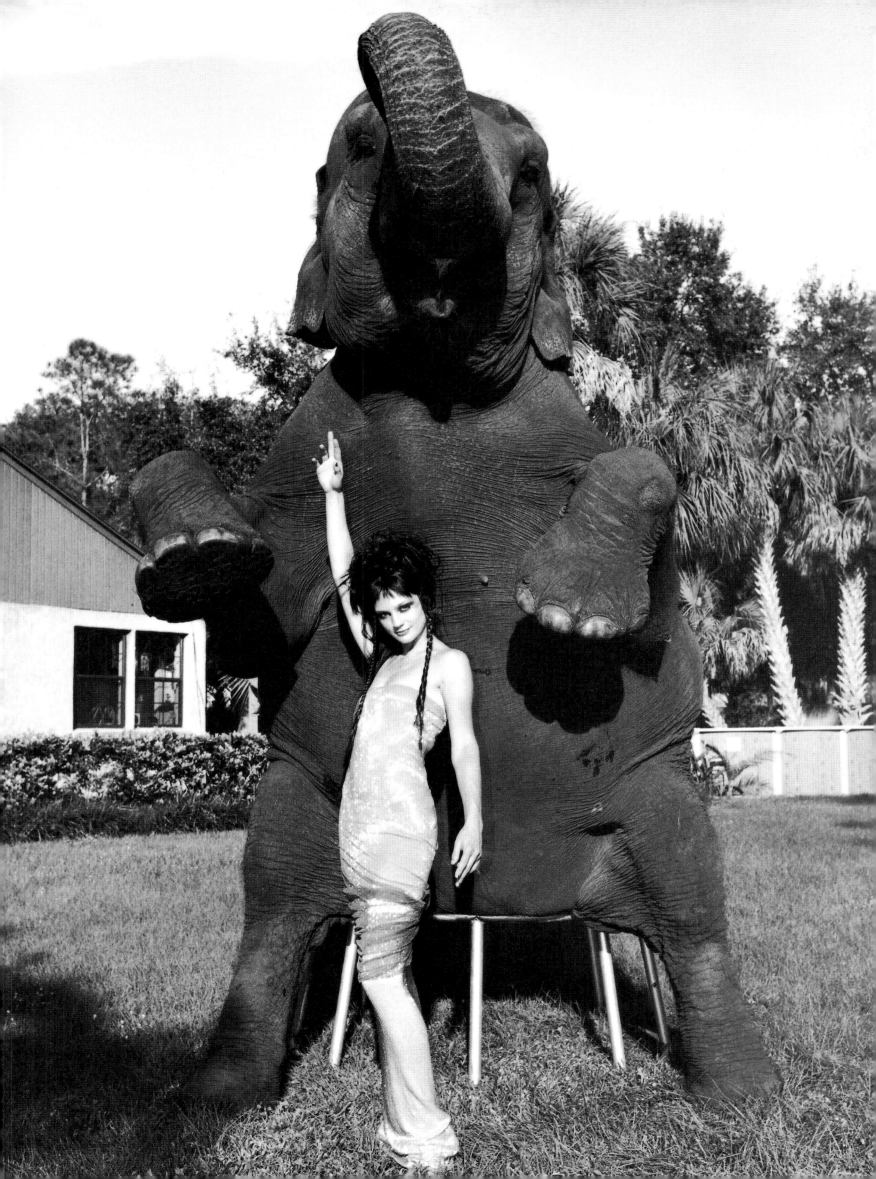

Scott Tailor,
The Great Nagana,
Snake Charmer

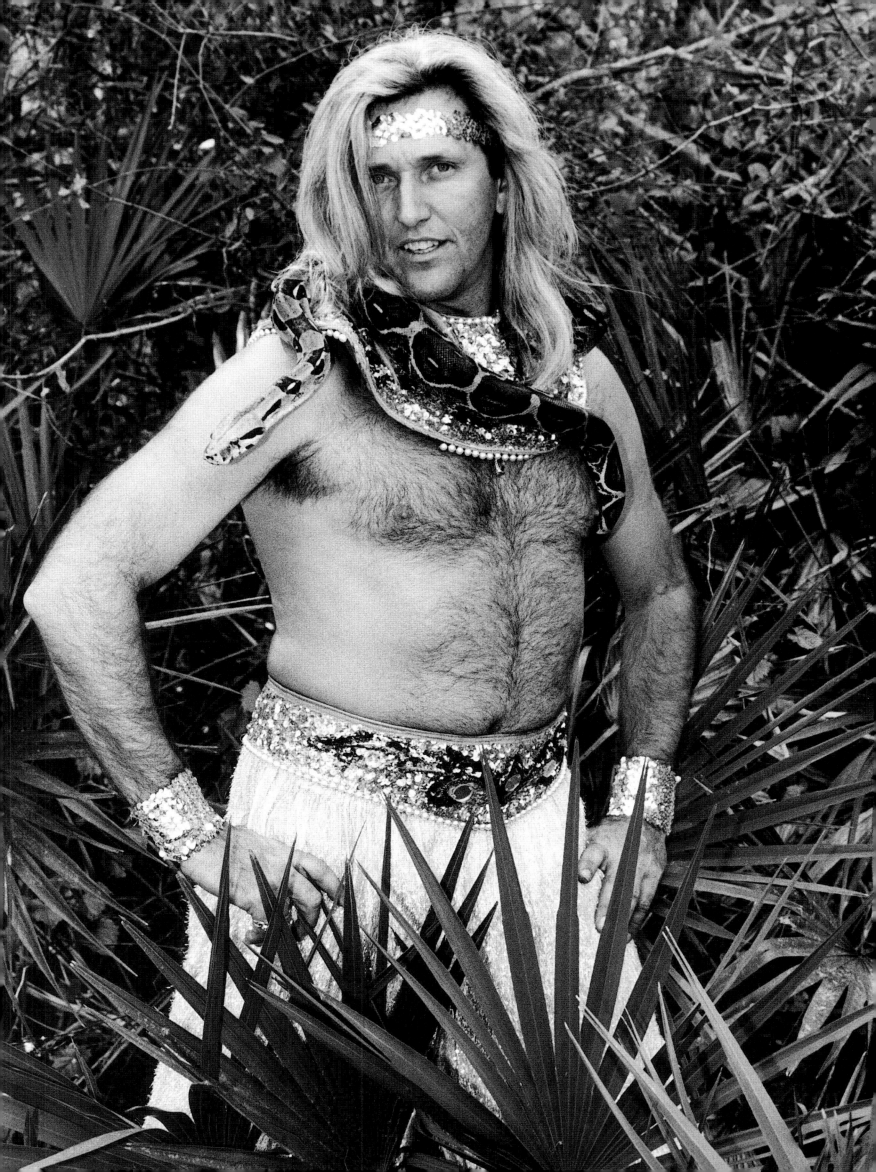

"You can call it Gib'town
or Carney town, or just
Showtown USA. There are
a lot of fish farms here,
but it's the people who
make it interesting."

Red Stewart

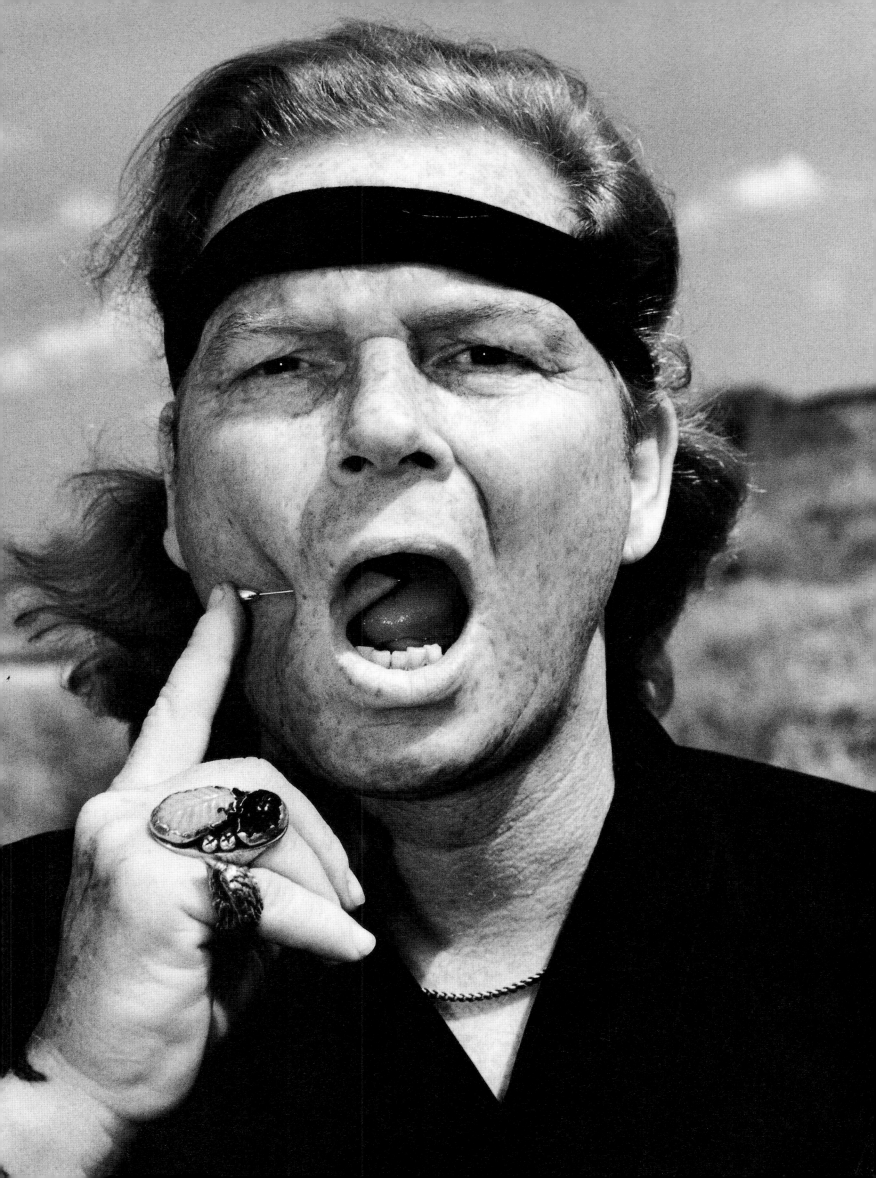

"When you're working in a Freak Show you are working with freak mentality. Many of them have been warped because of the way they've been treated throughout their lives."

**Melvin Burkhardt,
Human Blockhead and
Anatomical Wonder**

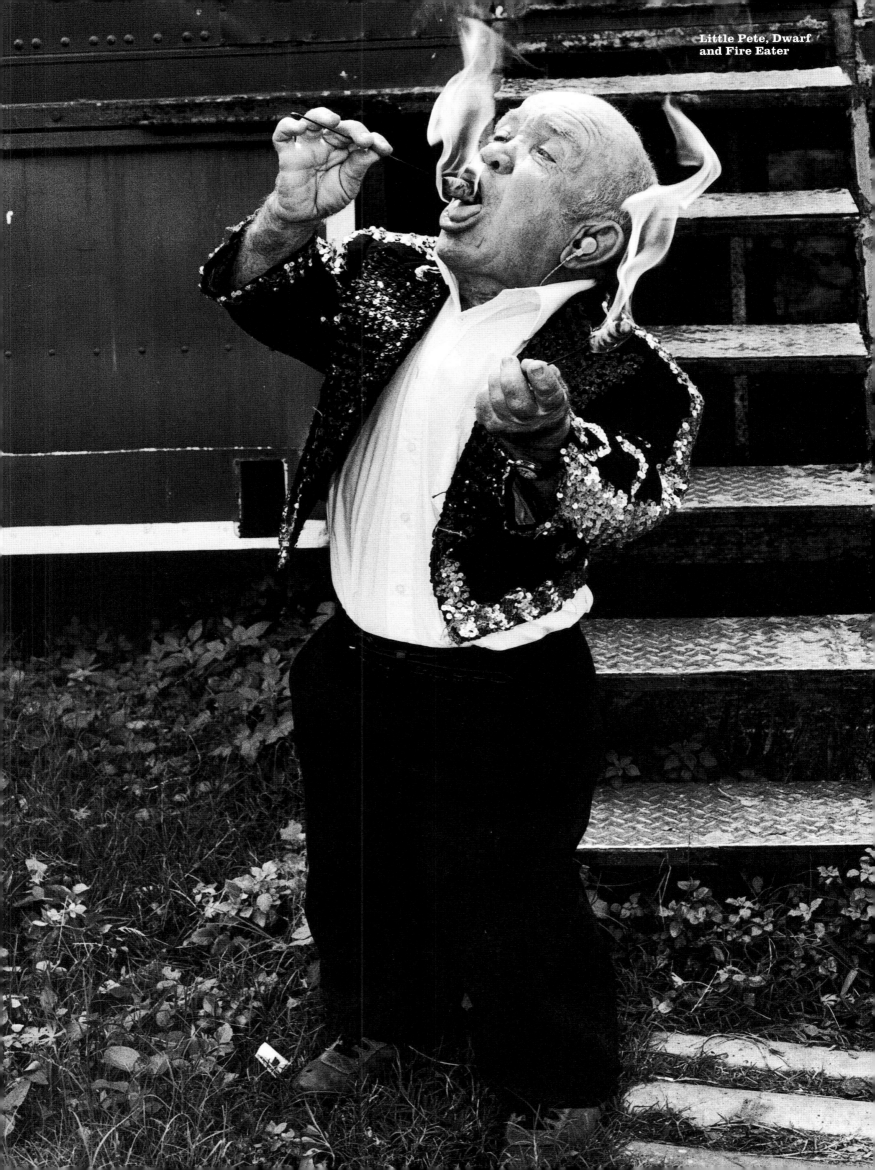

Little Pete, Dwarf and Fire Eater

"Cover one side of my face and I'm happy; cover the other side and I'm angry."

Melvin Burkhardt

"Cover one side of my face and I'm happy; cover the other side and I'm angry."

Melvin Burkhardt

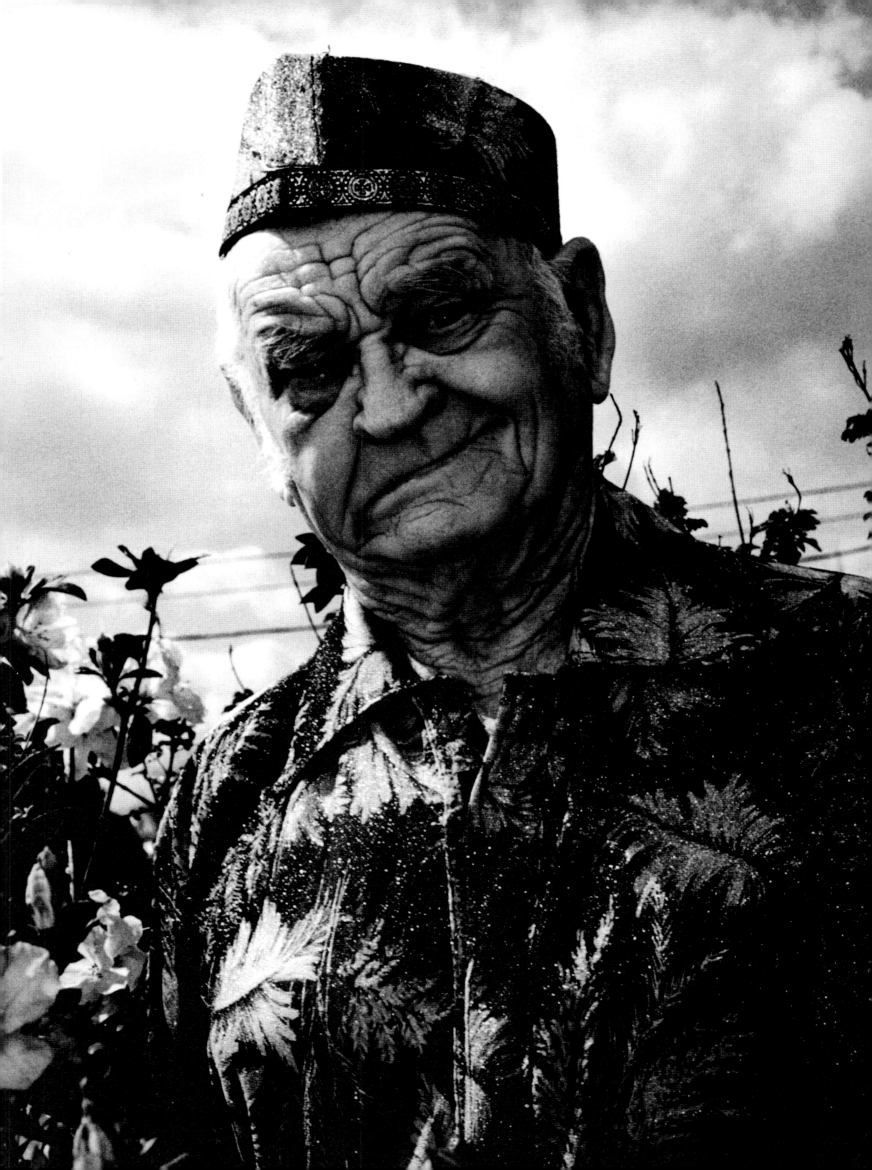

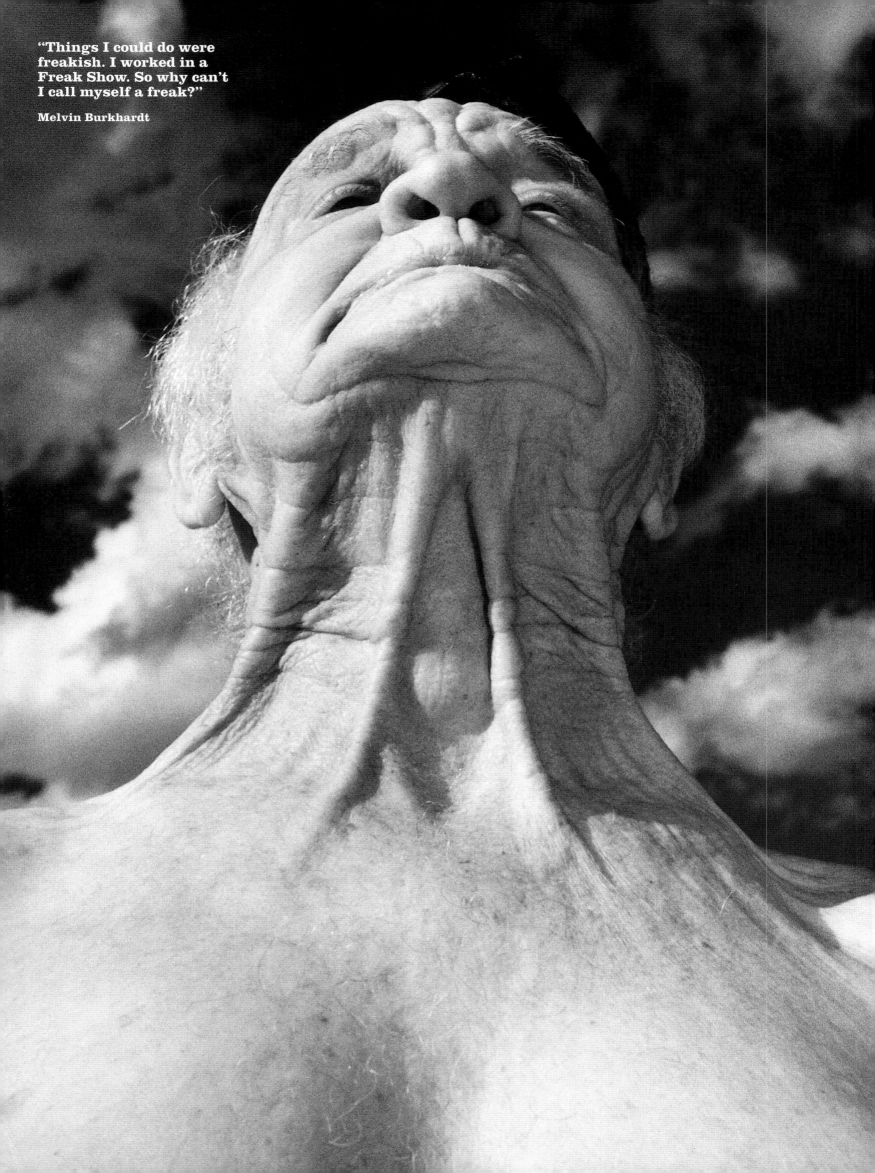

"Things I could do were freakish. I worked in a Freak Show. So why can't I call myself a freak?"

Melvin Burkhardt

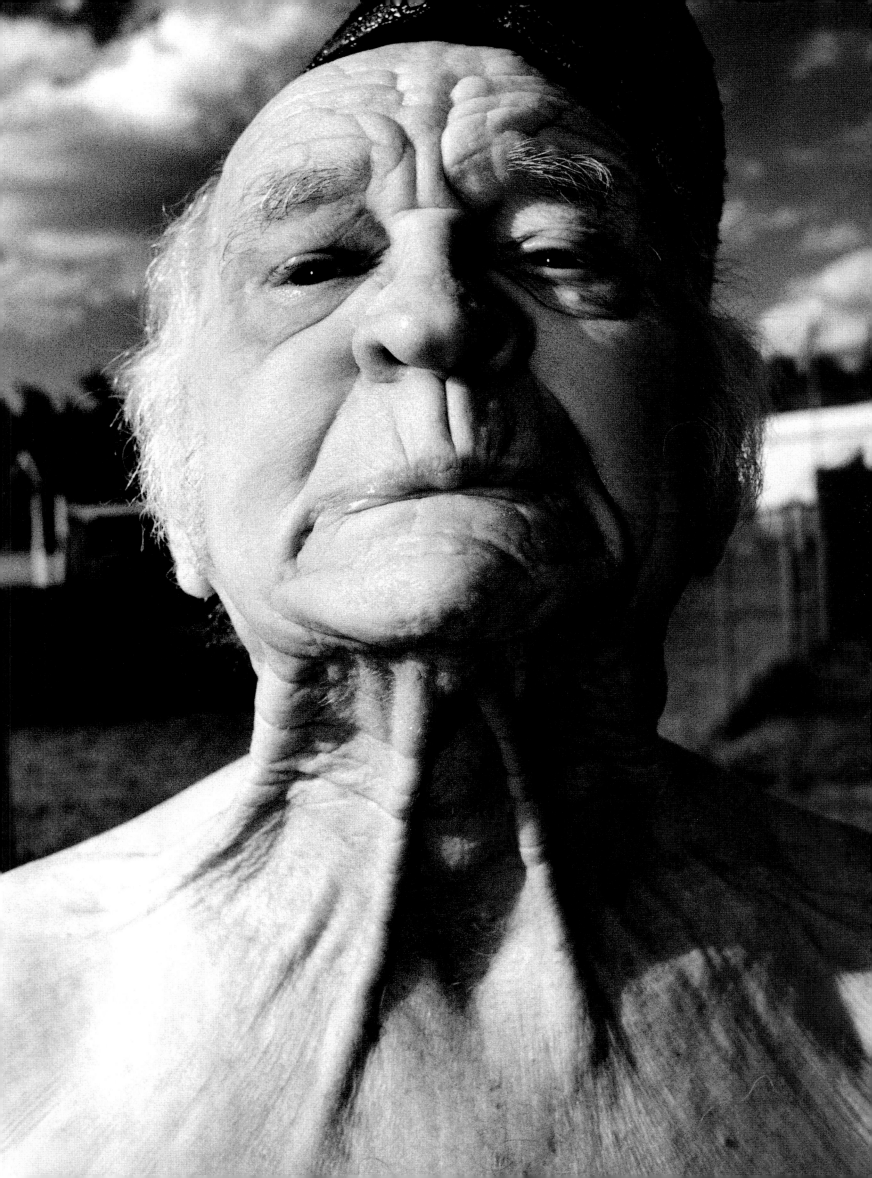

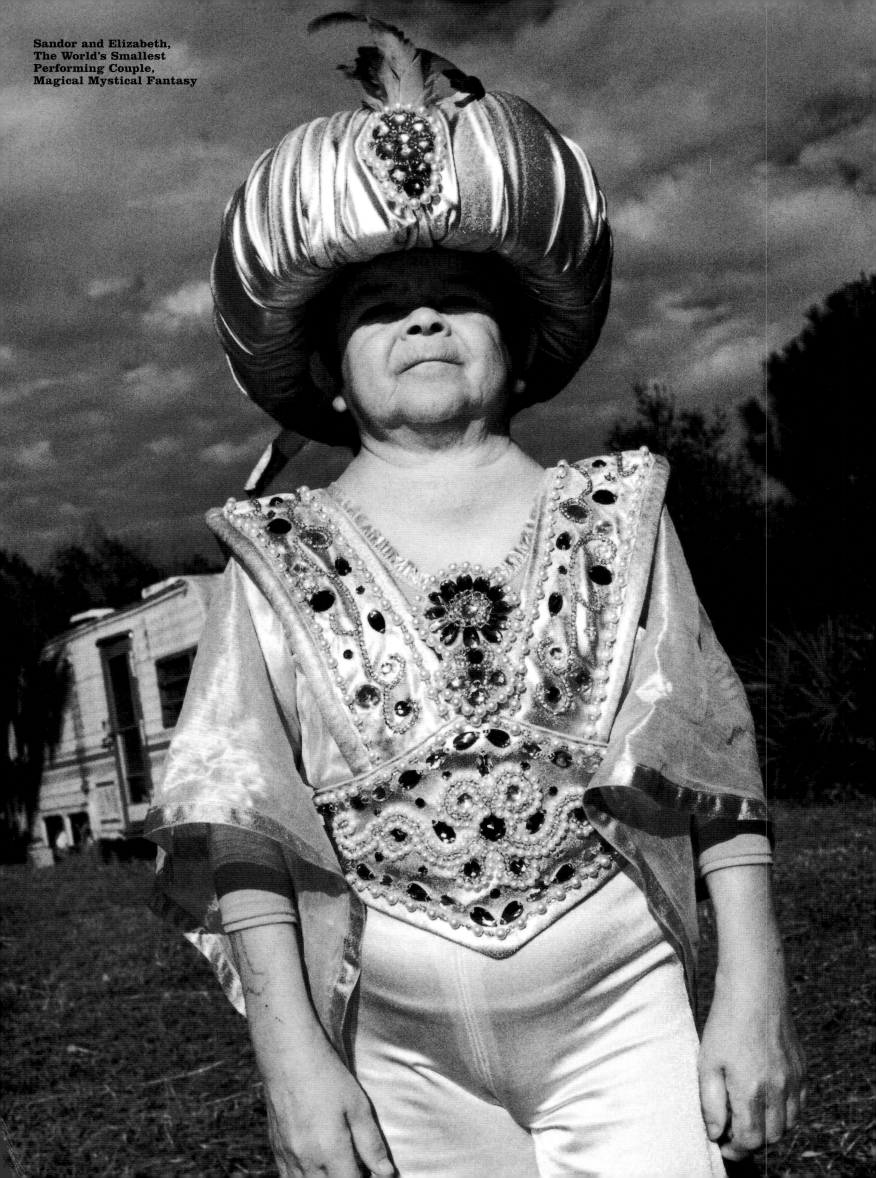

Sandor and Elizabeth,
The World's Smallest
Performing Couple,
Magical Mystical Fantasy

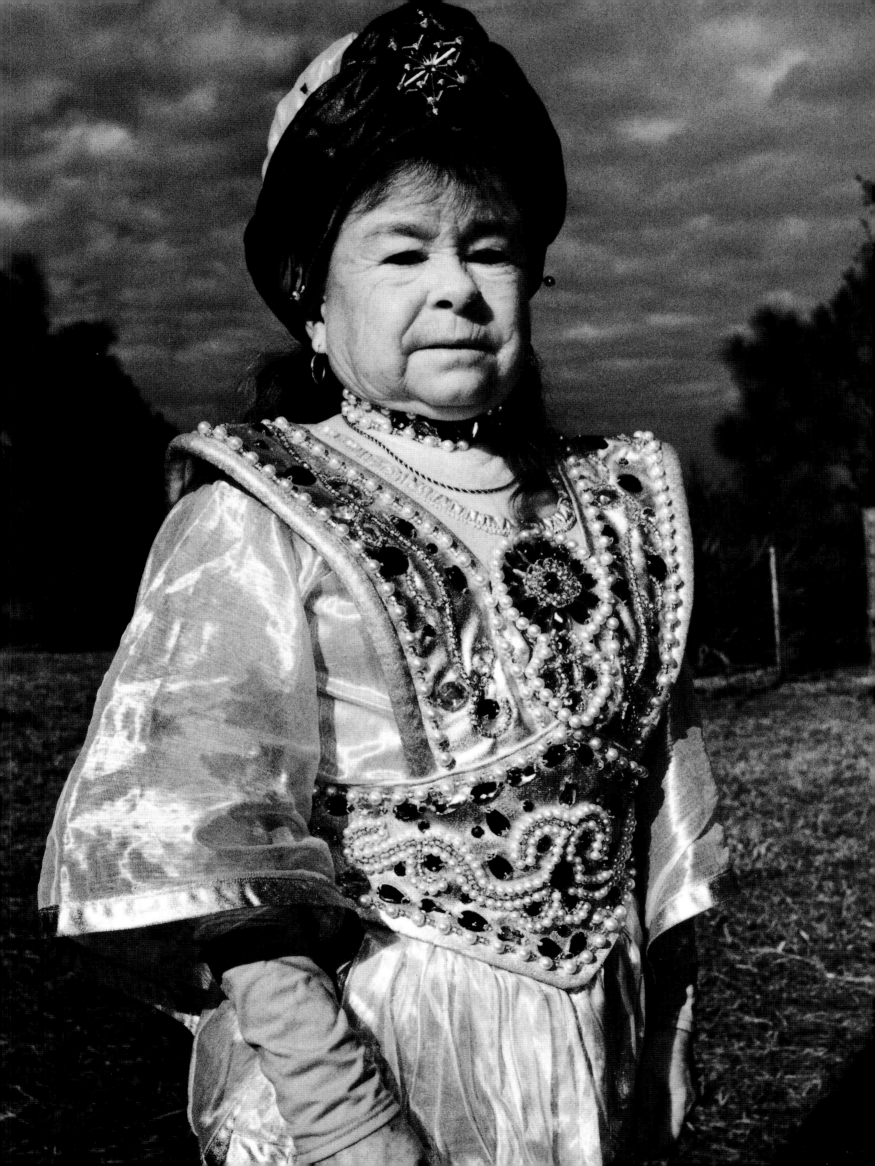

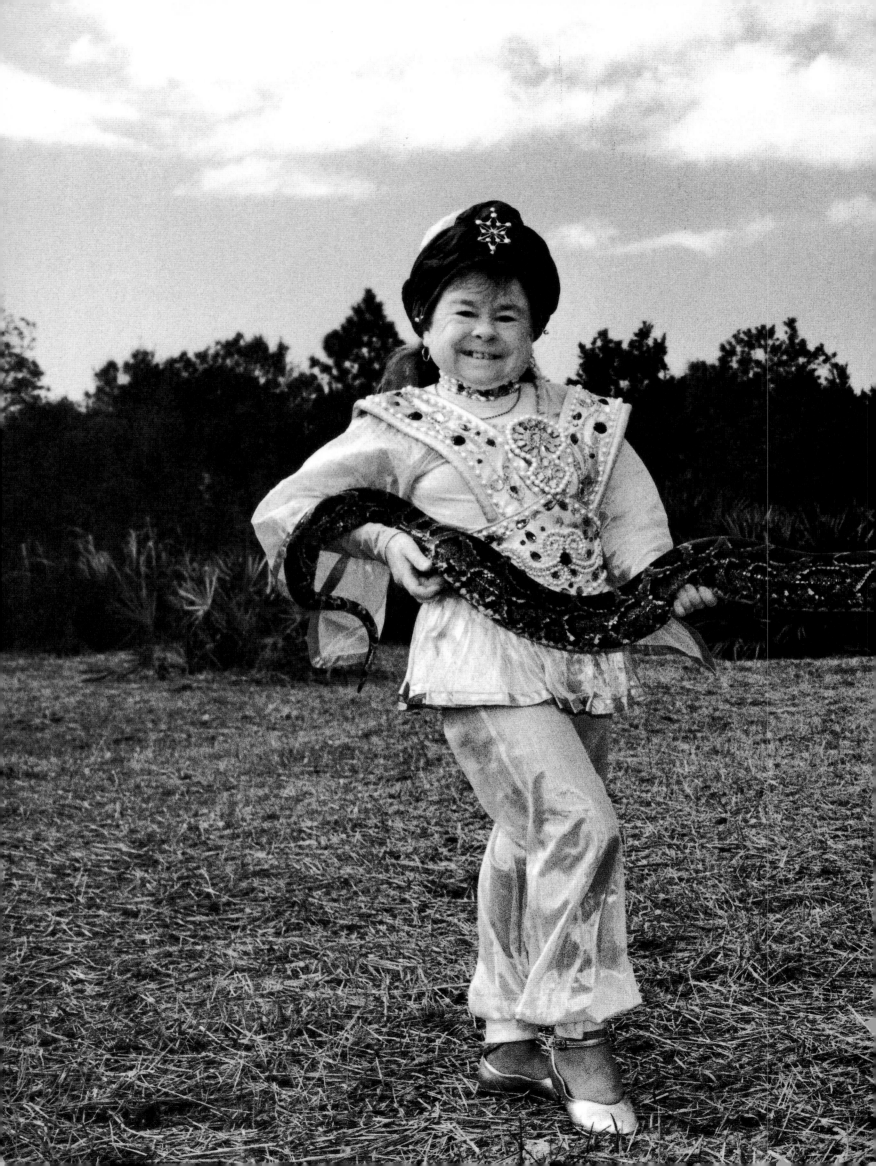

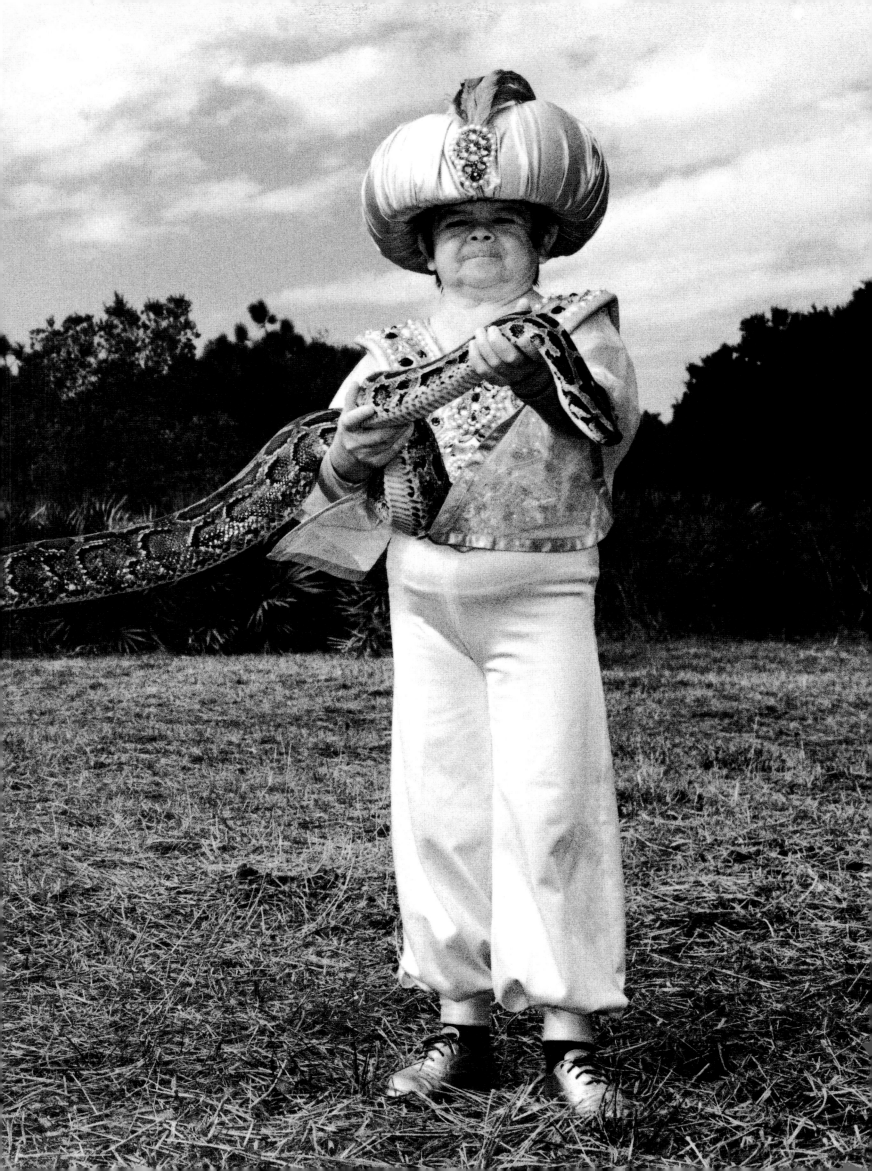

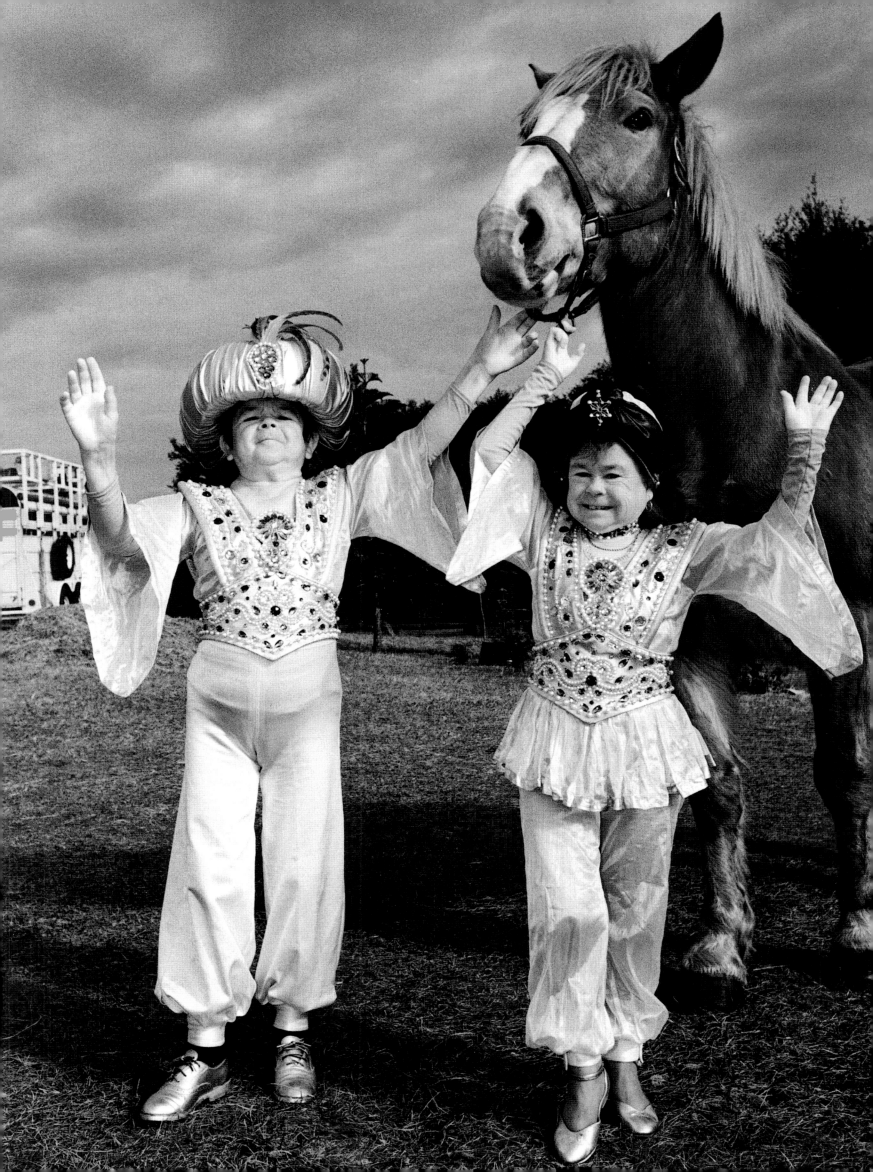

"There were times that I hated it, times that I absolutely loved it but most of the time I tolerated it."

Ward Hall, Sideshow Promoter and Production Manager

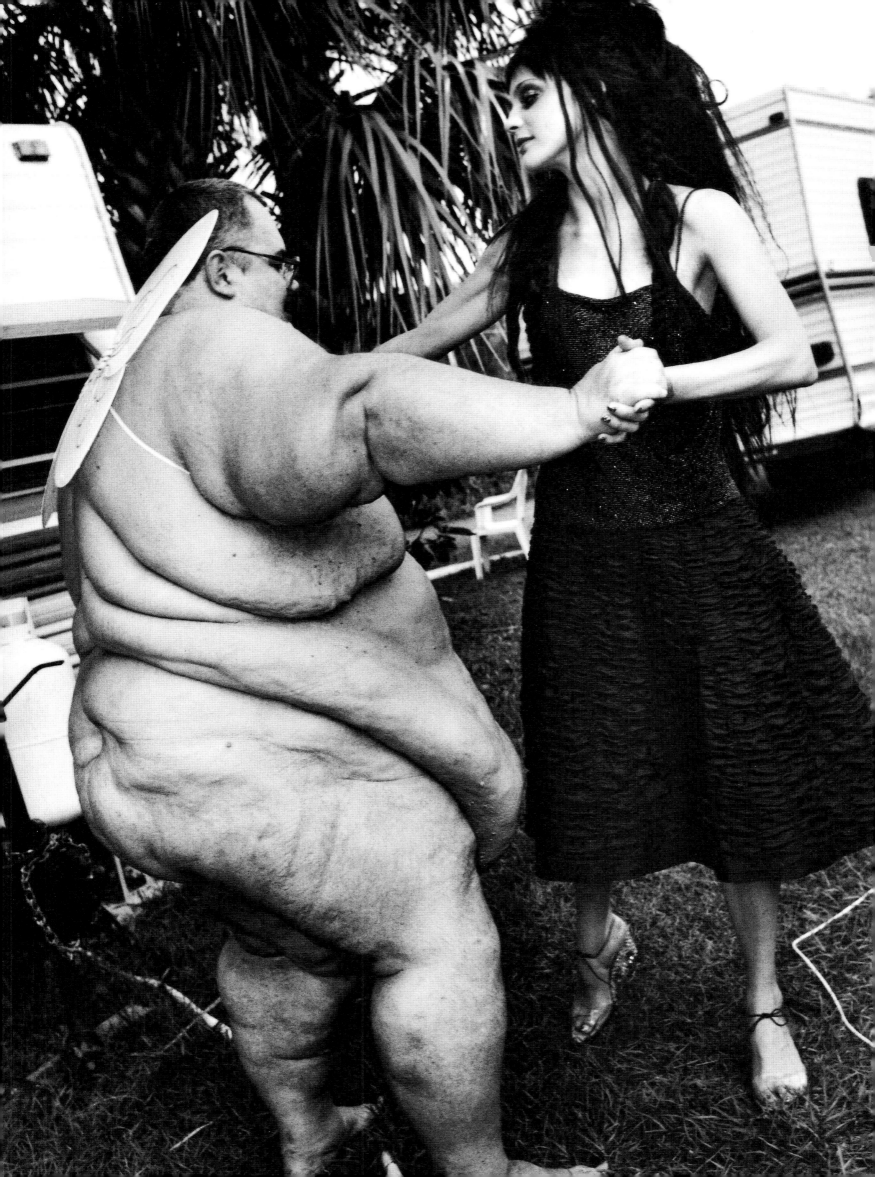

"My mother said:
'You are the prettiest
little baby I ever saw'.
This made me feel really
good. It still makes me
feel good."

Jeanie Tomaini, The Half Lady

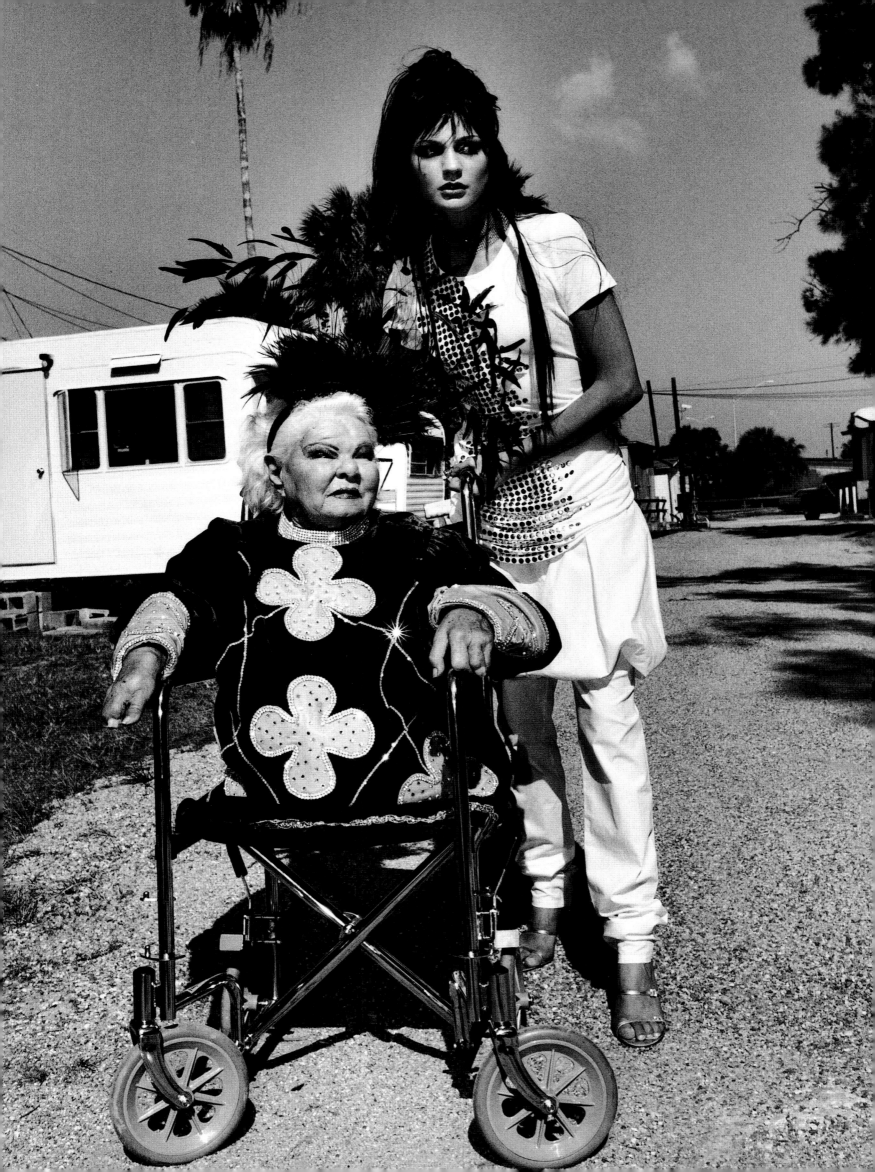

"My friends would fight to come and visit me, simply because my parents were more fun than their parents."

Judy, Jeanie Tomaini's Daughter

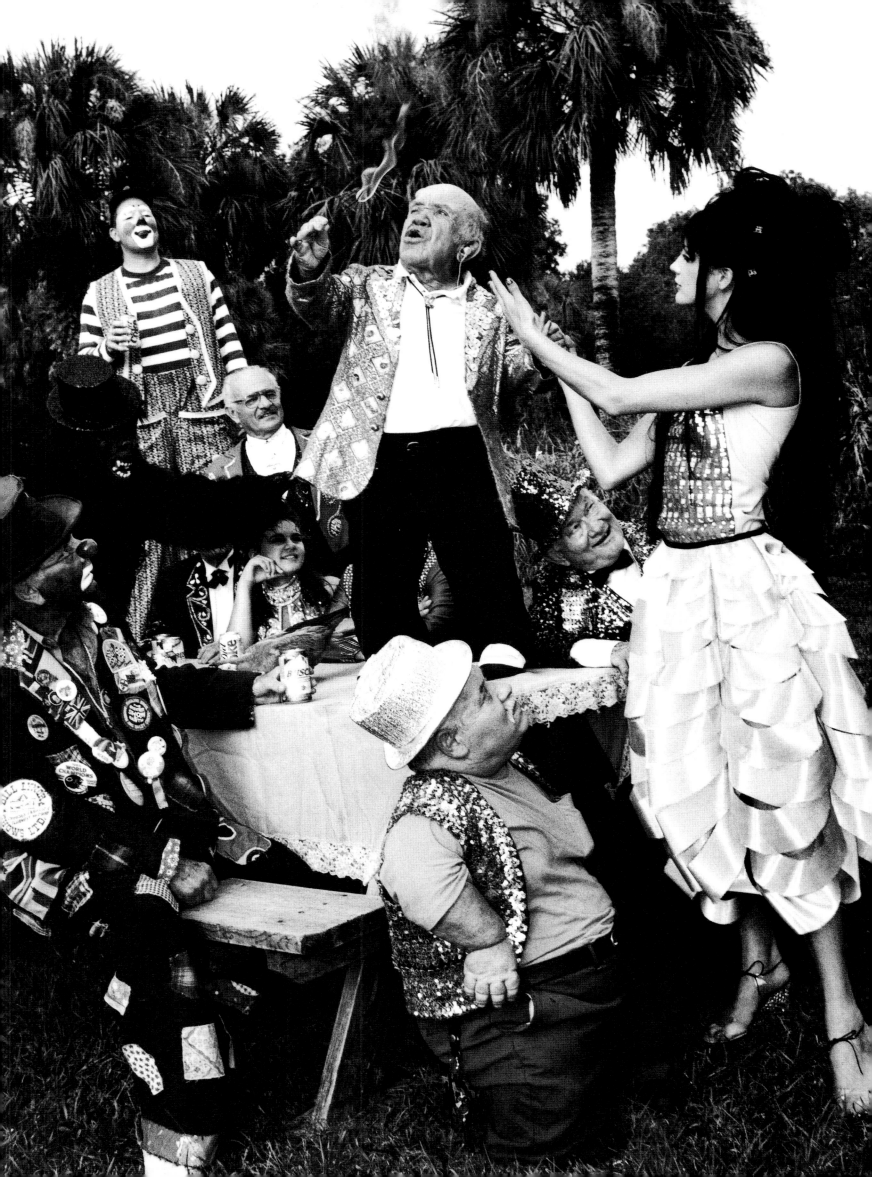

Back row, left to right: Tom Cooper, Clown; Dick Johnson, Ringmaster and Magician; Mr Miles, Stilt-Walking Clown; Bobby Fairchild, Ringmaster and Knife Thrower; Christele, Model; Melvin Burkhardt, Human Blockhead and Anatomical Wonder; Chris Christ, Sideshow Promoter and Production Manager; Bruce Snowden, Fatman; Roy Huston, Illusionist; Ward Hall, Sideshow Promoter and Production Manager

Front Row, left to right: Phil Chandler, Magician; Kelly Fairchild, Snake Charmer; Albert Carton, Gorilla Man; Little Pete, Dwarf and Fire Eater; Glen Newman, Dwarf

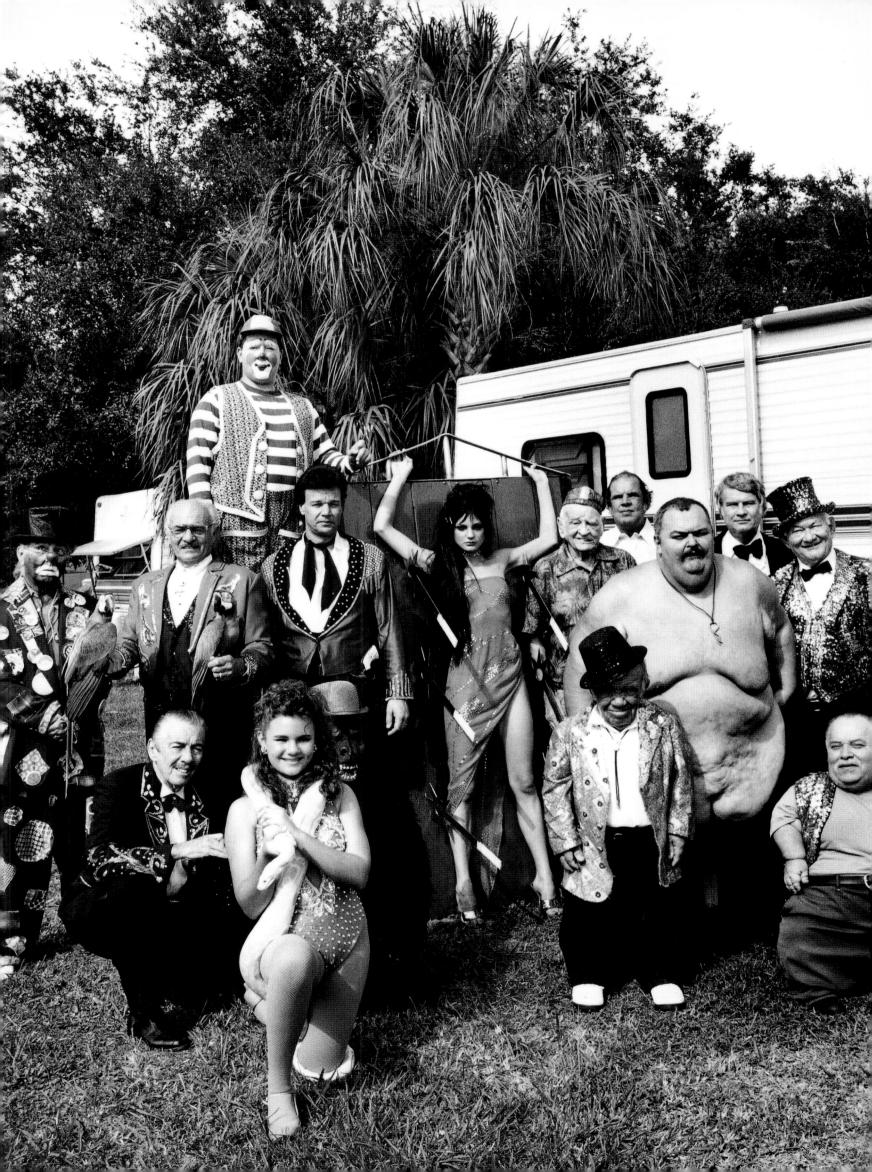

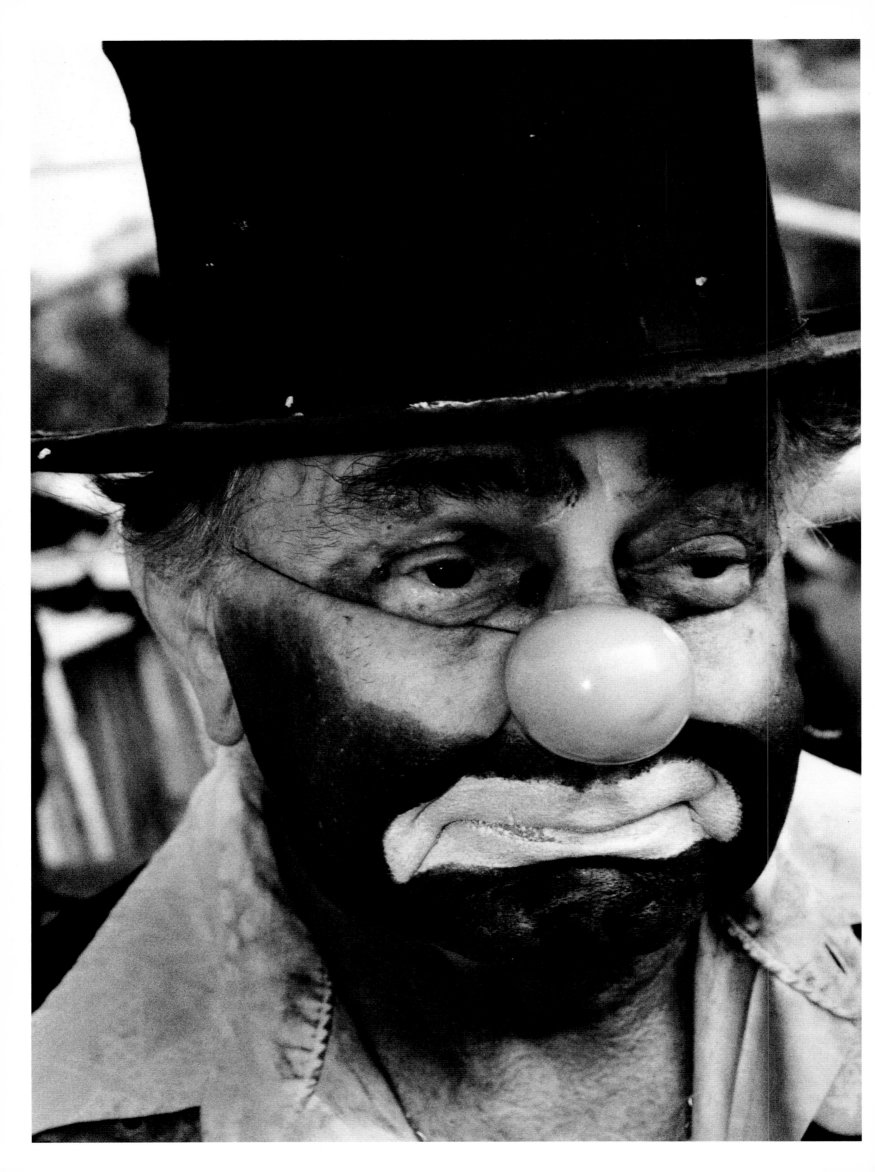

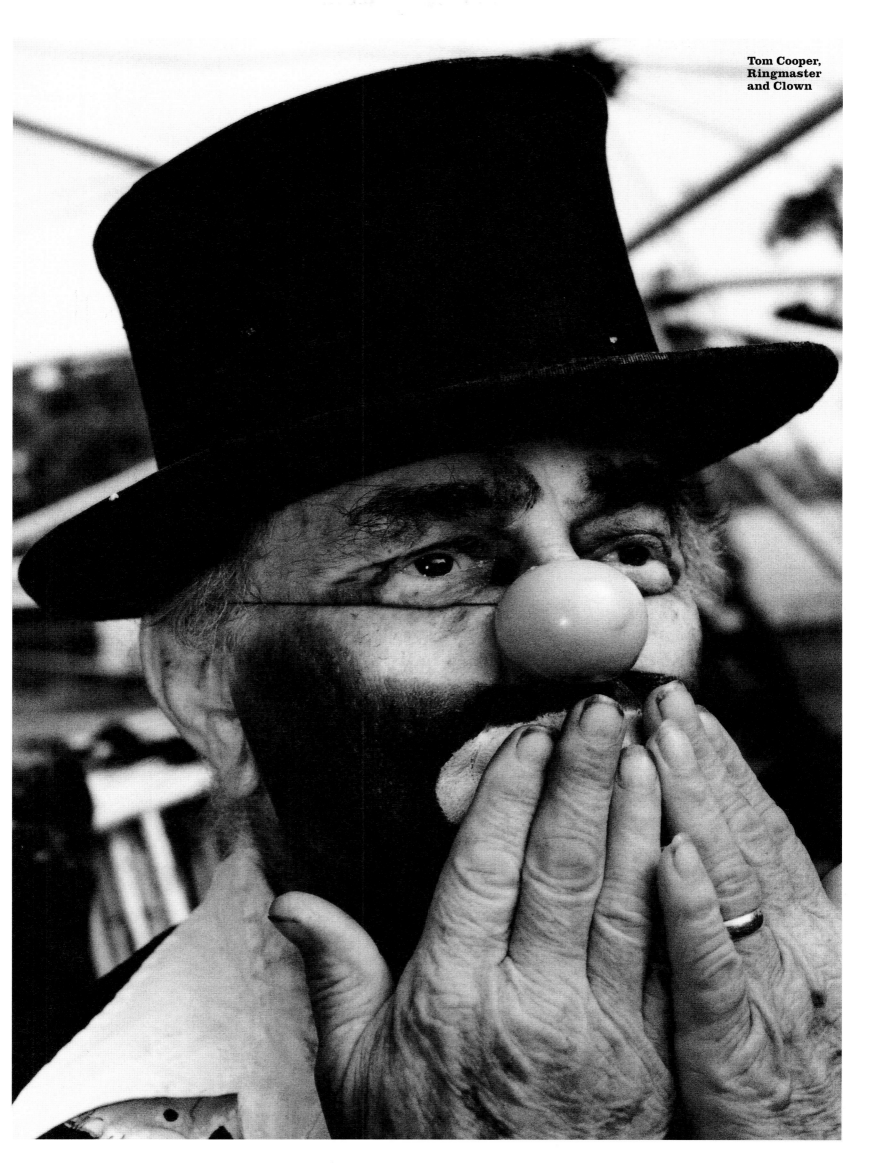

Credits:

The Last Sideshow

Photography:
Hanspeter Schneider

Art direction:
Nuisance

Design team:
Nuisance & Lisa Ling

Production team:
Paul M^cGuinness
& Catherine Scott

Print: Castuera

The Last Sideshow first
published in Great Britain
in 2004 by Dazed Books
112–116 Old Street
London EC1V 9BG
T +44 (0) 20 7336 0766
F +44 (0) 20 7336 0966
www.dazedbooks.com

All photography
© Hanspeter Schneider

Essay © Peter Schardt

Poem © Hanspeter Schneider

The right of Hanspeter
Schneider to be identified
as the author of his work
has been asserted by him
in accordance with the
Copyright, Designs and
Patents Act of 1988.

ISBN 1-904688-02-0

Printed and bound in Spain

Contacts:

www.hanspeterschneider.com
USA: www.barbaralaurie.com
UK: www.terrimanduca.com
Europe: www.schierke.com

Filmography:

"Gib'town", Documentary,
USA, 2001, by Melissa Sachat,
produced by Loretta Harms,
Roger Schulte, Mary Solomon,
edited by Roger Schulte.

"Freaks", USA, 1932, by Tod
Browning based on the story
"Spurs" by Tod Robbins' with
Wallace Ford, Leila Hyams,
Olga Baclanova, Roscoe Ates.

Bibliography:

Articles on Gibsonton,
Sideshows and Show Freaks:

Daily Telegraph,
March 4th, 1995

Orlando Sentinel, "Florida",
July 4th, 1993

Tampa Tribune & Tampa
Times, "Florida Accent",
May 21st, 1978

Washington Post,
August 23rd, 1991

Courier Express Magazine.

Weekly Planet, no.40, 1995,
September 18th, 1977

Special Editions
on Show Freaks:

James Taylor: Shocked &
Amazed, vol. 1 and 2, 1995

Autobiographies/Monographs:

Ward Hall: excerpt from
Secrets of the Sideshow
(manuscript)

Ward Hall: My Very Unusual
Friends, 1991

Ward Hall: Struggles and
Triumphs of a Modern
Showman, 1981

Daniel Mannix: We Who Are
Not As Others, 1976

Daniel Mannix: Memories of
a Sword Swallower, 1996

Hans Scheugl, Sammlung
Felix Adanos: Freaks Monster,
Köln, 1974

Thanks to:

Debora Bee and Scene
Magazine, Alison Fitzpatrick,
Christof Lonsdorfer,
Hywel Davies and Anna
Burns, Christele Cervelle,
Peter Schardt,Barbara
Laurie, Terri Manduca,
Elaine Milligan, Helga
Schierke, Mondlane Hottas,
Kirk Teasdale, Rankin, the
Dazed team and all my friends
in Gibsonton.

Special thanks to:

Jeffrey S Kane/Black+White,
N.Y. for the beautiful black
and white prints.
Maciria Rossi for your
inspiration and the
amazing hair and make-up.
Tom Cooper for your
friendship. I could not have
done this book without you.
I never will forget you.

Prints:

Black+White, N.Y.

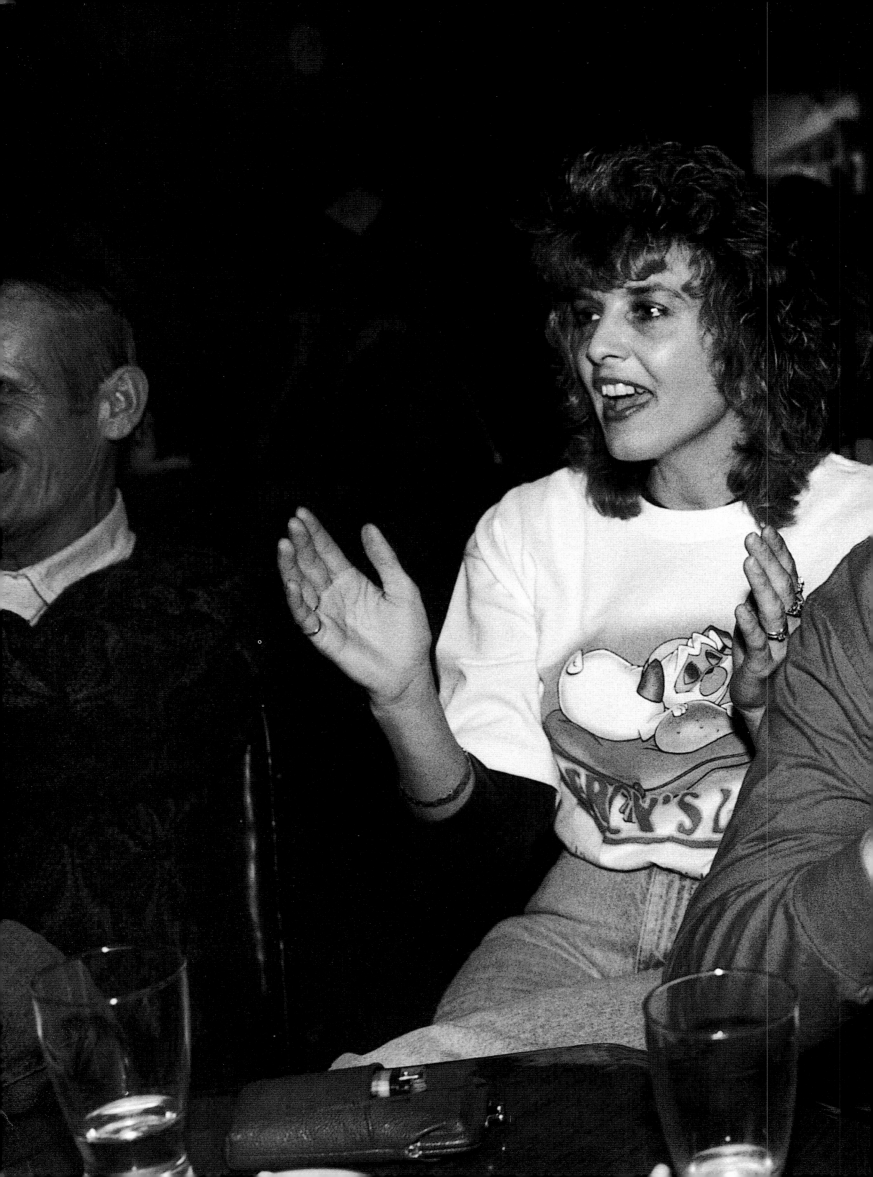

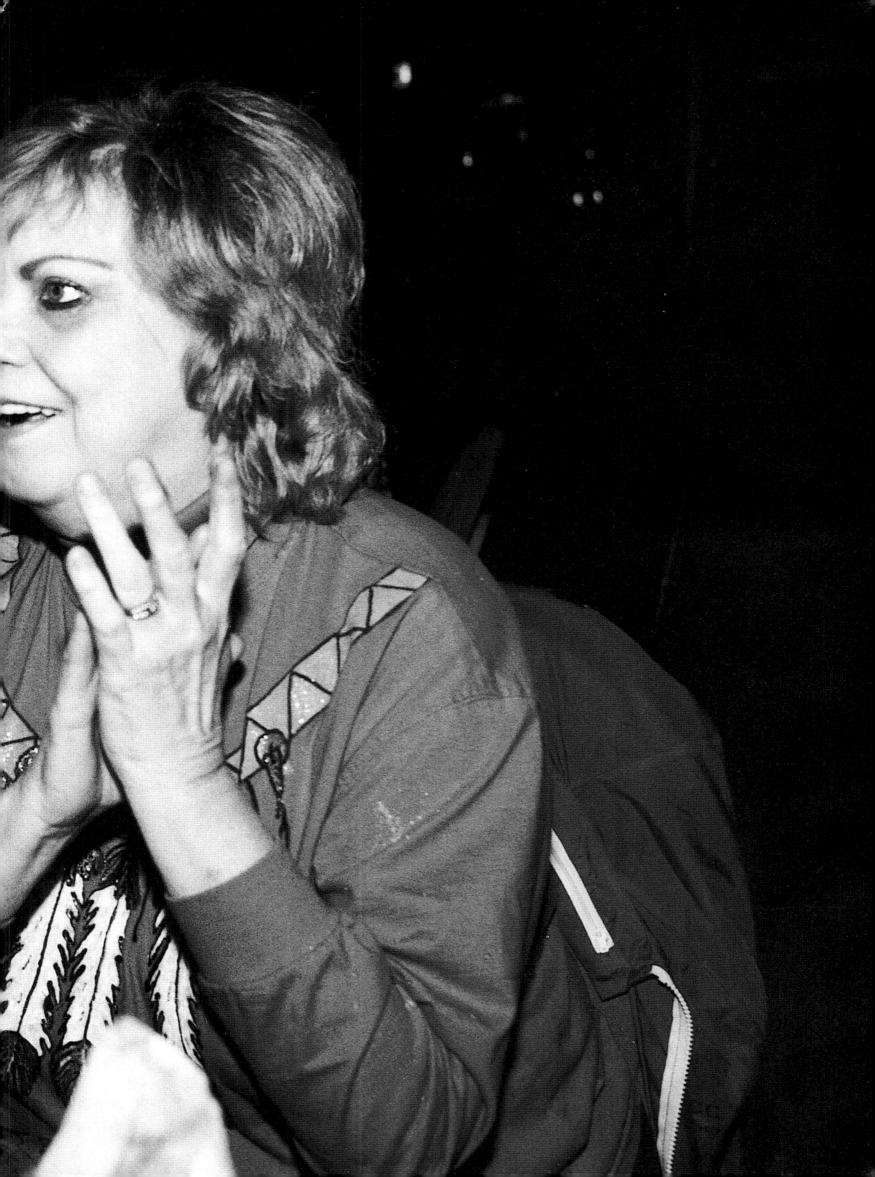

Dedicated to:
Jeanie Tomaini, Melvin Burkhardt, Garland Parnell, Frank Cain, Scott Taylor and Connie Welde
who have since gone to the Great Sideshow in the Sky.

Hanspeter Schneider

Hanspeter Schneider is a reporter deep inside his heart.

He is not only a voyeur and an observer, he is a storyteller. His pictures, taken in a fragment of a second, are frozen stories. They start before the push of the button and go on in the fantasy of the viewer's mind after the shutter is closed. They are sly stories, more than just fashion photography.

What interests him is the flow of staging and fashion reportage into one another. His pictures are real and authentic.

Hanspeter has worked as Art Director for international advertising agencies such as JWT, Lürzer Conrad, Leo Burnett, Mirabelle and Advico Y&R. He has shot regularly for Vogue, GQ, Vogue Homme, Rolling Stone and Details, and has shot campaigns for Sisley, Levis, Lancaster, Bacardi, Guerlain and more.

Exhibitions

Art-Fashion, New York 2002

Publishedunpublished, Pin Up, Paris 2002

New York Dolls, Picto, Cape Town 1999

New York Dolls, Picto, Paris 1999

New York Dolls, Fashion Gallery, London 1998

Backstreets of Desire, Parco Gallery, Tokyo 1994

Backstreets of Desire, Hohenthal & Bergen, Munich 1994

Portraits, Hohenthal & Bergen, Cologne 1994

Unplugged, DOG, Kobe 1993

Unplugged, Festival de la Mode, Barcelona 1991

Other books by Hanspeter Schneider

Unplugged
(U.Bär Verlag, 1993)

Backstreets of Desire
(Benteli, 1994)

Vila Mimosa
(Dazed Books, 2004)

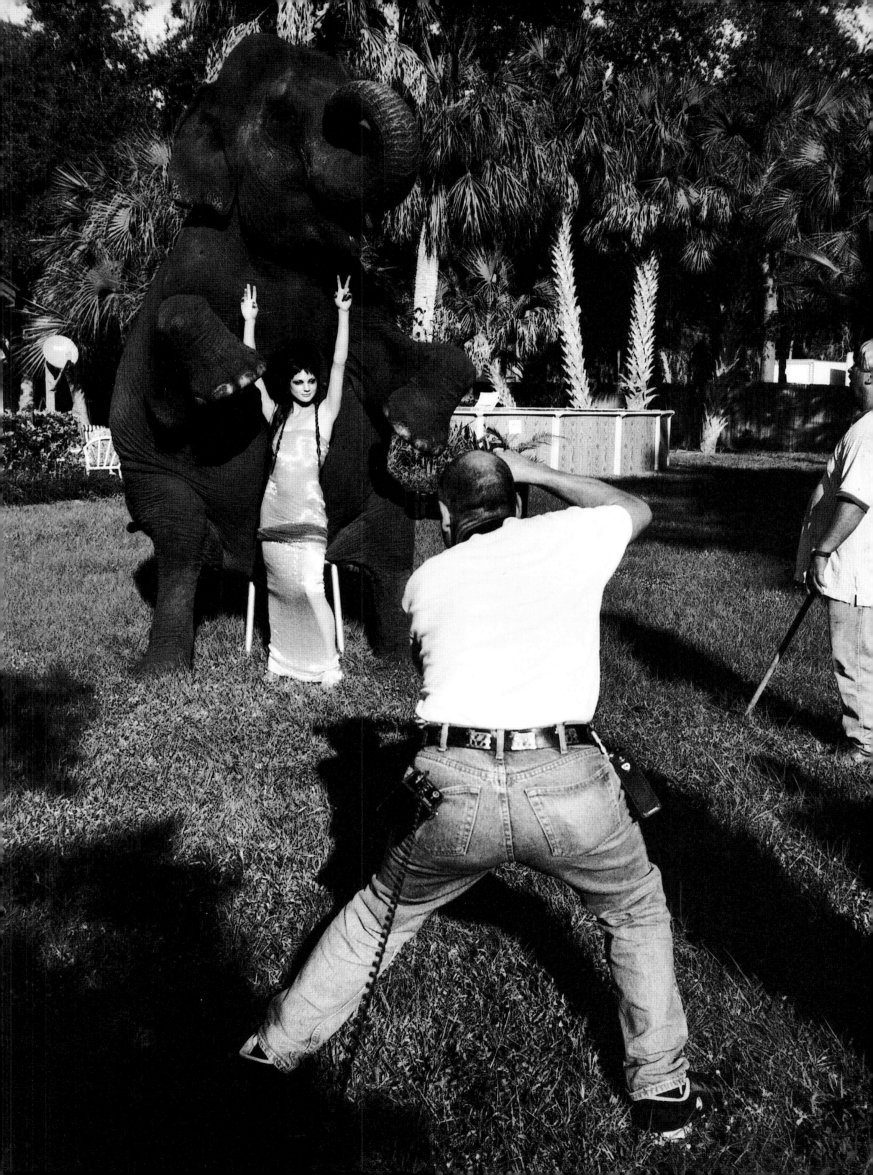